ALL
about techniques in
COLOR

ALL

about techniques in

COLOR

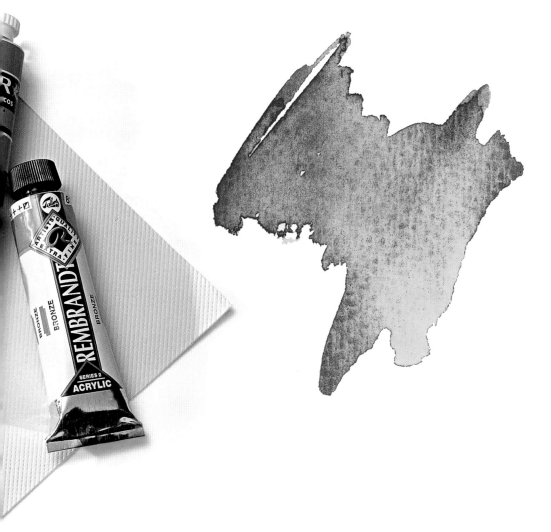

BARRON'S

Contents

Excavations and archeological finds have shown humans' longstanding and insatiable desire to paint what they see. Today, we can contemplate paintings of hunting scenes executed by early humans on rocks and prehistoric cave walls. These images, created with primitive materials, are at times very realistic and at times more abstract. Early on, artists already knew how to depict the volume of an object through color and form. These first artists even used the relief of the cave walls to make the figure look more realistic. The colors used by cave painters were plaster white, smoke black, and the ochres, brown, red, and violet.

The artists of ancient Egypt discovered many more colors beyond smoke black and earth colors. Their murals also contain lead white, dark yellow, malachite green, and Egyptian blue. As we leap forward in time to the Renaissance we see that mankind diligently continued to search for a wider range of colors. The advent of oil paint opened up a new chapter in art history; sources for new colors were discovered in response to the new demand. These included a variety of whites, Naples yellow, royal yellow, raw sienna, dark sepia, vermilion, carmine lake, earth green, and ultramarine blue. The eighteenth century bore witness to the development of watercolor paint and pastel, generating even more demand for color. With the Industrial Revolution and the development of commercial dyes and chemical pigments, the palette of colors available to the public grew to be practically limitless.

Thanks to the technical and chemical advances within the field of fine arts, today's painter has a great deal of flexibility in using color.

The artist's personal style and aesthetic sense are basic to the painting process. There is an intentionality in the color blends, the way in which they are applied to materials, and the search for a personalized, subjective, color harmony. Although the artist has many media to choose from, this book deals especially with oil, acrylic, gouache, and pastel. The characteristics of each medium offer their own distinct vehicle to visual interpretation.

The world of color can be immensely attractive for anyone. But for artists, it is a field that must be handled with grace, and in which their own personal color interpretation is paramount. The perception and use of color makes a harmonic relationship possible among them. This use runs the gamut from the riskiest to the most soluble solutions: the use of contrasts at one end and the most delicate harmonizations on the other. All things considered, the world of color captivates us with its limitless blends and infinite possibilities of visual dialogue.

The aim of this manual is to show the practitioner how to handle color. The reader is first introduced to the media. This is followed by an explanation of the principles of color theory and the possible techniques for each medium. Oil, watercolor, acrylic, gouache, and pastel each have different possibilities, depending on their makeup. The techniques that artists can use are a direct result of the properties of its components. This book will provide a comparative analysis of the characteristics of each medium.

Mercedes Braunstein

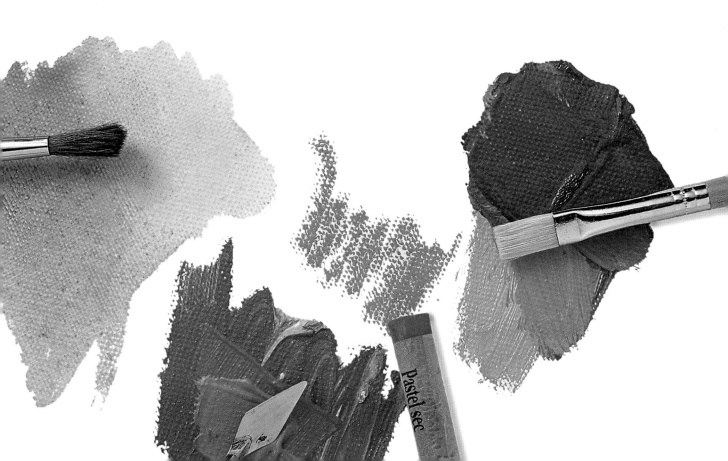

The Artist and Color

In order to paint an image, painters require a blank surface (paper, canvas, wood, and so on) and some colors. Whether doing a still life, landscape, figure, or any other subject, the painter must re-create the subject's three-dimensional volume on a flat, two-dimensional surface.

The composition, center of interest, the working out of the drawing, and any problems that may be involved in the preliminary sketch are matters that artists must resolve before they begin to apply paint. They are required to study the subject's basic color scheme in order to work out an order for the pigment's application, taking into consideration such characteristics as density, mixture, and texture. The first task, therefore, is to study the colors you see before you.

All objects have a local color, the coloration of the object, tonal values, and the shadow cast.

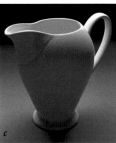

The same white pitcher as in the previous example, this time situated against a blue background, illuminated with frontal lateral lighting (a), with light from above (b), and with backlighting (c). By changing the background, several hues of blue appear reflected on the white jug, as a result of the surrounding color.

HOW TO SEE COLOR

Several natural phenomena determine how we perceive a specific color. First, it is important to keep in mind that there is no color perception without light; the color of the light source and ambient light will influence the coloration of an object.

We must first ascertain whether the lighting is natural (daylight) or artificial (electric, etc.) and determine the direction of the illumination. Once we have examined the light that bathes the subject, we can begin to think about the dominant color.

Light travels around, between, or through the objects that form an image. With careful observation, we can identify the factors that determine the color of those objects. There are three main points to keep in mind: the local or actual color of the object, the tonal color (its darkness or lightness), and the reflected color. Color is always easier to see when we know what we are looking for.

LEARNING TO SEE

THE ACHROMATIC REPRESENTATION

Many values can be seen in an object, such as this white porcelain pitcher. By observing the light in each one of the photographs of the pitcher at the bottom of this page, we can see a tonal range that extends from white, passing through a series of gray tones, almost to black. The distribution of these tonal values varies according to the type of light shining on the object. With observation we can ascertain the object's tonal values. The pitcher's local color is white, and the illumination creates the tonal colors. In addition, there is an intense area of ambient reflection, which, with the

A white porcelain pitcher, placed against a white background, with three different types of illumination: frontal lateral lighting (a), light from above (b), and backlighting (c). As we can see, the same object takes on a different appearance according to the type of lighting that shines on it.

Note the reflections on the jug. In addition to those produced by the light, there is the bluish tone, corresponding to the horizontal blue surface, and the mauve, which is reflected from the wall.

warm white of the porcelain pitcher, situated within its cool white environment, creates an interesting shimmer.

THE CHROMATIC VERSION

The various forms of lighting over this green cup produce different effects. There is the object's local color, green; but just as with the white pitcher, the tonal colors produced by each form of lighting are distributed differently on the object. The green cup contains an area of color caused by the reflection of ambient light. It is easy to verify that this reflection results from the blue surface on

which the object is sitting. It can be said, therefore, that the object has been altered and influenced by the surrounding color, particularly and most directly in the area of the reflection. The type of highlight produced depends on what the object in question is made of. In the examples provided, the reflection is most intense on ceramic enamel. On other surfaces, the reflected color of the object's surroundings may cause only a slight change of hue. Reflected color has a less extreme effect on the flesh colors in a figure painting, the reflections on a newspaper, or objects such as

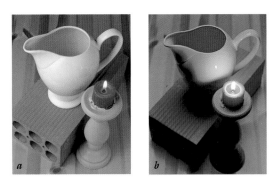

These two photographs demonstrate different forms of illumination. With daylighting (a) the effect of the candle is secondary. But it is still possible to observe the flame's shine and the reflection of the blue candleholder on the pitcher. The candlelight in the other photograph (b) has a very different quality than the one on the left (a). The effect is no longer diffuse, lit by the strong white light of day. Instead, the candlelight casts a warm, focused light, which casts clear, deep shadows.

those in the photograph of the colored sponges placed on a white surface.

THE LIGHT

The three examples of illumination of the white pitcher and that of the green cup have been photographed with the same type of electric lighting coming from various directions. When the chromatic quality of the light is changed, for example, using candlelight, we can observe how the local color of the object and the tonal range of its shadows take on strikingly different characteristics.

An object does not appear the same on a sunny day as it does on a rainy day. A yellowish light is produced by

the midday sun in summer, whereas an orange light is produced at sunset. All the colors of an object will change with alterations of light. The elements of a landscape (trees, vegetation, a river) will change dramatically as the light shifts, the colors of each of the elements appearing quite different as the light changes color.

The sun and the moon are the sources of natural light. In general, moonlight casts a bluish, silvery-gray light. Day-lit colors vary according to the intensity of sunlight. The dominant colors in sunlight range from yellowish, orange, and reddish tones in conditions of bright sunlight (depending on the time of day), to the blue and gray shades caused by an overcast sky.

COLOR AND DISTANCE

When we speak in terms of distance, we take into account effects caused by intervening atmosphere. A nearby object does not appear to have the same colors as it did when it was situated on a distant

plane. In a landscape, for example, one can readily distinguish between the various planes—the foreground, the middle ground, and the background—because of the effects of atmosphere and distance. In the foreground, the plane nearest the observer, the sharpness and contrast among the different colors is greatest. These characteristics gradually diminish as the planes recede into the distance.

This effect is best observed in hazy landscapes and also on overcast days. Water vapor (clouds), pollution (smoke, etc.), air convection (wind), and other factors are elements that influence the quality of large air masses that intervene between the observer and the distant planes of a landscape. Depending on the conditions, the intervening atmosphere may heighten the sharpness between colors and alter them, adding grayish, bluish, brown, and pinkish tones to the elements.

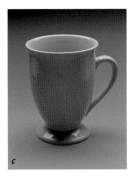

In the photograph of sponges, the colors of the surrounding environment can be observed in the cast shadows. Against a white surface, the shadow cast by each of the sponge's colors takes on a reddish, yellowish, and bluish hue.

NOTE

By looking at something through squinted eyes, it is easier to study the quality of light and the delineations of large color masses. This method of observation has the effect of simplifying detail while making more obvious the more fundamental characteristics. See the section on the nature of light (pages 138–141), which discusses the coloration of objects and color perception.

A green cup placed against a blue background, illuminated with frontal lateral lighting (a), with light from above (b), and with backlighting (c). Note the different greens. In order to understand this phenomenon, it is essential to consider the light, its quality, quantity, and direction, as well as the blue background.

Paints in Today's Market

Paint is made up of media and pigment. The color of paint is derived from the mixture of pigments, which are obtained from natural or manufactured substances of organic, inorganic, and synthetic origin. Nowadays, pigments can be bought in powdered form.

In order to apply or handle pigment, a binder must be added to dissolve the particles. When powder pigment is mixed with a medium or a binder, it acquires a specific mass. The pigments and the media are mixed together until each particle of pigment is completely enveloped in binder.

The combined characteristics of the components of each medium produce the properties of each type of paint and determine the way the color can be worked. The nature of pigment and mediums govern the results, possible limitations, and even problems in conservation of the work.

MOST COMMONLY USED BINDERS AND SOLVENTS

OIL

The most common binders used with oil paints are linseed oil (cold-pressed), raw, refined and dense; poppy oil; walnut oil; sunflower oils; and the various artificial oils. The most common types used by painters are linseed oil and walnut oil. Oil paints can be used thick, or diluted for thinner, smoother application. The most traditional thinner used for oils is a combination of linseed oil and turpentine; the ideal proportion is 60% oil and 40% turpentine. This is a solvent mixture that prevents the paint from cracking even if it dries very slowly. Mediums containing varnishes, wax, and synthetic resins will shorten the drying time quite a bit and help to overcome some of the problems inherent in the slow drying time of oil. Quick-drying mediums will also prevent dripping when applying glazes.

WATERCOLOR

Gum arabic is the binder used in watercolor. Though very fine watercolors are plentiful in the marketplace, some painters may wish to manufacture their own colors and will require pigment, sugar solution mixed with glycerin and gum arabic (2 or 3 parts) and a few drops of ox gall. The solvent used with watercolor is water. Precise recipes are hard to come by, though a good one exists in *The Artist's Handbook* by Ralph Mayer.

ACRYLIC

Acrylic paints are manufactured with the same pigments as those used with oil and watercolor. In addition to the traditional colors, a wide range of variations can be created using synthetic pigments. Polycrylates and polymetacrylates are

Linseed oil and rectified turpentine for diluting oil paint; turpentine is also used to clean the brushes and palette.

Pigments.

Plaster.

Gum arabic.

used as binders and as a solvent for mixing the pigments. Acrylic polymer emulsion is soluble in water.

There are also acrylic mediums manufactured to mix with acrylic paint to obtain different effects. First, there is the glossy medium, though it is not as glossy as oil-based varnishes or oil paint. Matte medium, somewhat denser, does what its name suggests, creating a matte (not glossy) finish. The gel-type medium contains thickener and is used to add body to the paint. Due to the fast-drying capacity of acrylic, a number of retardants are made, in the form of gel or liquid, that can be added in small quantities as the artist works. Acrylic paint can also be diluted with water, then mixed, before applying it, with the medium of choice.

PASTEL

Soft pastels are mainly powdered pigments. Gum or resin is used to bind them, forming a paste. Then the paste is given a cylindrical or stick form. Their opacity can be increased by adding gesso or plaster. The different ingredients of chalk allow pastels of varying degrees of hardness to be obtained—soft, medium, and hard. Pastel is considered a direct painting medium that does not require any additional substance or agent for application.

GOUACHE

The composition of gouache is like watercolor. Gouache was traditionally regarded as watercolor pigment to which white was added. Today, gouache is made of resins (gum arabic, Ghatty gum, rubber glue) and dextrines (starches derived from potato or corn). In addition, some white pigment is added to each color. This gives the medium its characteristic opacity. Gouache has a more full-bodied color than transparent watercolor. It is made to be used in a creamy consistency and is known for its smooth finish and covering ability. It can also be diluted and worked more transparently.

Glycerin can be added to gouache to prolong the drying time of the paint, thus allowing colors to be blended. Water is the solvent used with gouache.

COLOR INDEX

The following chapters discuss the uses of oxides and artificial pigments to obtain specific colors. The international Color Index is used to explain which pigments form part of a particular color. Each letter refers to a specific color:
PW: Pigment White
PR: Pigment Red
PY: Pigment Yellow
PO: Pigment Orange
PG: Pigment Green
PB: Pigment Blue
PV: Pigment Violet
PBr: Pigment Brown
PBk: Pigment Black.

The numbers indicate the type of pigment; for example, PW4 is Pigment White 4, or zinc oxide. Although very few artists and specialists manufacture their own paints, the information sometimes provided on packaging may refer to a paint's ingredients, which can tell the artist about resistance to light, opacity and transparency, pigment composition, and the type of oil used as a medium.

EACH MEDIUM HAS ITS OWN TECHNIQUES

OIL

As its name indicates, oil is just that: a medium that is made with one of several types of oil and pigment. It is sold in tubes, and its pastiness makes it ideal for blending, modeling, and mixing. Oil paint is diluted by means of a combination of components, with linseed oil and turpentine the most commonly used.

Oil paint is a versatile medium, known for its workability and plasticity. Oil's techniques and applications are unique to each painter. When oils are used over a period of various sessions, the first applications of paint must be applied in thin layers, diluted with turpentine, and allowed to dry. Subsequent layers are then applied thicker and less diluted, as the painting is finished.

The artist can alternate thick impastos, frottis (washes, glazes), and blending, using both wet-on-wet and wet-on-dry techniques. Oil paint creates rich tones and colors, whether applied very diluted, in transparent layers and glazes, or in very thick layers.

WATERCOLOR

Water is the solvent used with watercolor. By increasing the proportion of water to the pigment, artists can obtain extraordinary tonal ranges.

Areas or single brushstrokes of watercolor can be applied wet on wet or wet on a dry background.

The beauty of watercolor as a medium lies in the transparency of the paint. Its colors gain luminosity—light reflection—when they are painted on a white paper background. Watercolor's luminosity can create shimmering colors. One secret of obtaining its dramatic impact lies in painting dark over light. The lightest colors form the first layers of the painting. Then, painting wet on wet (with multicolored washes)

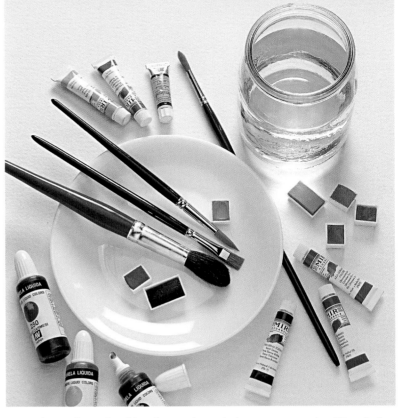

Watercolor can be purchased in cakes or tubes, or in jars as tempera paint. Water is the solvent and thinning agent for watercolor, gouache, and tempera. A china plate can be used as well as a commercially manufactured palette to mix colors. Color mixing is traditionally done with the brush.

or wet on dry, mixtures are created by superimposing layers or tonal gradations, with the darkest colors applied last. Watercolor can be worked in loose, brushy strokes, applied with uniform washes, or painted with precise gradations.

GOUACHE

Gouache comes nearly ready to be painted directly onto the paper or other support. Its degree of water saturation allows it to be applied in opaque layers, adding only a little water. Gouache tends to crack if applied too thickly. Enough water should be added until the paint has the consistency of heavy cream. Water can also be added when the tube or bottled paint has begun to dry out.

Compared to watercolor, gouache is an opaque paint. This means that dark colors can be painted over light ones and the reverse as

well. Gouache tends to lighten color as it dries, and it can scar when used in layers. Like any other medium, it takes some experience to understand how best to use it.

Gouache paint is perfect for covering broad areas with uniform flat color. It is quite colorfast once dry. When gouache is diluted with water, it can be used much like transparent watercolor, to apply color in thinner areas or layers of paint, a method that reduces the opacity of the paint. Though less luminous than transparent watercolor, gouache's saturated hues create beautiful variations and glazes when diluted with water.

Gouache can be applied wet on wet and wet on dry. It is a medium that, in a sense, bridges transparent watercolor and oil, as it can be used in washes, as well as in thicker applications, to

There are various sizes of tubes of oil paint. The most common ones contain between 15 and 20 ml (the smallest size) and 60 to 200 ml (the largest size). The palette, brushes, palette knives, and solvents make up part of the oil painter's basic equipment.

model form in a plastic way. Certain colors may crack or scar more easily than others if it's applied too thickly, however.

ACRYLIC

Acrylic is a synthetic paint medium that disperses pigment in a liquid emulsion base. Once dry, it forms a layer that is resistant to the effects of light and water. Acrylic is a water-based medium and can be used with gels and polymer mediums, manufactured to give acrylic a finish akin to that of oils. Like oils, acrylics can also be used to create impastos or, in transparent layers, applied as glazes. Water can always be added to acrylic paint, yet only within certain limits, as it reduces the resistance of the paint when it has dried and can create a surface that looks like thin, soft plastic.

Gouache and acrylic have their own set of techniques, but both media can be worked dark over light and vice versa when applied opaque.

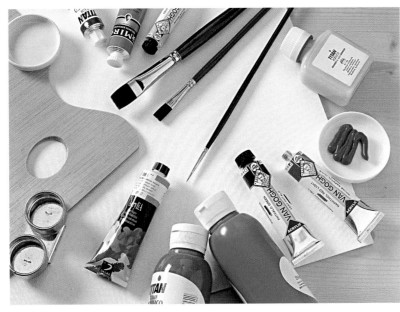

Acrylic paint is a relatively recent painting medium. It is sold in various kinds of tubes and jars. In addition to water, polymer products such as gels and gluelike substances can be used as mediums. Acrylic can be applied with the same implements used in oil painting. Color mixtures can be done in dippers or other small receptacles or on paper palettes.

Acrylic paint is frequently the product of choice in the field of fine arts today. The synthetic resins, which bind the pigment by means of the polymerization process, dry very quickly and make the paint very versatile and permanent. When acrylic is combined with opaque or transparent gels, with a gloss or matte finish, it can be used with an almost limitless number of techniques: uniform washes and gradations, opaque gradations, impastos, taped hard edges, blendings, glazes, sgraffito, and stenciling are just a few of its possibilities.

PASTEL

A dry medium like pastel does not require any additional substance to be added for its application on paper or other type of support; it is therefore regarded as a direct medium.

Nonetheless, pastel can also be worked as a water-based medium, in which case the characteristics of the paint are considered more like those of a watercolor-type paint, although without the transparency of conventional watercolor.

It is difficult to obtain mixtures with pastel. Therefore, a wide selection of commercially manufactured pastel colors is available.

The most common techniques used with pastel are blending, grading, and using the medium with a fixing agent. The quality of its chiaroscuro, or light and dark effects, and its brilliant color, is what distinguishes pastel from all other media.

Pastel can be used with such drawing techniques as strokes, shading, coloring, and linear work. In addition, there is an immediacy to its color effects, as pastels are almost 100% pure pigment. Pastel is a highly plastic medium, as it is easily modeled and blended. It is an opaque medium, more or less so depending on the pressure of application, which allows the artist to paint dark over light and light over dark. Tonal gradations can be created in large areas or lines of color by altering the pressure applied to the stick. The medium can also be used semi-transparently, as its colors are delicate, and its soft chalky substance allows the paper's texture to show through. Unless worked with water, pastels are a dry medium.

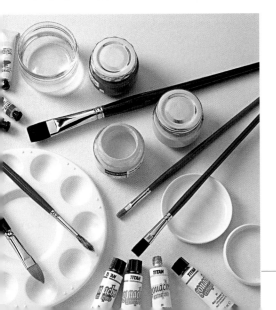

Gouache is very popular with poster designers and advertisers. This type of paint is sold in tubes and jars (as tempera). The same implements and solvents used for watercolor are used for working with gouache. Flat brushes are useful for painting flat, even coats of gouache.

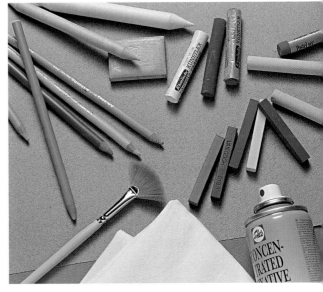

Soft pastels can be bought in cylindrical sticks. The harder varieties are sold in the form of rectangular sticks; the hardest pastels are manufactured as pencils. In general, in addition to the artist's fingers or a cloth, blending sticks and fan brushes can be used to blend colors. A kneaded eraser and liquid fixative are also important tools. Another essential ingredient to keep in mind is the color of the paper on which you will paint your picture, as it will set the color mood.

Forms, Colors, and Media

When painting a subject from nature, the artist must first study the problem inherent in the subject's drawing and color presentation. Procedures and techniques will vary from medium to medium, depending on the qualities and capacities of each. Regardless of whether you are going to paint in oil, watercolor, acrylic, gouache, or pastel, however, the first step consists of sketching the subject and resolving its composition on your support and, if representing an object, translating its three dimensions into two.

THE SKETCH

The painter divides up the space of the surface using general and more detailed lines and strokes. These lines will begin to suggest the distribution of general areas of color as well. The sequence in which the successive layers of paint are applied will vary with each medium, as will the working of areas of color and line as the representation of subject matter is developed in paint.

PASTEL

Some artists prefer to block in the motif in charcoal, and then work over that image with pastels. But charcoal dust will muddy colors, especially paler ones. When striving to preserve the purity of color, it is best to sketch with pastels from the outset, either soft or hard.

The presence of different degrees of binding material in charcoal, Conté crayon, chalk, and pastel can produce interesting variations and blends, much the way any mixed media techniques may. The medium you are using to draw the sketch, therefore, becomes the first of the sequence of steps required for applying colored pastels.

OIL

A sketch intended for an oil painting can be drawn in charcoal. Next, the sketch lines must be gone over with a brush dipped in turpentine to fix the drawing to the support. The piece should then be left to dry, after which a clean cotton rag can be used to remove any remaining charcoal dust. At this point, it is ready to paint, the charcoal fixed and faint enough not to dirty the colors to be applied on top. Another approach is to sketch the general lines of the subject using thinned paint; the type or number of brush to use depends on the style and preference of the painter, and the diluted color can be the subject's dominant color.

ACRYLIC

When acrylic paint is applied in thick and opaque layers, sketch lines will be covered over. Thus, the artist can draw the sketch with virtually any drawing media, even felt-tip pens. With charcoal or pastels, it is important to keep in mind that

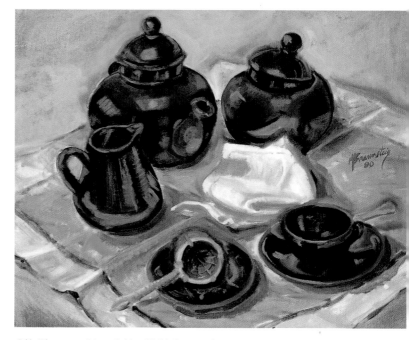

Oil. The composition of this still life is somewhat unconventional; the center of attention is the napkin, created by arranging the other elements around it. The volume has been achieved through successive layers of paint applied using thicker coats over very thin coats. The highlights and reflections, which are well delineated, help to create the impression of volume. Oil is an ideal medium for representing the characteristic sheen and multiple reflections of ceramic surfaces, whether painting is done with glazes or thick impasto-like strokes. Here, the pink, blue, and green tones give the teapot a colorful shimmer.

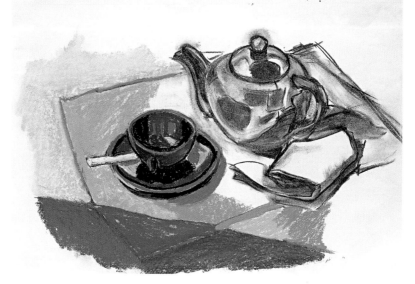

Charcoal and colored chalk. On the right-hand side of the image we can see that the original sketch was drawn with charcoal. Color has already been applied over the charcoal lines in the left-hand side, using large areas of chalk in the dominant color of each zone, without gradation. The strong visual impact of the color becomes obvious when viewed this way, alongside the black and white sketch.

heir dust will blend with the paint, altering he colors somewhat. One way to reduce this problem is to spray fixative on a faintly drawn sketch.

When the painting is to be developed with transparent glazes, the first sketch can be done in watercolor pencil, using the same color as the subject's dominant color.

WATERCOLOR

Watercolor's transparency demands a preliminary sketch that must be integrated into the work. To preserve the purity of the watercolor, you must sketch the subject with a watercolor pencil, using several general faint lines, just enough to define it.

For a combined wet-dry painting, the sketch can be given more detail. The pencil lines will not disappear under the different washes, but will appear fainter. They become an attractive element in the composition, clearly define color areas, and may be darkened or added to sharpen detail.

GOUACHE

Gouache is often used for its opaque covering capacity. When using

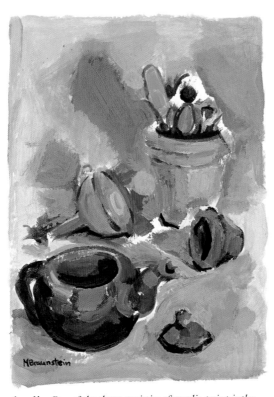

Acrylic. One of the characteristics of acrylic paint is the way in which it can be used to quickly apply flat areas of color that will dry rapidly. This illustration shows the result of a first application of acrylic that covers a sketch drawn on paper. The artist has filled in large areas of color, without attempting to obtain any volume. The subsequent applications are painted over this underpainting to create the desired effect, the first suggestions of depth.

Gouache. The teapot has been painted on highly absorbent watercolor paper. The paint is very opaque, and the white of the paper has been completely covered. Gradations have been used to model the forms and volumes. The transitions in tones are subtle. The gouache color areas do not create sharp delineations. Notice the difference between the texture of this teapot painted with gouache and the one done in watercolor. Notice the sharper edges of the shadows and tones in the latter.

Watercolor. In this example, the sketch was drawn with a black watercolor pencil. Strokes of white wax were used to protect and reserve the white areas of the paper where the highlights will go. The transparency of watercolor, the different colored washes, and the white reserved areas lend a sensation of volume to the whole.

this medium, the artist can do the preliminary sketch in pencil or colored pencils. The gouache used in sufficient density (mixed with water to the consistency of heavy cream) will cover any sketch lines. By diluting the gouache with water, the paint will be more transparent and the sketch will remain visible, particularly if it is done with pencil. Colored pencil or thin washes can be used to sketch, however, as these will fade with successive paint applications.

If the sketch is executed directly in gouache, some gum arabic can be added to slow the drying process, thus increasing the paint's plasticity to make it workable, as well as allowing subsequent color applications.

THE AREAS OF COLOR

Before beginning a painting, the artist must identify the colors that make up the subject, then analyze the tone scheme. Where is it darkest? Lightest? Note the varying degrees of tone and shadow so that you can represent them. A ceramic teapot is an excellent study subject with its interesting shapes and forms and reflective surface. Tone and shadow are elements that will darken, lighten, and neutralize the local color of the object.

NOTE

Each medium, be it oil, watercolor, acrylic, gouache, or pastel, will have its own look, its own visual effect, which becomes part of the character of the representation. Any subject can be painted with any medium. Sometimes a particular medium may be especially suitable for the representation of a specific subject. Watercolor, for instance, will portray beautifully the translucency of flower petals. Oil paint will create the solidity of a building.

Whichever medium is used, the task is the same. Color must be applied in successive layers onto the support. The relationship between color areas, lines, and strokes is what finally lends body and rhythm to the work. Each medium has its own characteristics, and each lends itself to different techniques.

In all cases, when color is used well, it will create not only form and light but also beauty.

The Characteristics of Color

What terms are used to describe the characteristics of color? The medium and techniques used to apply the color create different characteristics. As a result, although the color, or level of chroma, as it is called, is the same, the appearance may be very different. In painting, color is not only color, but also texture.

This chapter is important for understanding, through comparative analysis, the relationship that is continuously being established between different colors when they are seen juxtaposed to one another. When it becomes necessary to produce a mixture, several factors come into play regarding color mixing and application. Which colors should be combined? What chromatic qualities should the mixture have? What technique should be used to apply the color in order to achieve the desired texture? This last question depends particularly on our familiarity with the techniques that can be used with different media: oil, watercolor, acrylic, gouache, pastel, or combined media techniques.

TERMINOLOGY

COLOR

Pages 138 to 141 discuss color theory, the reasons objects appear to have certain colors. The observer will only perceive the color of an object as long as there is enough light reflecting on it. The same is true of paints: They are made up of pigments, each one absorbing and reflecting part of the color spectrum. Oil, watercolor, acrylic, gouache, and pastel each possesses its own textures and qualities. Each has its characteristic visual effects when seen under different kinds of light. The way that the paint has been applied to the surface can change the way it reads chromatically.

HUE AND TENDENCY

When we see a color, a category identified by a name comes immediately to mind—blue, for example. This is the color's generic name. The next step, however, involves defining the characteristics of the color more exactly. Is it a violet or cool blue, a green or warmer blue? Is it an earthy green or a tincture, or sharp, green? Commercially produced colors have been given many different names. Lemon yellow, a cool yellow, or olive green, an earthy green, are examples of manufactured paints with names that have become universal, and that adhere to certain color standards.

A similar procedure is used to define mixed colors. If the result of the mixture is a "pure" color, there will always be a color to associate it with: the predominant color in the mixture. For example, if a large amount of carmine is mixed with a small amount of light yellow, the result is a kind of red that can be called carmine red. If more yellow is added, the mixture could be called orange red. The hue can also refer to the degree of intensity of a color. The terms "toning up" and "toning down" can be used to refer to the process of increasing or decreasing the tones (the dark/light qualities) that make up a color.

TONES AND TONAL RANGES

Opaque tones, tints and shades can be produced from any color. When using oil, acrylic, or gouache tints are produced by mixing with white. When white paint is added to an oil color, the result is a lighter, less chroma-intense color. By varying the amount of white paint in the mixture, we can obtain several tints of the initial color. Adding black will produce shades in a similar way.

Watercolors permit the creation of different transparent tones of a color. The more water added, the more transparent the paint becomes. This allows the white of the underlying paper to show through the paint, lightening the tone. It is also possible to produce transparent tones with oil or acrylic.

With pastel, each stick contains the amount of white necessary to

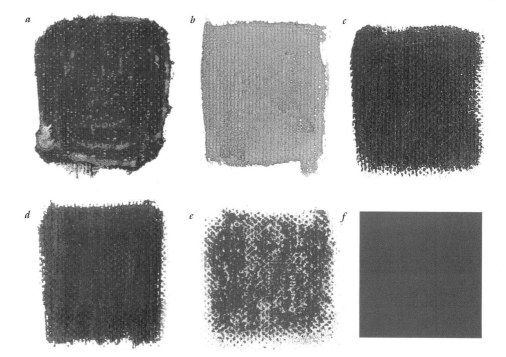

*The same color red in different media: oil (**a**), watercolor (**b**), acrylic (**c**), gouache (**d**), pastel (**e**), and printer s ink (**f**).*

*The same color of acrylic paint with a glossy (**a**) and matte (**b**) finish.*

the strength and luminosity of a color.

GLOSSY OR MATTE

Matte paint is not shiny. Light does not reflect from its finish.

Glossy paint catches light even when it is dry. A color can be glossy without being luminous. For example, an opaque application of ultramarine blue given a glossy finish with a medium or varnish reflects light from the surface of the finish rather than from the luminosity of the color.

LUMINOSITY

A color is called luminous when it seems to have light of its own, especially in contrast with the surrounding colors. Yellow is the most luminous color of the spectrum.

RESISTANCE TO LIGHT

The resistance of a color to light is its capacity to withstand the changes light may cause, such as fading or color changes. Resistance depends on all the components of paint: the chemical makeup of the pigment,

Adding linseed oil to oil paint makes the paint glossier.

Adding turpentine to oil paint has the opposite effect: The paint becomes matte.

Symbols of degree of resistance to light:	
★★★	Maximum resistance
★★	Good resistance

the characteristics of the dilutant, and the proportions of these components.

Paint manufacturers rate their paints' resistance to light with symbols.

COVERING CAPACITY

The covering capacity of a particular paint depends on its composition. Prussian blue and burnt umber, for example, have great covering capacity. Just a small amount of these colors darkens or blackens any color.

produce a specific tone, or depth of color.

A range of colors consists of an ordered succession, such as the colors of the spectrum. In the same way, a tonal range is an ordered succession of tones, tints, and shades of the same color.

SATURATION AND INTENSITY

An oil paint color as it comes out of the tube is saturated, or

color rich. When white is added to the color, its chromatic intensity decreases, that is, it is no longer fully saturated. Chroma, color, luminosity, tone, value, saturation, intensity, tints, and shades are all words that make up the language of color. A mixed color is never as luminous, or light reflecting, as any one of its component colors. Saturation and light intensity refer to

*Three patches of manganese blue acrylic paint: intense (**a**), transparent after having been diluted with water (**b**), and opaque after adding white paint (**c**).*

TRANSPARENCY

Transparency is a characteristic of paint once it has been applied to a surface. The degree of transparency indicates how much we can see through the layer of paint, whether it is the surface of the paper or another color that is visible. Paints with a low rate of reflection tend to be very transparent. Watercolors are transparent, as are some colors of oil and acrylics.

The opacity of gouache can be illustrated using a yellow-green color. When it is very diluted with water it becomes semi-opaque.

Oil paints and acrylic paints are generally classified for opacity or transparency using the following symbols:

☐ *Transparent*
■ *Opaque*
◩ *Semi-opaque*
☐ *Semi-transparent*

paints include oil, acrylic, gouache, and pastel, especially when they are applied in thick layers or impastos.

DULL COLORS

Matte colors always look duller than glossy ones. Neutral, earth, or broken colors look dull compared to pure colors. Working with a

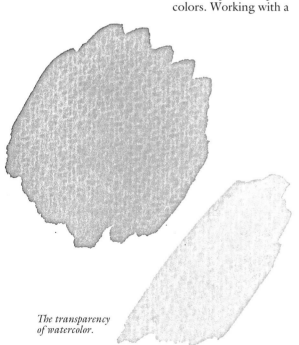

The transparency of watercolor.

OPACITY

The rays of light that hit a painted surface can be either reflected or absorbed. The degree of opacity of a paint depends on how much light it reflects. Very opaque

dull palette means painting with mixtures, toning pure colors up or down, or adding small amounts of their complementary colors, making them grayish and less luminous.

STRENGTH

The strength of a color refers to the psychological effect produced when a color attracts and holds the viewer's attention more than other colors seem to. The red hues tend to be the strongest. For a painting, however, we can refer to the strength of certain areas of color in relation to those around them.

TEMPERATURE

Human beings have certain psychological associations with colors. For example, we associate red with warmth and blue with cold. Starting from these associations a classification of colors has been developed, based on the order of the colors in the light spectrum.

Painters commonly arrange the tubes of paint according to their "temperature."

WARM COLORS

The warm colors include all of the yellows, oranges, reds, carmines, some earth colors, and some neutral colors. A mixture is warm if it is composed of warm colors.

COOL COLORS

The cool colors are blue and green. Some neutral colors, such as

grayish and bluish-brown tones, can also produce a markedly cool effect. As with the warm colors, a mixture is cool if it is produced by mixing cool colors.

COMPLEMENTARY COLORS

Pairs of colors that produce the greatest contrast when placed together are complementary. In the subtractive mixing process, the complementary color of any primary color is the one that results from mixing the other two primary colors. Orange and blue are complementary colors. Green and red are also complementary, as are

An opaque oil color.

violet and yellow.

It can be useful to experiment with the commercially manufactured paints that you will use on the palette. The pure colors should be mixed, two by two. When the pairs are complementary, the resulting mixture will be almost black.

NEUTRAL OR BROKEN COLORS

A color can be "broken," grayed, or mixed into browns by adding varying amounts of its complementary color. These colors are known as chromatically mixed grays, browns, earth tones, and neutrals. When working with

A transparent oil color.

A sample of acrylic paint. The first sample has been diluted with transparent gel, whereas the second has been diluted with water. The color is transparent in both cases, but its appearance is different: dense and glazed as opposed to thin and matte.

Yellow ochre can also be included among the yellows, and sienna among the reds. Burnt umber can be placed among the browns, which also can be classified as a group. Color groups are not fixed; many colors easily cross from one group to another.

The commercial brands of paint have gradually expanded their selection, introducing many new colors and tones. Among these are shades of pink, which are classified as red tones. The same has happened with the purples, violets, and magentas. A good variety of greens is also available, ranging from earth tones such as chrome green to warm transparent colors such as sap green. New pigments appear on the market all the time, but each can be classed into one or more of the above categories. Organizing color is important both for its perception and use.

opaque media, artists commonly add a little white to lighten the resulting mixture, which is generally very dark.

GROUPS OF COLORS

Colors are often classified by group. This practice is useful because it allows us to apply a set of rules and characteristics to the group. In practice, however, each color has a unique influence on the mixtures in which it is used. Whites, yellows, reds, blues, violets, greens, browns, and blacks are all groups, as are the earth colors, such as yellow ochre, sienna, and earth greens. Although they might seem muddy and grayish when compared to the purer colors, it's extremely important that artists learn to use them.

UNDERSTANDING PAINTS

Artists should know the chromatic properties of the standard colors sold under the leading brands of paint, be they oil, watercolor, acrylic, gouache, or pastel. The mixtures that result from these colors depend on their chromatic qualities. By carefully examining the characteristics of both the color and the paint, we can establish the essential relationships between the colors.

Manufactured colors will have the same name as long as they are standard colors in any of the known painting media. Prussian blue, for example, is a standard color. There are often slight differences between brands, however, and these can be ascertained through practice. Some brands make their own colors, which are given names to suggest their chromatic properties. An insert or manufacturer's color chart will often have helpful information on pigment and binder ingredients.

Color swatches or samples of the different colors are printed to show the differences among colors. The samples on the following pages allow us to compare the effects produced by different colors. Each color area also shows how transparent and opaque applications of color differ.

With opaque wet media, the paint will be opaque when used directly from the tube. It must be diluted to become transparent. With pastel, the amount of pressure applied to the stick determines the opacity of the layer of color.

A different surface has been used for each medium. The oil paint was applied to coarse-grain primed burlap canvas. The watercolors were painted on a coarsely textured watercolor paper. A medium-weave canvas was used for the acrylic paint, and a matte Bristol paper was used for the

An example of color with its accompanying characteristics	
	Meaning of the symbols:
	★★★ Maximum resistance to light
	506 Classification number in the general table of colors
Ultramarine blue deep □	Transparent color
★★★ 506 □ 2	2 Refers to the price group
PB 29	PB 29 The composition of the paint in pigments

gouache. Finally, the pastel colors were applied to a white Canson Mi-Teintes pastel paper. The varying textures of these supports further highlight the differences between the media.

A warm color.

A cool color.

A neutral color.

Yellows

Azo yellow lemon

Yellow is the most luminous color on the palette. Each tone or type of yellow, however, has its own clearly defined characteristics. Many general characteristics depend on the pigments that form part of the tone or particular yellow, and the medium and the binder vehicle carrying the color (oil, acrylic, watercolor, gouache, or pastel) also plays a role in determining the chromatic effects perceived by the viewer. Yellows can be grouped into warm yellows, cool yellows, and earth yellows. The choice of an orange yellow or a lemon yellow in a mixture will result in very different colors. Yellow mixed with blue results in green; mixed with red, it will produce orange.

PIGMENTS AND OXIDES

The yellow pigments or oxides include the following: Hansa (arylide or arylamide, of the azo chemical type), barium chromate, chrome, zinc, cadmium, aureolin (or cobalt), antimony, and titanium. Orange pigments include perinone orange vermillion, and cadmium. Since pigments are what give color to paint, any information about them can build understanding of the mixtures they produce. The composition of oil paints is usually given on the manufacturer's color chart, as well as on the individual tubes of paint. Yellow pigments are indicated by the letters PY.

Although yellow paint is basically made using yellow pigments (PY), white pigments (PW) may also be present. Darker, orange-colored paints often have orange pigments (PO) or red pigments (PR). Each pigment has its own chromatic properties. The Color Index classifies all of them. For example, yellow ochre may use an iron oxide (PY43).

THE MOST COMMON YELLOWS

These pages show several patches or applications of color. Each medium is illustrated, and each patch and pigment has a name that helps to illustrate its chromatic properties. All of the

colors are different tones or types of yellow.

Because yellow is so highly reflective of light, it takes some experience to understand its use. Too much yellow tends to overwhelm other colors, as well as take on an almost monochromatic effect, while small amounts of yellow can be quite beautiful. A little yellow can go a long way.

The most commonly used yellows include lemon yellow, cadmium yellow light, medium and deep yellow ochre, and Indian yellow. Naples yellow is often used for flesh tones and portraiture. All of these yellows are examples of standard specific colors that many painters may routinely include on their palettes.

PRIMARY YELLOW

Some brands offer a primary yellow for oil paints, watercolor, acrylic, and gouache. This yellow is ideal for generating the secondary and tertiary colors as suggested on pages 48 through 51. This yellow is shown below.

Cadmium yellow light

OCHRE

Compared to the other yellows, yellow ochre has a golden mustard kind of color. Its appearance is also browner or more broken. Yellow ochre is an earth color. The Rembrandt brand of oil paint offers several versions of this neutral color: yellow ochre light, yellow ochre, golden ochre, and orange ochre. Yellow ochre has traditionally been used as an underpainting color for the glow it tends to lend colors that have been applied over it.

The ochres have a warm, tawny glow that can be seen in the illustration.

Cadmium yellow medium

Yellow ochre. *Golden ochre.*

Orange ochre. *Yellow ochre light.*

Naples yellow

Yellow ochre light and yellow ochre display a marked golden tendency, in contrast to the orange tone of golden ochre and orange ochre. These two have been included in the orange chart on pages 20 and 21.

Primary yellow.

Yellow ochre light

WATERCOLOR	ACRYLIC	GOUACHE	PASTEL

Permanent lemon yellow | *Hansa yellow light* | *Cadmium lemon yellow* | *Solid yellow light*

Azo yellow light | *Azo yellow light* | *Lemon yellow* | *Light yellow*

Azo yellow medium | *Cadmium yellow medium* | *Cadmium yellow light* | *Lemon yellow*

Yellow ochre 1 | *Cobalt yellow* | *Cadmium yellow deep* | *Permanent deep yellow, light shade*

Yellow ochre 2 | *Mars yellow* | *Light ochre* | *Permanent deep yellow, dark shade*

Yellows and Oranges

Moving from yellow through orange, we get closer to red, which gradually begins to dominate. The colors in this chart are all orange; yet each one has its own characteristics.

TRANSPARENCY AND OPACITY

In oil paint, tones of yellow, ochre, and orange are opaque colors. This should be kept in mind when mixing yellow or orange with other colors.

As watercolors, however, these same pigments are highly transparent when diluted with sufficient amounts of water. Gouache remains more opaque, even when diluted. The opacity of gouache varies from pigment to pigment.

In acrylic paints, Hansa yellow and orange are transparent, whereas the cadmium yellow tones are fairly opaque.

All pastel colors are opaque.

THE VARIOUS MEDIA

A dry media like pastel features a wide range of colors, with several tones of yellow, orange, and ochre. Pastel paintings have a powdery look. By applying pastel to a textured paper like Canson Mi-Teintes, the painter can achieve a look that enhances the effect of yellow, oranges, and ochres.

The differences among the patches of color areas of oil, acrylic, and gouache are harder to see in a photograph. In practice, however, the varying characteristics of each paint are obvious. Each medium has its own distinctive look. Watercolor is transparent and washy, pastel is vivid and soft, and oil is substantial and textured by a brush or a palette knife.

THE IMPORTANCE OF HIGH-QUALITY YELLOW PAINT

Practice shows that the more economical yellow and orange paints on the market provide poor results when mixed.

In most art supply stores the paints are classified by series, each with its own price. It is a good idea to invest in a good pure yellow, a medium yellow, and a deep yellow, even if the paints are the most expensive brands.

ORANGE TONES

As we have seen, orange is derived from a mixture of yellow and red. Many shades of orange can be produced from different tones of red and yellow, but practice shows that it is difficult to obtained a good, luminous orange from a mixture.

For this reason, it is worthwhile to have manufactured orange paints on hand. These are especially important when painting certain subjects, such as still life portraits of fruit and flowers and autumn landscapes.

THE ORANGE TENDENCY

In oil paint, orange tones include cadmium orange, permanent orange, orange ochre, and transparent oxide orange. The first two colors

have a cleaner appearance, which contrasts with the neutral orange appearance of the ochre and oxide.

Oil paints, from top to bottom: cadmium orange, permanent orange, orange ochre, and transparent oxide orange.

NOTE

To achieve effective results, mixtures with pastel should be produced using the techniques particular to this medium, such as blending and the use of fixative. It is essential to have a wide range of colors when working with pastel.

Pastels are available in a wide variety of hues for each color, and each color and hue has a tonal range. Various tones of each color are often available.

This chart shows yellow and orange colors in oil, watercolor, acrylic, and gouache. The patch of color on the left shows a dense application, whereas the one on the right shows a highly diluted application of the same color paint. For the pastel, the circular patch is an opaque application, while the rectangular patch shows a light application.

Azo yellow deep

Indian yellow

Cadmium yellow deep

Cadmium orange

Permanent orange

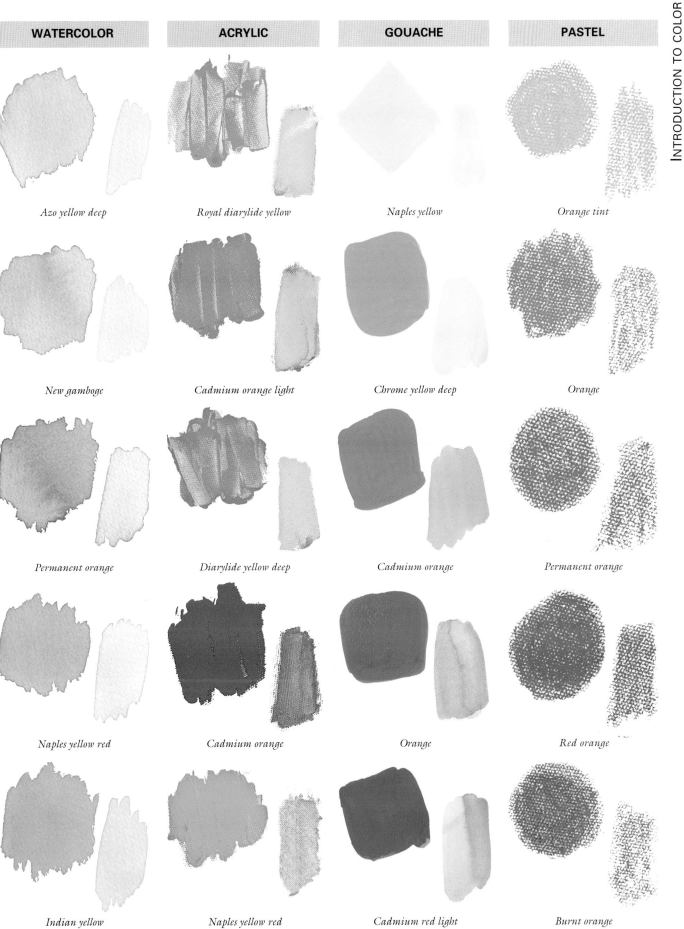

WATERCOLOR	ACRYLIC	GOUACHE	PASTEL
Azo yellow deep	*Royal diarylide yellow*	*Naples yellow*	*Orange tint*
New gamboge	*Cadmium orange light*	*Chrome yellow deep*	*Orange*
Permanent orange	*Diarylide yellow deep*	*Cadmium orange*	*Permanent orange*
Naples yellow red	*Cadmium orange*	*Orange*	*Red orange*
Indian yellow	*Naples yellow red*	*Cadmium red light*	*Burnt orange*

Reds

The tones that fall into the red category make up the strongest group of colors on the palette. Each tone of red has its own clearly defined properties, which are determined by the pigments it contains. As with the yellow orange and ochre tones, the various types of media influence the chromatic effect.

Only one of the tones of red can be used as a primary, or basic, color, but there are a wide range of hues and tones. Among the various hues of red, the so-called lake reds deserve special attention. These reds have an unusual intensity and brilliance. The range of reds differs according to the brand of paint. Most artists have at least one balanced red or carmine to use as a primary, as well as one vermilion and one lake.

PIGMENTS AND OXIDES

Red pigments are designated by the letters PR. Red pigments or oxides include naphtol (PR7, acrylic) alizarin lake (PR83, oil, watercolor), cinnabar (PR106, mercury sulphide), or cadmium (PR108). Another common red is permanent red (PR112). Included in the category of reds is a long list of pigments generally designated only by a number: PR144, PR166, PR168, PR160, PR177, PR188, PR190, or PR207. For red tones with a tendency to quinacridone violet, for oil, watercolor, and acrylic, a violet pigment, PV19, is added. Orange pigments, such as PO34 and PO20, are used to produce lighter or more orange reds.

TRANSPARENCY AND OPACITY

These factors are especially important for oil and acrylic paints, which can be used to produce glazes. Carmine and carmine lake are very transparent paints. These reds usually contain PY, PO, and/or PW (yellow, orange, or white pigments) in addition to PR (red pigments). This makes them generally more opaque. The cadmium reds, whether light, medium, deep, or purplish, are very opaque.

CHROMATIC QUALITIES

The characteristics of different tones of red result from the properties of the pigments used in them, or of the component colors, in mixtures. They are usually grouped under the categories red, vermilion, lake (red, carmine, or geranium), carmine, and madder. Some colors are available in three tones: light, medium, and deep.

The chromatic qualities of reds include bluish or carmine red, red, rose pale, bright orange red, and yellow red. The differences between these hues can be seen easily if they are placed next to each other. Different chromatic qualities will effect different results when they are mixed with other colors.

It is always a good idea to check the information on the paint and find out what pigments it contains and how transparent or opaque it is.

The light resistance rating only needs to be checked in special circumstances, since the manufacturers of most well-known brands can be trusted to provide a good product, light-fast and fade-poor under most conditions.

SIENNA

Any shade of sienna, for example, burnt sienna, has PB6 or 7, which are the ferrous oxide browns. Sienna, as its French name (Terre de Sienne) suggests, is an earth color. The earth colors can be produced from a mixture of the three primary colors: red, yellow, and blue. The method consists of mixing equal parts of red and yellow, with just a touch of blue. In fact, we are creating a kind of red that is then "muddied" with a little blue. Logically, then, this color is included in the red chart, since it is actually a neutral, or broken, red. Similarly, another earth color, yellow ochre, is usually included with the yellow colors.

NOTE

The red paints that guarantee the best results when mixed are generally more expensive. However, most brands offer their own house red, which carries their name and guarantees good general performance. Most painters keep a few special hues of red on hand for touches that require a special chromatic effect.

This chart shows red colors in oil, watercolor, acrylic, and gouache. The patch of color on the left shows a dense application, whereas the one on the right shows a highly diluted application of the same color paint. For the pastel, the circular patch is an opaque application, while the rectangular patch shows a light application.

Azo red light

Vermilion

Cadmium red light

Cadmium red deep

Carmine

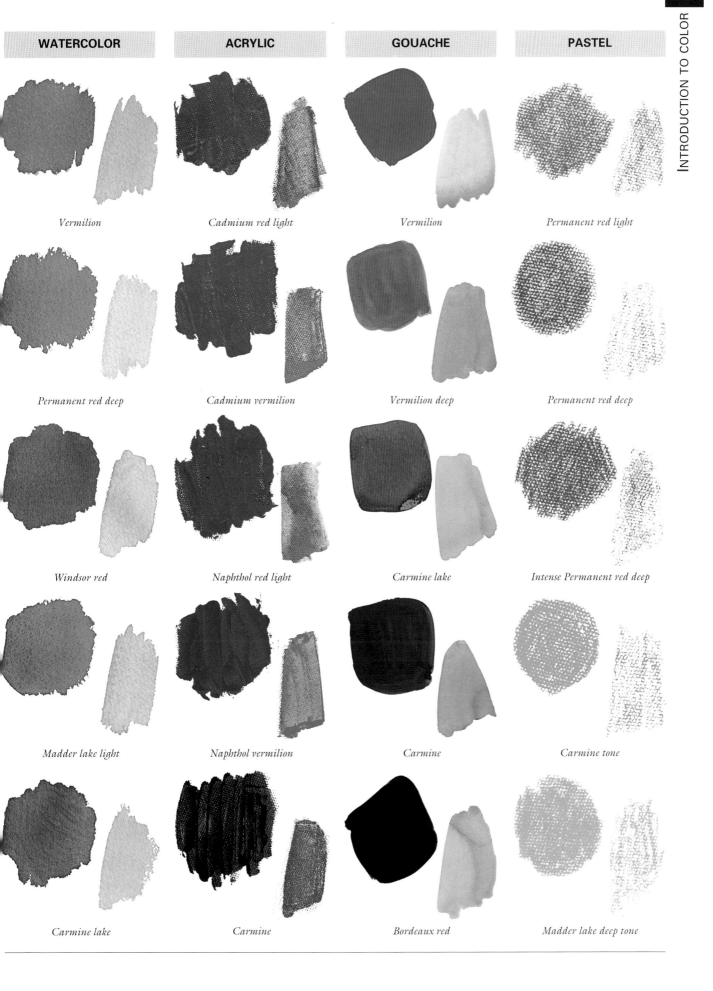

WATERCOLOR	ACRYLIC	GOUACHE	PASTEL
Vermilion	*Cadmium red light*	*Vermilion*	*Permanent red light*
Permanent red deep	*Cadmium vermilion*	*Vermilion deep*	*Permanent red deep*
Windsor red	*Naphthol red light*	*Carmine lake*	*Intense Permanent red deep*
Madder lake light	*Naphthol vermilion*	*Carmine*	*Carmine tone*
Carmine lake	*Carmine*	*Bordeaux red*	*Madder lake deep tone*

Purples and Violets

The various hues of purple and violet are essential colors on the palette. Between magenta and blue is a wide range of color that offers an infinite number of hues. Although many violets and purples can be produced from the primary colors magenta and cyan, commercially manufactured brands also offer an interesting variety of colors, which include several different pigments. The use that artists make of these colors depends on the subject they are painting and their own interpretation of it.

RECENTLY PRODUCED COLORS

Purple and violet paints were developed in the twentieth century after the introduction of synthetic pigments. The reddish violet hues include magenta, cobalt red violet, red violet, and purple lake. The bluer hues are composed of mauve, deep violet, permanent blue violet, and ultramarine blue violet.

PIGMENTS AND OXIDES

Purple and violet paints are generally made with red and violet pigments (PR and PV, respectively). Adding more red pigments moves the color closer to red, whereas adding more violet pigments shifts it toward blue. The violet pigments include dioxazine (PV23), cobalt (PV14), quinacridone red (PV19), ultramarine (PV15), and manganese (PV16). Remember that both cobalt violet and manganese violet are toxic. The most common red pigments were mentioned in the previous chapter on the red colors.

TRANSPARENCY AND OPACITY

Purple and violet are both very transparent colors. The artist should be careful to use only high quality products in order to ensure the desired degree of permanence. Large, luminous tone ranges can be produced by adding white, which also increases the paint's opacity. In oil paints, purple and violet colors are transparent or semi-transparent. In general, these colors permit the creation of wide ranges of opaque tones by adding white paint.

THE VARIOUS MEDIA

Even if the same pigments are used, each medium inevitably appears distinctive. Quinacridone produces a bluish red, whereas cobalt produces a red that ranges from bluish to violet. Manganese produces a violet tone and ultramarine a purplish blue. Each purple or violet hue creates a different effect when mixed with other colors. Pure, vibrant hues are more likely to result when using good quality purple and violet paints.

TOWARD BLUE

Several oil colors are available that make up a measured progression from warm violet to deep violet-blue. Starting with the almost magenta color of cobalt violet, the next step is the bluer hue of permanent blue violet, and finally the even cooler color of

Oil colors, from top to bottom: burnt carmine, cobalt violet, permanent blue violet, and ultramarine blue violet.

ultramarine blue violet.

Also available are a number of violet hues in pastel, ranging from red violet to blue violet or purple.

Three tones of red violet in pastel.

Three tones of blue violet in pastel.

This chart shows purple and violet colors in oil, watercolor, acrylic, and gouache. The patch of color on the left shows a dense application, whereas the one on the right shows a highly diluted application of the same color paint. For the pastel, the circular patch is an opaque application, while the patch to the right shows a light application.

Red violet

Permanent red violet

Violet carmine

Titanium violet

Violet

WATERCOLOR	ACRYLIC	GOUACHE	PASTEL

| *Permanent red violet* | *Quinacridone rose* | *Hot pink* | *Purple tone* |

| *Rose madder* | *Quinacridone red or magenta* | *Deep pink* | *Purple 2* |

| *Windsor violet* | *Quinacridone violet* | *Lilac* | *Purple 1* |

| *Permanent blue violet* | *Dioxazine purple* | *Violet* | *Blue violet tone* |

| *Aniline violet* | *Dioxazine violet* | *Mauve* | *Deep violet* |

Blues

Blue is another essential color on the palette. In addition to basic or primary blue, specially manufactured hues of blue are available for each medium. The various hues of blue are the coolest colors on the palette. Along with violet, they are the colors that reflect the least amount of light and, therefore, the darkest colors of the spectrum, whether applied as is or in a mixture. Each blue has its own clearly differentiated chromatic properties. Since one of the most important uses of blue is for mixing with other colors to produce umber and other dark tones, it is important for the artist to master the techniques of blue tones for shading.

PIGMENTS AND OXIDES

Blue pigments are represented by the letters PB. Phthalocyanine blue is sold under the manufacturer's name. Prussian blue is also known as iron or bronze blue (PB27). Cobalt blue is also known as royal blue (PB29). Other shades of blue include ultramarine blue (PB29), manganese blue (PB33), cerulean blue, and indanthrone blue (PB60).

The prestigious Rembrandt brand of oil paints offers the following hues in the blue range: violet ultramarine blue, ultramarine blue light, ultramarine blue deep, cobalt blue light, ultramarine cobalt blue, cobalt blue deep, royal blue, Sèvres blue, cerulean blue, manganese blue phthalo, phthalo red-blue, phthalo green-blue, Prussian blue, indanthrone blue, indigo blue, ultramarine green-blue, cobalt turquoise blue, and phthalo turquoise blue. This wide selection of colors ranges from purplish to greenish blue colors. Ultramarine cobalt blue contains three different pigments: PB29, PB15:6, and PW4, two blue pigments, and one white pigment. The white pigment PW4 is also used in royal blue and Sèvres blue. Indigo contains two blue pigments plus one black pigment, PBk9. Another important hue, turquoise blue, contains PB15:4, PG7, and PW4: one blue, one green, and one white pigment.

TRANSPARENCY AND OPACITY

Intense blues tend to be very transparent. Generally speaking, the blue colors that contain white pigment are opaque or semiopaque. Some paints made with the blue pigments PB28, PB74, and PB15:4 are semiopaque. This property is especially useful for producing glazes with oil and acrylic paints.

THE VARIOUS MEDIA

The differences among the various hues of blue are apparent in the illustrations on these two pages. Although the color may be the same, the different levels of gloss, consistency, and texture bring a multitude of visual effects into play. The only unchanging aspect is the color family. Ultramarine blue is clearly distinguishable in any medium, as is Prussian blue or turquoise blue. The tendency toward green or violet, warm or cool, of a blue hue is also easily noticed, no matter what the medium.

Two of the most commonly used blue hues, ultramarine and Prussian, are usually available as ready-to-use manufactured colors. Cerulean blue is often used to paint skies. Each shade of blue has subjects for which it is especially well suited. Ultramarine blue, for example, is good for painting the sea, whereas cobalt blue is ideal for creating luminous shadows.

THE INFLUENCE OF BLUE

Each tone of blue has its own effect when mixed with other colors. A violet-blue, for example, brings a specific chromatic quality to the mixture, which is different from that of a greenish blue. When a shade of blue contains white pigment, the color white becomes an additional element in the mixture. Whenever a new color is added to the palette, the artist should study its chromatic qualities. The color can then be used straight from the tube or in a mixture. One good way to become familiar with the various hues of blue is to practice painting and mixing with cobalt blue, turquoise, ultramarine, and Prussian blue. Cerulean blue and azure blue are hues that come in handy for painting skies.

NOTE

Some blues, like Prussian blue or indigo, have great tinting capacity. Only a tiny amount of these colors should be used when making mixtures. The painter should be sure to have a basic, or primary, blue for the medium being used as part of the palette. Each hue of blue has its own particular use for creating a desired color by mixing.

This chart shows blue colors in oil, watercolor, acrylic, and gouache. The patch of color on the left shows a dense application, whereas the one on the right shows a highly diluted application of the same color paint. For the pastel, the circular patch is an opaque application, while the rectangular patch reveals a light application.

Dark ultramarine blue

Cobalt blue

Prussian blue

Cerulean blue phthalo

Turquoise blue

WATERCOLOR	ACRYLIC	GOUACHE	PASTEL

Ultramarine blue

Dark ultramarine blue

Ultramarine blue

Ultramarine blue deep

Ultramarine cobalt blue

Cobalt blue

Light blue

Ultramarine blue light

Phthalo blue

Manganese blue

Cobalt blue light

Intense Ultramarine blue deep

Cerulean blue phthalo

Prussian blue phthalo

Turquoise blue

Imitation cobalt blue light*

Prussian blue

Phthalo blue

Paris blue

Imitation cobalt blue tone*

Greens

Turquoise and phthalo blue are examples of blue colors that contain green pigments. These colors are closely related to the bluish green hues. The proportions of blue and green pigment content will determine which way the colors will be weighted—toward cool blue or toward warmer green. Similarly, many green paints contain yellow pigments and display a marked tendency toward yellow. The various hues of green can be divided into the bluish greens, the balanced greens, and the yellowish greens. In addition, certain green hues are treated as specific colors. These are often the duller hues, such as olive green, sap green, chromium green, or hooker's green.

IMPORTANCE ON THE PALETTE

These colors are essential for any subject that includes any type of plants. The use of green requires experience and a knowledge of mixing. When painting with green, many other colors can be used to make mixtures that will produce an attractive range of greens. Small amounts of red, for example, will make earthy, natural greens useful for leaves and landscapes. The addition of Prussian or phthalo blue will darken a green hue and make it suitable for the depictions of rich shadows.

The painter's own sensibility can lead to the creation of a range of green hues that will work harmoniously together.

PIGMENTS AND OXIDES

Green pigments are indicated with the letters PG. The organic and inorganic green pigments include phthalocyanine (PG7), chromium oxide (PG17), cobalt (PG19), green earth (PG23) oxides of cobalt and titanium (PG50), viridian (PG18), and green gold (PG10). The tinting capacity of these pigments ranges from very good to moderate or even weak. Many artists prefer to use paints based on the phthalocyanine or nickel-azo dyes because of their greater intensity and tinting capacity. Others prefer the natural organic pigments because they provide colors with a more "classical" appearance.

TRANSPARENCY AND OPACITY

In general, the green paints that contain white pigments are opaque, whereas the ones that contain yellow pigments are semiopaque. Phthalo green, emerald green, and sap green tend to be transparent.

THE VARIOUS MEDIA

The chromatic qualities of the various green hues are apparent in all the media shown: oil, watercolor, gouache, acrylic, and pastel. Their appearance makes them easily identifiable as yellow-green, balanced green, or blue-green, and may tend toward dark, light, or earthy.

MIXTURES WITH GREEN

The yellow, blue, or earthy cast of a green hue has a direct influence on the mixture that results when it is combined with another color. Neutral greens are often used directly from the tube. Pure greens, on the other hand, are rarely used without mixing when painting landscapes. Pure, balanced greens are commonly used in design, illustration, and more abstract painting.

GREENS IN NATURE

The color green naturally comes to mind when dealing with subjects that have plants, trees, or any other vegetation. One need only look at a landscape to see how many hues of green are present in nature. Green hues shift and change depending on the daylight, the season, or the predominant color of leaf and vegetation masses. They range from blue-green to yellowish green, and include traces of violets, oranges, ochres, reds, and earth colors. Because greens are so richly pigmented in nature, it is essential to use green hues in mixtures made up of all the other colors on the palette.

NOTE

The bluish tendency of emerald green is a characteristic of the green pigment PG18. Permanent green is a more balanced green, made with blue pigment PB15.

Olive green contains green, yellow, and red pigments. This should be kept in mind when using this color for mixtures. Olive green is a neutral color that can be very useful when dealing with a subject that requires a duller, more neutral, or even earthy palette.

This chart shows green hues in oil, watercolor, acrylic, and gouache. The patch of color on the left shows a dense application, whereas the one on the right shows a highly diluted application of the same color paint. For the pastel, the circular patch is an opaque application, while the rectangular patch shows a light application.

OIL PAINT

Phthalo green

Prussian green deep

Emerald green

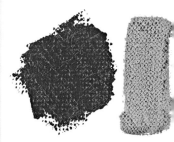

Permanent green

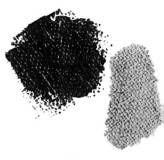

Olive green

WATERCOLOR	ACRYLIC	GOUACHE	PASTEL

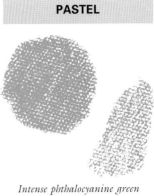

Emerald green *Hooker's green* *Moss blue-green* *Intense phthalocyanine green*

Windsor green *Chromium oxide green* *Permanent green* *Intense permanent light green*

Permanent yellow-green *Cadmium green* *Light green* *Light olive green tone*

Sap green *Sap green* *Moss yellow-green* *Chromium green light*

Olive green *Olive green* *May green* *Chromium green deep*

Earth Colors

Raw sienna

Earth colors are paints that are derived from natural soil, whether burnt or raw. The most common earth colors are the various hues of ochre, sienna, and umber, in both the raw and burnt varieties. Ochre is generally included in the yellow color group, and ranges from golden to reddish. The more reddish earth colors are included in the red group.

The most frequently used brown colors are umber and Van Dyke brown. These are very dark colors. Although they can often reach tones approaching black, they are warm colors. For this reason, many painters prefer to use them in place of black.

Green earth is a greenish brown color composed of silicates and iron oxide. There is also a burnt version of this color with a reddish brown hue.

Burnt sienna

PIGMENTS AND OXIDES

The earth colors contain inorganic pigments. The ochres are composed of aluminum silicate clay tinted with ferrous hydroxides. The resulting hues range from reds like iron oxide or Venetian red. Similarly, the various hues of umber are made up of aluminum silicate clay with iron oxide and manganese oxide. The hues range from a warm, reddish brown to burnt umber, which contains natural toasted earth. Van Dyke brown has a variable composition that is partly organic. It is important to remember that this is a very unstable color, subject to fading, darkening, cracking, and wrinkling, depending on the medium it is suspended in.

Commercially prepared earth colors are usually manufactured with red, yellow, brown, and black pigments. In the Color Index, these are designated by the codes PBr (brown pigments), PR (red pigments), PY (yellow pigments), and PBk (black pigments). The most frequently used of these are: PBr7 (for ochre, sienna, and raw or burnt umber) and PBr27 (chrome titanate). Some brands, however, prefer to use more stable pigments, producing the colors by mixing red, yellow, and black pigments. The Rembrandt brand, for example,

makes a burnt umber composed of PR101 and PBk11. The raw umber contains PY42, PR1091, and PBk11, adding a yellow pigment to the burnt umber formula.

TRANSPARENCY AND OPACITY

The earth colors tend to be transparent or semitransparent. Some colors, such as Van Dyke brown, are semiopaque. Some opaque colors include yellow ochre, brown ochre, Mars brown, and iron oxide violet.

When transparent colors are mixed with each other, the mixture will also be transparent. When an opaque or semiopaque color is added to a transparent color, the element of opacity will be added as well.

OCHRES, SIENNAS, AND BROWNS

These colors are important paints to include in the palette mainly because of their role as neutral colors. Brown can be obtained by mixing primary red and blue with a very small amount of yellow. Varying hues of browns can also be mixed with each of the complementary color pairs: red and green, orange and blue, violet and yellow. Browns resulting from each pair will vary in character. Each brown

hue produces a different effect when mixed with other colors.

SPECIAL COLORS

Transparent terra rosa, composed of white, yellow, and red pigments, is very useful for painting portraits. Pink flesh tones can be mixed with this color, often with the addition of Naples yellow to the mixture. There is also a series of burnt reds, such as Indian red, English red, Venetian red, and Paris red. Each of these has its particular hue, and together they cover the range between reds and earth colors.

Transparent terra rosa

Paris red

This chart shows earth colors in oils, watercolor, acrylic, and gouache. The patch of color on the left shows a dense application, whereas the one on the right shows a highly diluted application of the same color paint. For the pastel, the circular patch is an opaque application, while the rectangular patch shows a light application.

Raw umber

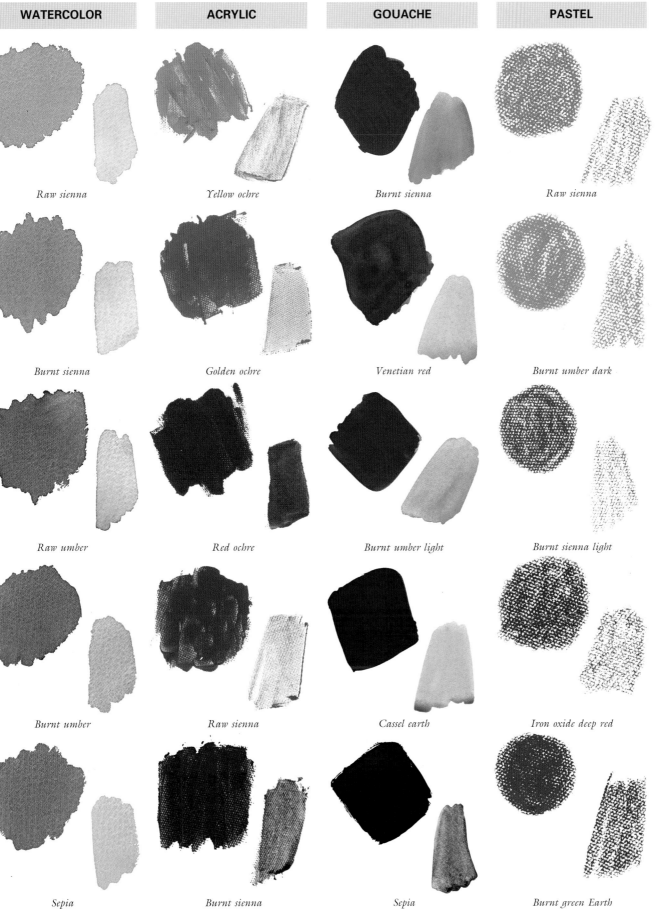

WATERCOLOR	ACRYLIC	GOUACHE	PASTEL
Raw sienna	*Yellow ochre*	*Burnt sienna*	*Raw sienna*
Burnt sienna	*Golden ochre*	*Venetian red*	*Burnt umber dark*
Raw umber	*Red ochre*	*Burnt umber light*	*Burnt sienna light*
Burnt umber	*Raw sienna*	*Cassel earth*	*Iron oxide deep red*
Sepia	*Burnt sienna*	*Sepia*	*Burnt green Earth*

Whites

The color white is essential for producing opaque tones in oil, acrylic, and gouache paints. White is one of the principal colors on any artist's palette, with the possible exception of some watercolor palettes if only transparent colors are being used. Each kind of white paint has its own characteristics of toxicity, drying time, resistance to light, and tinting capacity. For this reason, it is helpful to be familiar with them in order choose which paint is appropriate to each situation. Most brands offer one or two white pigments that are easy to apply and not subject to some common problems.

PIGMENTS AND OXIDES

There are many white pigments (PW), and white paints based on the same pigment can often have different names. PW4, or Chinese white, is a bluish white pigment composed of zinc oxide. It is appropriate for oil and watercolor. PW6, or titanium white, is another bluish white pigment. It is used in all media. PW1, known as silver white, basic lead carbonate, Cremnitz, or white lead, is only used for oil paints and tends to turn yellow over time. PW24 is also called alumina white. It is very clear, ideal for glazes and oil paint, and it acts as an extender to control the fluidity of the paint. PW5, or lithopone, is composed of barium sulfate and zinc sulfate. It is mainly used in water-based paints like watercolor.

Titanium white has currently replaced white lead for painting. Modern paints are constantly improving in terms of stability and resistance and seldom crack or turn yellow. They are also less toxic than the older paints.

TRANSPARENCY AND OPACITY

Zinc oxide white is a semi-opaque paint. Titanium white and Cremnitz are opaque. Alumina white and barium sulfate (PW21) are opaque in oil paints. Lithopone is opaque in watercolor.

THE MOST COMMON WHITE

Titanium white is the most frequently used white for oil and acrylic paint. It has the advantage of being nontoxic, and it is also opaque. Another possibility is a mixture of titanium white and zinc oxide white, which has a medium drying time. When white paint is used with transparent watercolor, Chinese white or zinc oxide is the best choice. If the paint is to remain somewhat transparent, white gouache is pigmented with titanium white. White pastels are generally based on titanium oxide.

WHITES IN GENERAL

White lead has an excellent covering capacity. It dries better when diluted with linseed oil than with poppy oil, especially if wax is added. But lead paints have, for the most part, fallen out of use because they are so toxic. The available whites do as fine a job. Zinc oxide white (Chinese white or snow white) has a bluish hue and is semi-opaque. Titanium white is also bluish and opaque. Titanium white and lead white are both resistant to tinting. The former can be used in any medium, whereas the latter is generally limited to oil paint.

The intense, warm pigment, zinc white, has a light yellow tone that is very luminous. Although it is not purely white, it can be used as any white for lightening, and adds a unique, warm, luminous quality to color.

WATERCOLOR AND GOUACHE

Watercolor technique, in general, is based on the transparency of watercolor paint. Permanent white is a gouache, a very opaque water-based paint that can be mixed with transparent watercolor to make the color more opaque. When permanent white is mixed with watercolor, it is effectively changing the watercolor into gouache. Chinese white, on the other hand, is only slightly opaque and,

Chinese white or zinc white in watercolor.

White in gouache.

when mixed, will more closely maintain transparent watercolor's natural luminosity.

Nevertheless, a few touches of opaque white used with watercolor, as a combined media technique, can bring enriching contrasts to a painting. Some watercolorists reject this technique and never use white paint on their palettes, while other artists use it to good effect, even to the point of alternating gouache and watercolor.

OIL AND ACRYLIC

When working with oil paints, the mixing of white with other colors reduces the intensity of the latter by diminishing their saturation. White is a color that tends to deaden a mixture, making it more grayish. For this reason, it should not be solely relied on to achieve the effects of light, but should be used sparingly with other colors.

The drying time of different colors of paint can be a problem. This is of special concern to the artist working with oils, which take a long time to dry. When white oil paint is applied straight from the tube or blended with very small amounts of other colors, it is the slowest drying color on the palette. When oil paint is applied wet on wet, the paint tends to mix, producing blends. In addition, some white paints cannot be applied in thick layers, because they can crack.

Acrylic paint can be easier to manage, though acrylic paint loses its tone and brilliance when it dries. Thus it is a good idea to test pure or slightly mixed whites to see how they look when they dry.

Thickening gel, available in glossy or matte, can be used to add body to acrylic paint. This product can make these paints look more like oil. In addition, adding gel to acrylic paint prevents it from losing brightness when it dries. A little practice will familiarize the artist with the characteristics of each medium in regard to white mixtures.

Silver white in oil paint.

Anastasa white in acrylic paint.

Brilliant yellow, or zinc white, in oil paint.

Iridescent pearl medium in acrylic paint.

Titanium white in oil paint.

Acrylic gel or paste.

Zinc white in oil paint.

Titanium white in acrylic paint.

PASTEL

In most mediums, adding white is the only way to lighten a color. With pastel, however, the light shades of all colors are available ready-made. The pastel tonal ranges can be easily consulted on a color chart, which includes light tones of all colors. All of the pale pastel colors (the colors with very little hue pigmentations) tend to have all of the strength of the pigments they contain. The chromatic quality of even the lightest tones is one of the great advantages of pastel as a medium.

White in pastel.

Note the difference between the lightest tone of yellow and white, in pastel.

The term "pastel" can have several meanings. It is the name of a technique, of the product of the technique (i.e., a "pastel," much like a "painting"), and it can also refer to the paste used to manufacture the sticks. Finally, by extension, it can be used to indicate a type of palette.

A work that is painted with oil or acrylic, for example, can be said to use pastel colors when it is composed of the light, white-rich, fresh tones that are characteristic of pastel. This type of painting uses soft contrasts and a delicate harmony among its colors. Psychologically, a painting that is painted solely in pastel colors is likely to convey a calm, peaceful feeling.

A selection of neutral whites in pastel: lemon yellow and neutral gray, both in their lightest tones, contrasted with white.

NOTE

Each tone of white produces different results when mixed with other colors. The creation of opaque tones by adding white has its limitations with certain colors. In general, lemon yellow and light yellow quickly lose their color when a large amount of white is added.

Blacks and Grays

Most of the leading paint manufacturers offer gray and black paints, although the range varies according to the medium. The most common black colors are smoke black and ivory black. A wide variety of gray tones is available in pastel, including greenish gray, bluish gray, violet gray, neutral gray, Payne's gray, and mouse gray. The color black represents the total absence of light, and its dark quality on the palette is important. Nevertheless, it is also important to know that many of the darker colors on the palette are preferable to black when producing mixtures. These colors tend to produce the deeper, richer tones of black than the characteristic flatness of black itself provides.

Some manufactured gray hues are valuable because of their particular chromatic properties, which are difficult to reproduce by mixing complementary colors or by toning up black paint. Their presence on the palette will enrich the possibilities in this color range.

PIGMENTS AND OXIDES

BLACKS

The group of substances that are used to produce the color black are called black pigments, indicated by the letters PBk. Ivory black, produced from burnt bone, is the purest and most intense black in any medium. Frankfurt black, with a charcoal base, is also commonly used. Lamp, or soot, black is used for India ink. Iron oxide produces a black color that changes to very dark red when heated. Manganese black is a very dark manganese brown color.

GRAYS

Almost all of the major brands offer a wide selection of grays.

Payne's gray is available for watercolor, gouache, oil, and acrylic. The warm variety of Old Holland gray contains white pigments along with PBr7 and PB7, which are brown and blue pigments, respectively. The cool variety of Old Holland gray includes white, blue, and black pigments. A cool gray for gouache paint is obtained from PBk6, whereas a warm version of the same color comes from mixing PBk6 with PBr7, a brown pigment. Pastels come in a wide variety of gray hues in all variations and tones.

TRANSPARENCY AND OPACITY

In oil paints, black hues are either opaque or semi-opaque. The acrylic paints Mars black and carbon black are opaque. Ivory black and smoke black are transparent in watercolor. For gouache, intense black is opaque. The most common blacks for pastel are PBk6 and PBk7, both called carbon black.

Practically all of the gray hues contain white pigments to some degree, which makes them mostly opaque.

VARIOUS BLACKS AND GRAYS

The temperature and even hue tendency of any black or gray color is usually easy to distinguish. There is a wide variety of warm and cool blacks available, and the same is true for the grays, which are also available in neutral hues.

The more opaque blacks, which consequently have great covering capacity, can be useful for completely covering other colors.

The overall chromatic feeling or harmony of a painting should indicate which black or gray tones are the most appropriate for the subject. The results of color combinations produce different effects depending on the pure or mixed colors employed.

Since a hue of black or gray produces a different effect when mixed with other colors, the choice of which colors to use in a mixture is important. When black is added to another color, the resulting mixture is not only darker, but also blacker. On the other hand, when gray is used, the mixture is duller, but not as black. When black is mixed with red or orange, the result is a warm black. When it is mixed with a blue or cool violet, the result is a cool black.

THE VARIOUS MEDIA

The impact of each hue of black or gray in different media depends on the artist's use and interpretation, as well as the objective characteristics of the color.

WATERCOLOR

When painting with watercolor, many artists avoid using black in mixtures. Black can make a mixture seem dark and "dirty," and this is especially undesirable in a luminous medium like watercolor. For this reason, black is often replaced by Van Dyke brown or Payne's gray. Nevertheless, brushstrokes of pure black can create sharp, engaging contrasts.

GOUACHE

It is extremely simple to produce gray colors with gouache by mixing white and black paint and then adding a touch of another color. Still, most artists buy one or two hues of gray in warm or cool tones. Mixtures with white and blacks combined with complementary pairs—red and green, yellow and violet, orange and blue—will also produce excellent grays in gouache.

Payne's gray in watercolor.

Ivory black in watercolor.

Smoke black in watercolor.

OIL

Many painters don't use black oil paint in mixtures. Instead, they mix other dark colors to produce blacks, which are then influenced to look black by the surrounding colors.

Ivory black in oil paint.

ACRYLIC

Black is often used in hard-edged, minimalist-style acrylic painting as a color that stands on its own. Its use is similar to oils and carries the same caution, depending on the painting technique.

Smoke black in acrylic paint.

Violet gray 1, tone, in pastel.

PASTEL

The wide selection of gray and black tones is apparent when looking at a color chart for soft pastels, gray and black chalks, or pastel pencils. In a good set, each color is available in several darker tones, or blacks, and several lighter tones, or whites.

THE GRAY RANGE

Portraits are ideal subjects for taking advantage of the wide ranges of chromatic gray hues and tones available in pastel. The various mixes of gray available in a variety of tones and hues are ideal for creating the zones of contrast in flesh. Pastel colors include specific collections of chromatic grays for portrait painting.

Mouse gray, medium tone, in pastel.

Neutral gray, medium tone, in pastel.

Greenish gray, medium tone, in pastel.

Bluish gray, intermediate tone, in pastel.

Black, intense tone, in pastel.

Violet gray 2, in pastel.

How to Mix Colors

In mixing colors, each medium has its own particular procedures. Color mixtures are usually obtained by means of time-honored practices, but artists are equally free to use any personal technique that may come to mind. The aim, after all, is to obtain the best possible color mixtures with which to represent the subject of the work.

This chapter will explain where, with what, and how to produce color mixtures using each one of the painting media. The mixing process is a broad subject that needs to be studied from various angles: the practical point of view, the sequence of the procedures carried out in a specific exercise, the colors chosen, their handling, application, and the end result.

The brush (or a palette knife) is dipped in solution using any type of container.

OIL

Linseed oil and turpentine are the solvents used with oil paint. These substances are added to colors and to mixtures in the course of painting to thin the paint or to make it more transparent.

WHERE TO MIX

Oil mixtures are done on a clean area of the palette, around which the mounds of colors are arranged. When oil is applied wet on wet, the artist can mix color directly on the canvas.

WHAT TO MIX WITH

A brush or a palette knife is used to separate out an amount of color required to create a mixture. The color is then mixed using either of these tools, on the palette or directly on the canvas.

HOW TO MIX

The first step is to separate the quantity of each color needed to obtain the mixture. First two colors are mixed together. After checking the result, more of one or the other of the two colors can be added until the right hue has been obtained. Sometimes you will need to add a third color in order to produce the tone you want. White can then be added for lightening.

The mixtures are traditionally done on the palette while the paint is still unmixed with dilutants. If a color is too thick it can be thinned by adding turpentine or linseed oil. Color can also be mixed directly on the canvas, wet on wet.

The brush is most commonly used for mixing oil paint. First, some of each color is placed on a clean area of the palette.

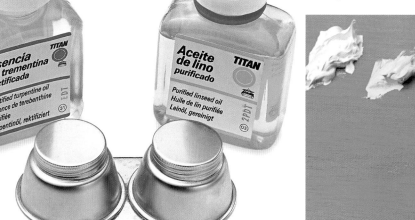

Turpentine, linseed oil, and receptacles to hold them are needed when working with oil paints.

The two colors are then blended. Depending on the result, more of one of either color can be added.

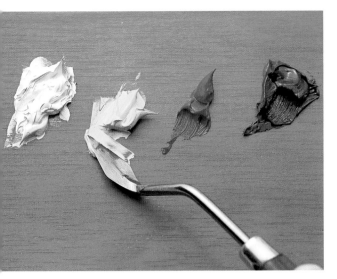

The palette knife can be used to obtain color mixtures with oil or acrylic. The advantage of this tool is that it is a more thorough mixer, while saving wear and tear on brushes.

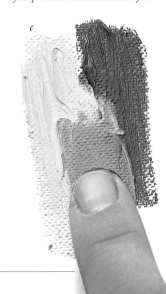

Using the palette knife, the colors are blended together on the palette until the desired hue is obtained.

When painting with glazes—colors or mixtures that are blended with enough oil to make them transparent—the dilutant liquid will influence the final result of the mixture by adding some of its own color. Therefore, it is best to use an oil that won't alter the color of the oil glaze or make the paint run when applying it to a dry surface.

In general, two small receptacles are attached to the palette, containing a solution of turpentine and linseed oil, in proportions of 40 and 60 percent, respectively. These proportions can be balanced in order to speed up the drying time. It is handy to have a container with turpentine to clean the brush after each mixture and every time you change color.

ACRYLIC

The solvents used for painting with acrylic are water and acrylic mediums or gels. They can be added to the paint at any time during the blending process. Drying retardants can also be incorporated. The amount and type of media solutions used with acrylic will modify the result of the color produced.

WHERE TO MIX

As with oil paint, acrylic can be mixed on the palette. Disposable palettes are practical for acrylic, but more traditional palettes can be used if they are carefully scraped down after use. Acrylic colors, like oils, can also be mixed directly on the canvas.

WHAT TO MIX WITH

As with oil paint, the brush and the palette knife are the painter's preferred tools for mixing. In order to set up the palette for mixing, the full spectrum of colors is needed, as well as all the solvents that will be added to them: acrylic gels, matte or glossy mediums, which lend body and transparency to the paint. Texturizers and thickeners, such as pumice stone, washed sand, and Spanish white, add their own color to blends.

HOW TO MIX

Separate a quantity of each of the colors required for the mixture with either a brush or palette knife and blend them together until the color is fully mixed, and you have achieved the desired tone. The procedure is the same used to mix oil paint.

*Oil paint is usually mixed on the palette, but it can also be done directly on the canvas: with a brush (**a**), a palette knife (**b**), a finger (**c**), or with any other type of implement that will do the job.*

a

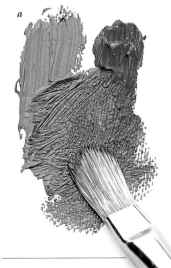

b

c

MIXING WITH BASIC COLORS

WATERCOLOR

Color mixtures with this medium use a variety of techniques. Water dilutes watercolor paint and is also an essential element of its composition, as are the particular pigments that make up its hue.

WHERE TO MIX

Watercolors can be mixed on the palette or in small receptacles. The lids of some watercolor paint boxes are made to be used as a palette once opened. Pans of dry colors are meant to be reconstituted with water. It is recommended that water be added even to tube watercolor in order to obtain transparent washes. Watercolor paints can also be mixed directly on the paper.

WHAT TO MIX WITH

Watercolors are traditionally mixed with a brush, but almost any instrument can be used. A natural sponge, for example, should never be lacking from any watercolorist's paint box. It is especially useful for producing many types of washes.

HOW TO MIX

Watercolor mixtures can be achieved by working wet on wet and wet on dry. In each case, the result of applying one color over another is different. Applied over a wet wash, another wash of a different color will produce a mixture. If the first wash is allowed to dry thoroughly, a second wash will produce a glaze or clear layer that will mix visually. The more water you add to a wash, the lighter the tone will be. Colors that are applied by strokes (rather than the broad areas of a wash) onto wet or damp paper will blend or bleed.

GOUACHE

This medium is ideal for obtaining homogenous blends, which are used to paint flat colors. Gouache is generally sold in tubes and sometimes in jars. This paint should be mixed with water to the consistency of light cream. Gouache must never be applied in thick layers, as it cracks after drying. It can also be diluted much as transparent watercolor can be and used almost as transparently. The addition of gum arabic to gouache will increase the paint's elasticity and allow it to be used in more traditional ways.

WHERE TO MIX

A watercolor palette or a white china plate, a small pan, or any type of small receptacle can be used to mix gouache. This medium can also be mixed directly on the paper or other support. Gouache tends to streak if it isn't mixed

WHAT TO MIX WITH

Gouache is traditionally mixed with a brush, although almost any object that allows the paint to be handled can be used.

HOW TO MIX

The brush is the best tool for measuring out amounts of paint for a mixture. The paint is transferred to a palette or receptacle. Immediately afterward, the brush is washed, dipped in water, and then dipped into another color, which is placed next to the first. It is then mixed until thoroughly blended. Gouache has comparatively less binder than oil. As it comes from the tube, it resembles acrylic. With gouache, as with watercolor, oil, and acrylic, a color blend can be obtained and adjusted by adding tiny amounts of other colors.

thoroughly, and it lightens as it dries. If large quantities of one color are needed, it is best to mix it all at one time to assure consistency of hue.

Watercolor paint must be diluted with water regardless of the form it comes in: dry pans or dense tube color. Watercolor from the tube is placed in a pan or on the palette, then the brush is dipped in water and the paint is diluted.

The brush is the most commonly used tool for mixing gouache paint.

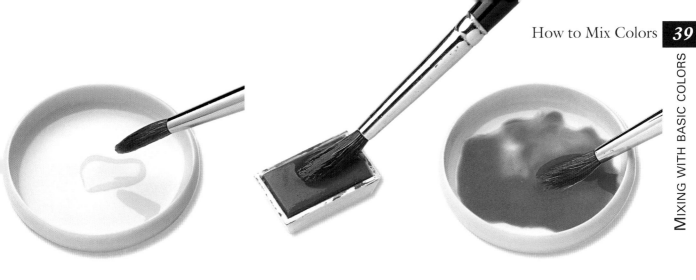

In order to paint using pans of watercolor, the brush is first dipped in water and then mixed with paint. The color is transferred to the palette, where more water is added to it until the right tone is obtained.

PASTEL

The mixing procedure used with oil, acrylic, watercolor, and gouache is done with their respective solvents. Pastel, on the other hand, is a direct painting medium, with which the paper or other support is colored without the need for intermediate agents.

WHERE TO MIX

In general, pastel colors are mixed directly on the paper or support. This can also be cardboard, canvas, or wood—anything to which the pastel adheres. Most commonly, this medium is applied to paper manufactured specifically for pastel. Canson manufactures Mi-Teintes papers in a wide variety of colors. It is also possible to produce blends by grinding down two or more pastels in a separate container and working the mixture with a brush or fingers.

WHAT TO MIX WITH

A stump and the artist's own fingers are the most commonly used implements for mixing pastel. Sgraffito can be effected using objects with a rough or prickly surface. A soft rag or chamois cloth or other materials with soft textures can be used to blend the pastel.

b

Watercolors can also be mixed directly on the painting surface using the wet-on-wet technique (a) or with the wet-on-dry technique (b), applying the second layer only when the first layer has dried properly.

a

HOW TO MIX

Pastels can be blended to produce mixtures. However, the visual mixing of the brilliant hues characteristic of pastel is what gives the medium its great beauty and appeal. Pastel can be applied opaquely by means of thick strokes or patches placed next to each other. Mixtures can also be achieved by layering and using sprayed fixatives, which will create glaze effects. The color of the pastel paper itself will tend to become a visual element, its texturized surface peeking through the application of powdery pigment.

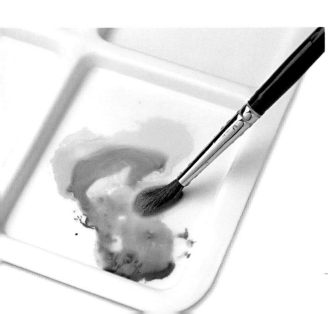

NOTE
Practically any instrument can be used to apply paint, including the painter's hands and fingers. But each medium has its own traditional implements for this purpose. Thus, brushes and palette knives are used for oils. Brushes and sponges are associated with watercolor and gouache. Acrylic is applied much the way oil paint is, using brushes and palette knives. But all media allow for the use of more modern accessories like rollers or anything else the artist may think of to lend the paint an interesting texture.

How to Adjust the Color

It is not possible to purchase all the colors of nature in cakes or tubes. This is where the need arises to create mixtures from colors that already exist.

Given that all media have a number of standard, commercially manufactured colors, a good palette includes colors that will produce the purest and most varied number of mixtures. Each standard color has its own specific chromatic qualities.

With a little knowledge of color theory and color mixing, and careful observation, it is possible to see which colors will be needed to start out with in order to obtain the right blends.

3. By adding white, we obtain an orange tone, not yet the color we are looking for.

HOW TO SEE COLOR

First, the chromatic characteristics of the color we are seeking must be observed. Then, if the colors needed for mixing are not available in the manufactured range of colors, we must mix them. To do this, the artist will need to find two suitable colors to start with.

The ability to mix colors, like most things, comes with experience. With practice, painters discover their own techniques for mixing colors.

A PRACTICAL EXAMPLE WITH OIL

The adjacent photographs show how the artist can obtain an oil color that is not commercially available, in this case, a dark flesh color.

Having studied the color, the painter chooses the dominant colors of the mixture, in this example, white, yellow, and vermilion, in similar amounts. The aim is to obtain orange, to which a generous amount of white is added. Since the mixture obtained is still too color-saturated or intense, a touch of ochre is added. The result is shown in the illustration.

The mixing procedure in oil painting involves adjusting a mixed color by adding tiny amounts of other colors until the desired hue is obtained.

A sample of the color being searched for. A glance at the palette indicates this is not a manufactured color; therefore, it has to be created.

1. These are the dominant colors of the blend: white, yellow, and vermilion.

2. Vermilion and white are mixed to obtain orange.

4. Then a touch of ochre is added to the mix.

5. The color is adjusted until the desired effect is achieved.

6. Finally, we apply a little to the canvas to be sure it is what we want.

WATERCOLOR

The mixtures produced with watercolor on the palette or in a pan tend to be multicolored, unless it is a uniform wash. Many watercolorists prefer to create single-color blends in individual pans. This method leaves the color intact and prevents it from being muddied by other colors or mixtures. As the artist searches for tones for his washes and new colors are added, the blend turns into a combination of marvelous chromatisms.

Watercolors can also be directly mixed on the paper, even when the paint application contains abundant pigment and little water. The mixture is completed while the colors are still wet.

In its execution, watercolor is probably the most intricate painting medium of all. The freshness of watercolor rests on the spontaneity of its brushwork. Revisions are difficult to carry out, since the artist deliberately roughs out the surface from the outset. The watercolor masters have ample experience; they have managed to attain a type of synthesis in their interpretation, which is based on very few steps. A competently rendered watercolor displays great life.

PASTEL

The most standard mixtures of pasty media (oil, acrylic, and gouache) do not have much in common with those produced with pastel. In this medium, the typical techniques depend on the chalk's blending capacity. The artist blends one color over another. The covering capacity of pastel produces a semiopaque layer that veils the underlying color. Each time a color is blended or superimposed over an underlying color, it creates a fine layer or glaze, which can eventually create a very delicate effect.

Adjusting a color is fundamental to the painting process.

The color obtained is assessed to see whether or not it is what the painter is looking for.

If the painter needs a slightly more intense tone of carmine, then the color must be adjusted by adding more carmine to the mixture.

So-called optical mixtures in pastel are easy to create without the need to blend; the technique is executed by alternating strokes of different colors. The effects of textures and of rhythm can be partially created by means of crosshatching or superimposing lines.

A fine layer of color can also be obtained by holding the stick horizontally and applying it over the surface of the paper. Pastel painted on colored paper can produce visual blends, as the original color of the paper will remain visible between the strokes, whereas a fine layer of color superimposed over another will alter the first. This type of blend depends on the color and intensity of the application of each hue, as well as on the order in which the colors are superimposed.

NOTE

In the example painted in oil, the dark flesh color could also have been obtained using different tones of red or yellow or with yellow ochre and a tiny touch of Sienna mixed with enough white to properly lighten it.

Continuing with the same example, how much of each color is needed when using other hues to arrive at a similar point? This will depend on the colors you are using; you will find that the proportions of each one will be different. The main aim of all these procedures can be summarized: One color is added to another in order to lighten it, darken it, or change its hue; to mix an earth color, a very small amount of the complement should be added. Whenever you are lightening or darkening or mixing hues, you are creating a new color. The procedure with acrylic and gouache is the same as that used with oil.

Types of Mixtures

When two colors are physically mixed together, both are altered and produce a third color. The resulting color may appear as a uniform color. A patch of color obtained from a mixture of colors, however, does not necessarily have to blend completely. This is because the eye allows us to optically mix colors and see the resulting color even when that mixture is not completed. Juxtaposed colors, that is, colors painted side by side at a certain distance, are also read by the eye as a mixture of those colors. In addition, a layer of transparent paint allows the underlying layer to be seen through it. In this case, the visual mixture has been obtained by superimposing.

PHYSICAL MIXTURES

In this context, "physical" should be understood as the blending of different colors of paint with the result that each individual color is altered, either partially or completely. When colors are altered to obtain an entire range of the same color, that range is referred to as a homogenous group of colors. Let us look at examples using each of the five media.

OIL

The two or more colors needed for the blend are mixed together with a brush. In order to obtain a uniform color, the artist must mix the colors thoroughly with the brush. The same thoroughness is required to obtain good blends with the palette knife.

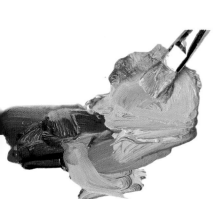

A well-blended oil mixture obtained with carmine, turquoise blue, yellow, and white. Note the uniform zone of color.

ACRYLIC

The procedure to obtain well-blended mixtures with acrylic is similar to that used with oil paint. With acrylic, in addition to water, transparent gels can be added. The blend obtained with this material is mixed with a brush or a palette knife until a uniform blend is produced.

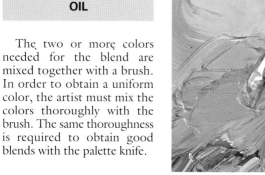

Note the area where the acrylic colors are completely blended.

WATERCOLOR

Two wet colors can be mixed together on the palette or in a pan until they are well blended. This is achieved by adding enough water and stirring the pigments thoroughly. Certain watercolor pigments possess sedimentation problems when drying. With practice, you will get better acquainted with those colors that produce more uniform washes.

This hue of watercolor is the product of a well-blended mixture of 40% carmine with 60% yellow.

GOUACHE

The pasty quality of gouache is different from that of oil and acrylic. This is an ideal medium to obtain highly consistent mixtures, as it is especially apt for painting broad stretches of color with an opaque and uniform paint. Note below how the dry homogenous patch of orange can be altered by adding water and obtaining a new, much lighter and yellower tone.

The area of dry orange that appears uniform can be altered by adding a little water to create another tone.

PASTEL

A very consistent color can be achieved with pastel by blending. To blend colors, two or more hues may be applied one over another, then mixed, either with your finger or a stump, working the pastel until the surface is entirely filled in with a uniform layer of color.

With pastel, one color is superimposed over another, in this case, yellow over blue. Then they are well blended using circular movements of a finger to form the desired color.

OPTICAL MIXTURES

Unblended or streaked physical mixtures will tend to function as optical mixtures. The mixtures obtained here have areas where the color appears uniform and others where the original colors can still be seen. The effect produced by a fully blended mixture is very different from an optical mixture.

With pastels, the artist can paint with strokes of various colors, without completely mixing their pigments.

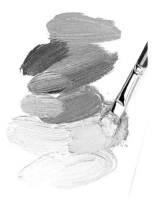

Effect produced by an unblended physical mixture of oil colors.

a

The appearance of partially blended pastel strokes (**a**) is strikingly different from circular blending (**b**).

b

A medium as opaque and dry as pastel does not prevent the artist from obtaining mixtures by superimposing. One color is simply applied over another. The pressure of the painter's hand controls the covering capacity of the glaze.

The physical characteristics of gouache make unblended mixtures appear like this.

BLENDS THROUGH SUPERIMPOSING AND GLAZES

A superimposed blend is produced when the underlying colors remain visible through the layer of color applied over them. This type of mixture, obtained by transparent or semitransparent glazes, looks very different compared to a physical mixture. A glaze does not conceal underlying colors, but instead partially veils them, thus subtly altering their characteristics. For example, green can be obtained from a layer of yellow applied over a blue glaze. But the green created with this procedure looks very different from green created with a physical mixture. Colors of the different layers of glazes will appear to merge together.

One important point to keep in mind with wet media, such as oil and watercolor, is that glazes reach their greatest degree of transparency when the artist allows each one to dry properly before applying the next. If the color is worked wet, the desired mixture will not be produced. A glaze can only appear luminous when the underlying layer of color is light. When using complementary colors, mixtures obtained by superimposing layers acquire a very dark appearance.

The transparency of watercolor paint allows the application of glazes, but in order to prevent the colors from contaminating each other, the wash cannot be painted over another color until the latter is completely dry.

Acrylic paint dries quickly and is highly versatile. It is easy to make glazes by adding some transparent gel, which lends more thickness to the layer of color, or water, which will thin the paint.

This is a multicolored watercolor wash obtained by blending two wet colors together.

The color of this paint is the result of mixing several acrylic colors together. Note the original colors and effect of partial mixtures.

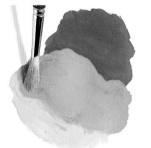

The opacity of gouache, even when diluted, gives it a semiopaque appearance. A semiopaque layer over a completely dry patch of paint allows a mixture to be obtained through superimposing; the result, however, will not be luminous.

Glaze produced with oil. The underlying layer must be left to dry first. In the area where the two layers are superimposed, we can observe the color of the mixture obtained. The work of painting glazes in oil is laborious due to the time taken waiting for each layer of color to dry before a new one can be applied.

Texture

Colors can be mixed in many ways. The effect produced by the mixture on the viewer depends on the colors used and on the texture they create. Each artist's personal experience and sensibility leaves the door open to an infinite range of possibilities.

The painter's choice of mixing tools will depend on the desired effect. The movement of the brush and the palette knife lend a particular look to a work. Various colors of paint can be applied, opaque or transparent, wet on dry, wet on wet, with mottled or rubbed effects. It all depends on the medium and the possibilities it can offer in terms of texture.

SAMPLES OF TEXTURE

From the harmonious textures of academic painting to highly textured abstract painting, today's artist can enjoy a wide range of possibilities.

One need not be limited to representing a form according to the direction of light and by means of tonal values. The use of more direct color application allows the artist to create tones with flat colors; this procedure forgoes the detail of academic painting to concentrate instead on visual synthesis. Color is perceived by the eye directly by way of optical mixtures of colors on the retina. In order to represent different types of surfaces, such as flesh, clouds, vegetation, rocks, wood, and so on, the painter must follow specific steps to obtain these objectives. Let us examine some examples of textures and see how they are achieved.

SAMPLE OF TEXTURES OIL

The techniques of blending and sfumato are done while the paint is still wet. The effect is produced by applying the brush in short curved or straight movements over the surface. A clean cotton rag can also be used to obtain a sfumato effect or to blend colors.

The paint over which you glaze, with a thin, transparent coat, must always be dry. This technique should be done with a brush loaded with little paint and transparent medium, such as linseed or copal oil, which the artist softly applies on the dry surface of the canvas. The result lends the work a pronounced effect of depth.

A rag slightly dampened with paint can also be used to produce frottis. In this way, glazes are painted with thin layers of diluted paint, applied on a dry background. By alternating different consistencies of paint, the artist can create highly suggestive textural effects.

It is easy to remove some color with a cotton rag while the layer of very diluted paint is still wet. This technique allows you to model the forms with removal, the strokes of the rag or dry brush augmenting the form.

Another easy technique that can be done on a layer of wet paint is sgraffito. Any implement can be used to apply the paint over the surface, as long as it does not tear the canvas or damage the underlying dry layer.

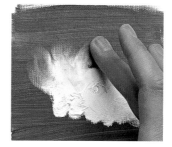

Here we can see how oil paint is worked with a finger. This technique can produce very misty effects.

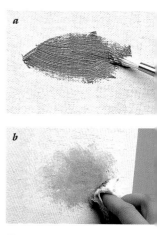

To create a sfumato with oil, first the color is applied on a wet white ground (a); then, with a cotton rag, the paint is spread over the canvas (b).

The frottis technique is done over a perfectly dried canvas, with a brush that is barely coated with another color.

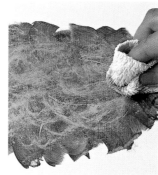

Frottis can also be executed with a rag. In this example, a coating or glaze of scumbled yellow is applied over a layer of dry green paint.

Sgraffito can be done with the edge of the palette knife by scratching into a layer of wet paint to expose a dry layer of dark paint.

Glazes alter underlying colors. But when the paint has texture, produced by impastos of irregular thicknesses, some beautiful effects can be obtained.

SAMPLE OF TEXTURES | ACRYLIC

Water is used to dilute acrylic. This allows a wide range of textures to be created by means of washes, which vary with the superimposed colors applied wet on wet or wet on dry.

Gels, which act as thickeners or thinners or make the paint appear transparent or more opaque, can also be added to this paint, as well as a number of other substances. This is possible because of the versatility of acrylic paint, which permits highly transparent glazes and dense impastos to be applied. Just like oil, a sgraffito effect can be produced on wet acrylic. Though acrylic can be used in ways that are similar to oils, they have the advantage of drying more quickly.

Superimposed washes of diluted black and carmine applied wet on wet. The effect achieved here is ethereal.

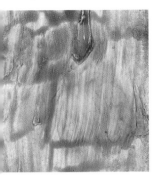

Acrylic gel creates thick glazes. We apply a thick glaze of transparent gel and very watered-down violet.

Note the effect of applying the paint on a still-wet background (a), and a very pale pink glaze, painted with a series of grays (b).

By alternating layers and tones, the artist can produce highly realistic textures such as the vaporous layers of clouds.

A gradation of violet thinned with plenty of water, executed on a white background.

SAMPLE OF TEXTURES | WATERCOLOR

With watercolor paint and sufficient use of water as a dilutant, the artist can paint uniform or multicolored washes. The latter are painted on wet, allowing various colors to bleed, or blend together. It is possible to produce washes of different intensity and thicknesses, although the technique is difficult to control and must be done with precise movements of the brush, and turning or lifting the paper up to allow the paint to flow in the desired direction.

If you paint wet on wet, the effect achieved is completely different than that created by applying the second layer over dry watercolor. In the latter case, the color mixtures are produced by superimposing transparent layers of paint.

The texture obtained after painting a uniform wash depends on the texture of the paper.

Multicolored washes are one of the most common types of watercolor applications. Here, orange has been painted over blue.

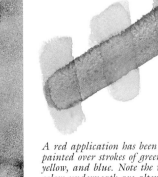

A red application has been painted over strokes of green, yellow, and blue. Note the way the colors underneath are altered. This is a glazing effect.

Circular and irregular sepia-colored brushwork applied on a wet ochre wash.

The texture produced by applying a burnt sienna wash over a semi-wet neutral green provides an excellent background for a landscape.

SAMPLE OF TEXTURES GOUACHE

Gouache is a medium that allows broad surfaces of the support to be filled in with an even color. The palette knife can be used to apply one color over another, whether the paint is wet, half-wet, or even dry. The only condition needed to obtain a good result is to spread the color evenly, without creating different thicknesses. Gouache applied in the form of impasto (thick applications) has a tendency to crack easily once it has dried. Even when gum arabic is added, it is best to paint gouache in thin and uniform layers.

a

b

When gouache is applied thickly (a), the paint has a tendency to crack easily after drying (b).

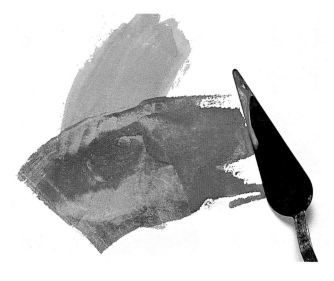

Example of texture with gouache applied in very thin layers. The effect is obtained through the contrast between orange and green. A palette knife is generally used for this procedure.

SAMPLE OF TEXTURES PASTEL

The texture of the paper can remain visible through a layer of pastel, provided it is not completely filled in with chalk. In addition to the standard procedures of blending and grading, pastels can be worked with combined medium techniques. By sketching with crayon, for instance, and then painting over it in pastel, the painter can achieve very interesting wax-resist effects since the pastel adheres only to those areas where there is no wax. In this way, all manner of textures are created, alternating layers of pastel and crayon.

Pastel is a dry medium, and it is traditionally applied using dry techniques. But pastel can also be applied as a wet technique by adding water. The amount of water added will determine whether the pastel appears more transparent or more opaque.

a *b* *c*

a Crayon effects. *Pastel will not cover the wax stroke.*
b Effects with water. *By applying a stroke of water over yellow pastel, an area of opacity is produced in the finish.*
c Effects of textures. *Two examples of texture: the texture of the paper on its thick, grainy side (violet), and that obtained with the application on top (green). Each application has a different look.*

SAMPLE OF TEXTURES | TAKING ADVANTAGE OF THE EFFECT OF TEXTURES

With practice you will see that various factors go into creating a specific effect. Here are some examples in oil.

Look at the three blends on this page. The first has been produced with variations of transparent and opaque layers, at the same time creating a tonal range.

In the second example, with the help of a cotton rag, the artist creates lighter strokes by removing color. The motion of these light touches is rhythmic.

In the last example, oil glazes have been applied over acrylic impasto mixed with acrylic modeling paste. The effect achieved contains a wealth of tones.

1. A visually striking composition created by means of alternated transparent and opaque applications, obtained with carmine, white, and mixes of the two colors.

2

2. An application of warm and cool violets meant to represent grass monochromatically. Note the marks left after removing wet paint with a cotton rag. The aim is to express the rhythm of the grass.

3

3. Effect of oil glazes on dried and textured acrylic impastos. The glazes heighten the effect of the texture, as the diluted paint puddles in the cavities.

Primary, Secondary, and Tertiary Colors

A primary color is one that cannot be produced by mixing other colors. A good practical exercise is to find out which colors are primary. An experienced artist, when mixing colors on the palette, is guided by concept of subtractive synthesis, so-called because concrete color, or pigment, subtracts or absorbs light waves from whole white light. In each medium, the colors closest to theoretical yellow, magenta, or cyan blue make the purest mixtures. By mixing the primary colors, the secondary colors can be obtained: red, green, and deep blue. From the primary and secondary colors come the tertiary colors: orange, carmine, yellow-green, blue-green, violet, and violet-blue. (Note that the color system discussed here is similar to that used in four-color printing.)

PRIMARY COLORS

The colors magenta, yellow, and cyan constitute the theoretical triad of primary colors. It is not difficult to find the primary colors in each medium. For example, if a medium yellow is the result of adding a little red to lemon yellow, then the latter is the primary yellow of the palette. In this way, the colors of a palette can be ascertained by elimination.

PRIMARY COLORS AND WHITE

In oil painting, acrylic, and gouache, white is indispensable. When arriving at the primary colors for each medium, it will become evident that to obtain a color similar to a theoretical primary, white must be added. This often occurs with primary red and blue. With acrylic and gouache, mixtures using white provide good results. With oil, on the other hand, adding white has a dual effect—it lightens the color but also dulls it. You can experiment by using primary colors to mix without adding white, and assess the results. You can also use a · manufactured color that already comes with white added. The mixtures of primary colors without white are purer, whereas when white is added, mixtures will appear grayer. But by working with small amounts of white, the integrity of the color and overall intensity of hue will, for the most part, be maintained.

OIL

The primary colors in oil are usually lemon yellow, madder lake, and cyan blue. Some painters prefer other options, using ultramarine or Prussian blue instead of cyan blue, a lighter carmine and some even choose light yellow over lemon yellow. Others prefer turquoise, which is closer to cyan. All of these options are valid, as the point is to understand the mechanics of mixtures. Theory should always be put into practice, and what really matters is the artist's particular sensibility for creating harmonious mixtures.

ACRYLIC

Cyan, or primary, blue for acrylics is a composite made of blue pigment, which could be PB15 or copper phthalocyanine, and white pigment, such as PW6 or titanium dioxide. The opacity of acrylic cyan may lead the painter to consider using another blue as primary, such as dark ultramarine, which is usually transparent. The triad of primary colors would be completed with Hanseatic yellow and quinacridone red or magenta. All of these colors are highly transparent and permit very clear mixtures. In addition, they can be thinned with water or transparent gels for creating transparencies.

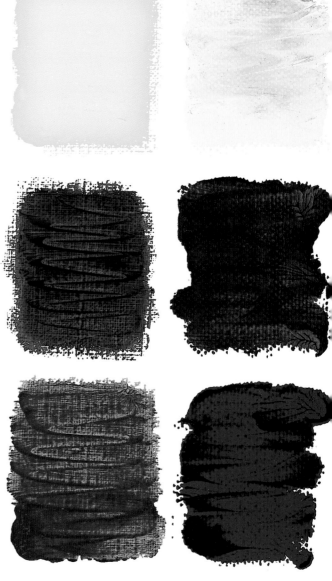

Primary colors in oil. *Primary colors in acrylic.*

WATERCOLOR

Watercolor paints are quite concentrated as they come from the tube. They must be highly diluted with water to be used, then their hues best reveal themselves. Such mixing will enable you to obtain the strength of pigment that can be used as primary. The following watercolors will work as primaries: medium yellow, madder lake, and cerulean blue, which is the closest to cyan.

GOUACHE

Gouache is a medium that has been associated with advertising for years, an area closely linked to the needs of printing. Manufacturers normally include in their selection the three colors on which present photomechanical reproduction is based: cyan blue, magenta, and primary yellow. Mixtures of primary colors in high-quality gouache normally provide very good results.

PASTEL

With pastel, mixtures often do not provide good results if they are carried out in the same manner as with wet media. A more or less wide variety of colors should be used. Therefore, a pastel palette would include manufactured secondary green, red, and blue, and each of these in an intense, medium, and light tone. The same holds true for tertiary colors.

SECONDARY COLORS

At the end of this book is a summary of some of the most important premises on color theory. One of the basic principles for understanding the mechanism of mixtures is the concept of subtractive synthesis, used by the artist in mixing colors.

Subtractive synthesis states that secondary colors are made by mixing two primary colors. Thus, secondary red is obtained by mixing primary red and yellow. Secondary green is made from cyan and yellow. And secondary blue, an intense blue, can be obtained by mixing cyan with primary red.

OIL, ACRYLIC, AND GOUACHE

The procedure for producing a secondary color is the same in oil, acrylic, or gouache, as these are all wet media with body. What varies is the specific consistency of each medium. But with practice, you will come to know how to use each.

In theory, a secondary color is obtained by mixing two primaries in equal amounts. In practice, on the other hand, you will see that at first with oil, it is not easy to separate two equal quantities of paint. You will need to get used to measuring these quantities by eye, using your brush or palette knife. Keep in mind that these measurements are always approximate. One of the first things that a painter learns is that color mixing consists of experimenting with color until obtaining the one desired. One begins by approximating; then small quantities of this or that color are added to modify and adjust the results.

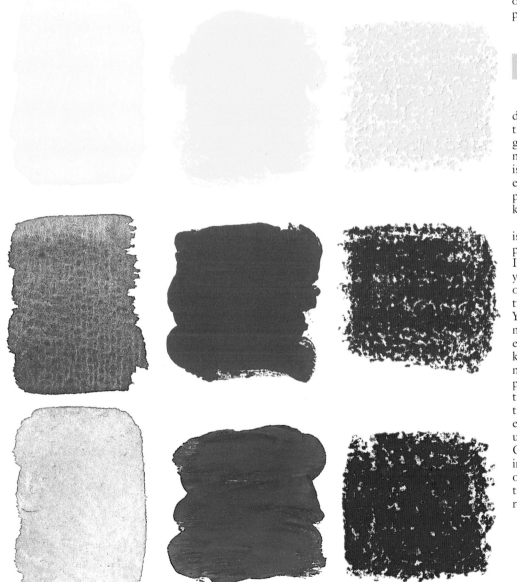

Primary colors in watercolor.　　*Primary colors in gouache.*　　*Primary colors in pastel.*

SECONDARY RED

The two primary colors yellow and carmine are measured out in almost equal quantities. The mixing is done in a clean spot where the colors are adjusted until they are similar to the theoretical balanced red.

Secondary red is obtained by mixing carmine and primary yellow in more or less equal amounts.

GREEN

The two primary colors yellow and blue are used in similar amounts. These are mixed, and adjusted, adding touches of the components until secondary green is obtained.

Secondary green is obtained by mixing primary yellow and blue. Adjustments in mixing will need to be made, adding one or more colors as needed.

DEEP BLUE

Secondary blue, which is a deep, dark blue, can be obtained from a mixture of carmine and primary blue.

Intense secondary blue is obtained from a mix of primary carmine and blue.

WATERCOLOR

When working with watercolors, the knack for obtaining secondary colors lies in adding just the right quantity of water to reduce the intensity of a color. When the right amounts of pigment and water are not used, the color will be too thick and dense rather than brilliant and luminous. The mixture can be gradually adjusted on the palette or in a mixing receptacle until the secondary colors are obtained.

To obtain a secondary red, mix the primaries carmine and yellow. The amount of water and dissolved pigment are the key factors.

To obtain secondary green, primary yellow and blue are used, diluted with enough water for the pigment to appear luminous.

For intense secondary blue, primary carmine and blue are mixed with the appropriate quantity of water.

PASTEL

With pastel, it is more difficult to create color mixtures without blending the chalk. The illustrations on this page show the results obtained when trying to mix secondary colors from primaries in

a

a

a

*When primary colors are mixed in pastel to produce secondary colors, the resulting mixtures appear dull and muddy (**a**) compared to manufactured colors (**b**).*

pastel. The samples in (**a**) illustrate the results of mixing two primary colors to produce a secondary, while the circular area of color shows the result of blending with the finger. The samples in (**b**) show the results of manufactured colors and the effects of blending them. The blends in (**a**) appear dull and muddied compared with those of the manufactured colors in (**b**).

b

b

b

TERTIARY COLORS

A tertiary color is the result of mixing two primary colors. Just as with mixing secondary colors, the key factor is the proportions. When producing a secondary color, the mixture is done with more or less equal amounts of primary colors, whereas for a tertiary mixture, a proportion of about 3 to 1 is used. There are six tertiary colors: orange, carmine red, violet, violet-blue, yellow-green, and blue-green. From primary red and yellow, secondary red can be obtained, and from there, the tertiary colors orange and carmine red. From primary yellow and blue, secondary green and the tertiaries yellow-green and blue-green are obtained, and from primary carmine and blue, dark secondary blue and the tertiaries violet and violet-blue.

OIL, ACRYLIC, AND GOUACHE

All wet media with substantial body can be treated in the same manner. Acrylic and gouache have similar textures, while oil is greasy.

In practice, the artist separates out the quantities of primary colors needed to mix orange. The mixture should be made with approximately 75% yellow and 25% carmine.

To obtain tertiary carmine red, the proportions are the inverse: 75% carmine and 25% yellow.

For violet, 75% carmine and 25% blue is used.

For tertiary violet blue, mix 75% blue with 25% carmine.

From primary yellow and blue, the following tertiary colors can be mixed: yellow-green, using 75% yellow and 25% blue; and blue-green, with 75% blue and 25% yellow.

OBTAINING TERTIARY COLORS IN OIL

The illustrations on this page show the procedure followed to obtain tertiary colors in oil. The amount of primary color used can be seen in each mixture. Mixtures in oil will often need to be adjusted to achieve the desired hue. The application of the brush will hold more of one color than another, lending the mixture a specific hue.

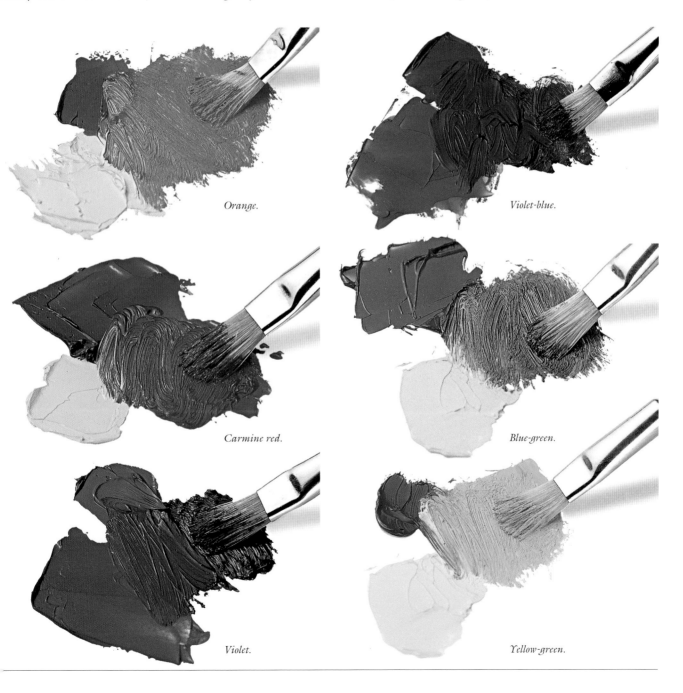

Orange.

Violet-blue.

Carmine red.

Blue-green.

Violet.

Yellow-green.

WATERCOLOR

With watercolors, the proportions of primary colors used to obtain tertiary colors will depend on the amount of pigment as well as the amount of water used to dilute it. This medium requires a great deal of palette work to control the intensity of the wash.

In watercolor, orange is obtained from 75% yellow and 25% carmine; carmine red from 75% carmine and 25% yellow; violet from 75% carmine and 25% blue; violet-blue from 75% blue and 25% carmine; yellow-green from 75% yellow and 25% blue; and blue-green from 75% blue and 25% yellow.

THE DIFFICULTIES OF WATERCOLOR

The greatest difficulty with watercolor is learning to master the use and mixing of water and pigment. When water is added to a color, a wash is created that has a specific tone. This results from the respective proportions of pigment to water. Therefore, when two colors are mixed, the quantities of water and pigments must be controlled.

In practice, it may be difficult to reproduce the same mixture of a concrete color, whether mixed on the palette or in a pan. But the watercolor artist will become familiar with this medium through practice. The most common implement, the brush, which is used to add water to the pigment, also functions as a measuring tool. The size of the brush and the degree to which it is immersed in clean water are two factors that allow the amount of water added to the mixture to be controlled.

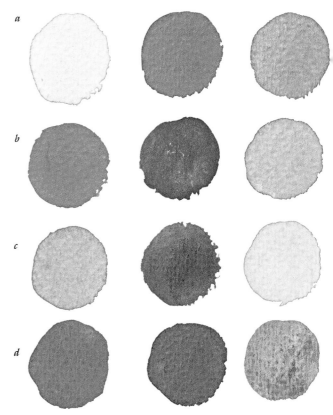

*Samples of colors in watercolor: primary colors (row **a**), secondary colors (row **b**), and tertiary colors produced from primary colors (rows **c** and **d**)*

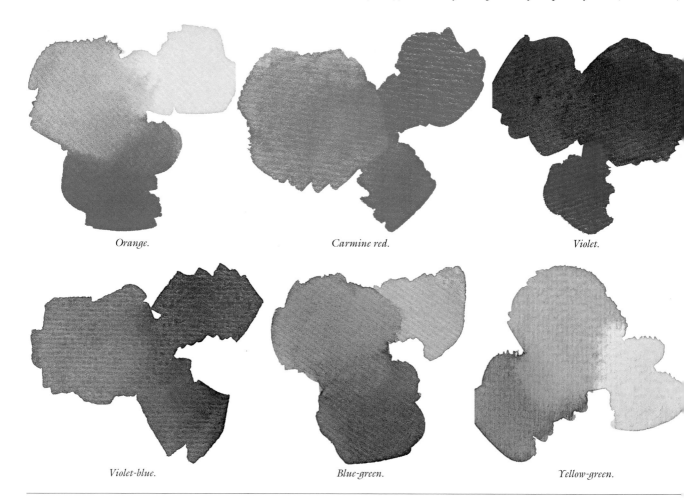

Orange. *Carmine red.* *Violet.*

Violet-blue. *Blue-green.* *Yellow-green.*

ALL PRIMARY, SECONDARY, AND TERTIARY COLORS

After creating all secondary and tertiary colors from primary ones, we have placed them all together, organized as a block. It is a good idea to familiarize oneself with the general color scheme and establish relationships between these colors. Altogether, from primary yellow, red, and blue, three reds can be obtained: orange, red, and carmine red; three greens: yellow-green, green, and blue-green; and three blues: violet, intense blue, and violet-blue.

DIFFERENCES BETWEEN THE DIFFERENT MEDIA

Acrylics and gouache are products that presently provide great color quality. They are chemically well-balanced and nearly embody the practical application of theory. The strength of gouache lies in its purity and consistency of opaque color, which cannot be compared to that of other media. But the difficulty of applying it thickly and evenly to create a smooth finish makes it a medium at least as delicate as watercolor. Of all the media presented here, pastel is the most difficult to preserve. Gouache is used mostly in the world of advertising design and graphics.

One advantage of watercolor is its resistance to light and fading over time. It also possesses a purity that becomes obvious in its luminous mixtures. Notice how delicate yet intense the watercolor mixtures appear in the sample chart as compared to the other media. Notice the even, flat look of gouache and the slight transparency of the acrylics.

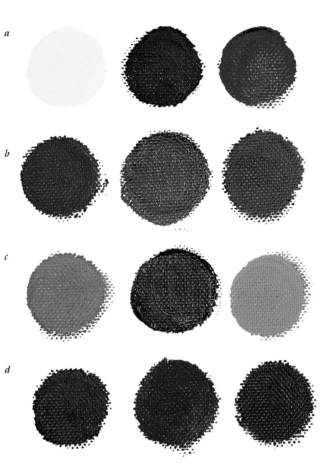

*Tertiary colors in acrylic. Compare the differences between the primary (row **a**), secondary (row **b**) and tertiary colors (rows **c** and **d**) in this sample group.*

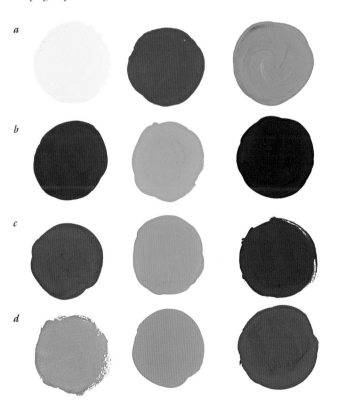

*Tertiary colors in gouache. It is easy to see the different tones obtained from the primary colors (row **a**) in producing secondary (row **b**) and tertiary colors (rows **c** and **d**).*

PASTEL

When attempting to produce tertiary colors from primaries in pastel, the characteristic difficulties of working with this medium appear. The colors obtained tend to be dulled, and the capacity of adherence to the support will rapidly reach saturation. Mixtures should be produced visually or by blending procedures conventionally used with pastel. The majority of pastel artists, whether they work using values or in a colorist manner, equip themselves with an extensive array of colors. In view of the difficulty of obtaining tertiary colors by mixing primaries, it is best to purchase a selection of manufactured tertiary colors. In addition to a stick in each hue, sets often come with a light, medium, and intense tone for each one. For some subjects, even dark tones can be of use.

THEORY AND PRACTICE

The theory regarding the creation of secondary and tertiary colors from the three primaries ones should be verified in each medium.

Experience will dictate the colors that will function as primaries in each medium. In oil, for example, it is best to use deeper colors. Cyan blue, a turquoise blue, comes with white pigment in it, which makes mixtures grayer. Whether working in oil, acrylic, watercolor, gouache, or pastel, the difficulty lies in measuring out the quantity of each color to be added to a mixture. In wet media, a color is created through approximations and experimentation. In a dry medium such as pastel, a color tone is established by controlling the pressure applied on the paper. The results of mixtures will also depend on the quality of the paints used.

Complementary Colors

Each complementary pair of colors, when placed next to another, has a high degree of color contrast. These color pairs have their use in painting, and their importance lies in achieving contrasts and in manipulating their mixtures. Working with complementary colors, however, requires a certain degree of caution; mixed together they create grays and earth tones, or neutrals. The latter, very beautiful and delicate, are important to palette work but require experience to mix and employ in a composition.

because one is a primary an[d] the other a secondary colo[r], all three primary colors a[re] present in the mixtur[e]. Therefore, these types o[f] mixtures also result in a colo[r] close to black.

PRODUCING BLACK

In practice, when the thre[e] primary colors are mixed, [a] very dark, dull color [is] produced. There are sever[al] methods for producing [a] richer black from the colo[rs]

COMPLEMENTARY COLORS

There is a very useful palette exercise for becoming familiar with the colors of a medium. If two manufactured colors are mixed, and a very dark, nearly black color is the result, then chances are those colors are complementary. Complementary colors negate hue and instead mix dark grays and browns. These resulting grays and browns can be very beautiful as well as useful for creating different tones of one hue.

BLUE AND RED

According to the color system used here, blue and red are complementary colors. Cyan blue is a primary color, whereas red is a secondary one produced from primary yellow and primary carmine. Therefore, the complementary color to secondary red is the primary color that was not used in the mix, that is to say blue.

Secondary red and primary blue are complementary colors.

YELLOW AND INTENSE BLUE

Yellow and intense blue are complementary colors. Intense blue is a secondary color, formed from mixing the primaries cyan blue and carmine. The complementary color to intense blue, therefore, is yellow, the primary color not used in the mix.

Primary yellow and secondary blue are complementary colors.

CARMINE AND GREEN

Green is a secondary color produced by mixing primary yellow and blue. The primary color not used in the mixture, carmine, is its complementary color.

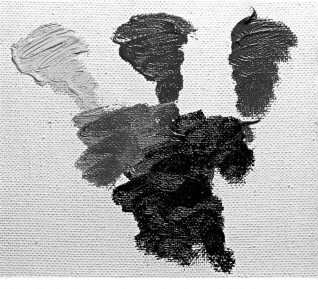

Mixing the three primary colors in oil produces a dull black.

MIXING THE THREE PRIMARY COLORS

Based on the subtractive theory of color mixing, if the three primary colors are mixed in equal proportions, the color black should result. When two complementary colors are mixed together,

Primary carmine and secondary green are complementary colors.

on your palette. By mixin[g] carmine, burnt umber, an[d] green in oil, very dark, near[ly] black colors are produce[d]. Another option is carmin[e,] ultramarine, and burnt umbe[r]. The black produced w[ill] appear warmer or coole[r] depending on the hues tha[t] are mixed. These kinds o[f] mixed blacks are known a[s] chromatic blacks, and th[e] grays that can be made b[y] adding white are called chro[-] matic grays. These blacks an[d] grays tend to be richer tha[n] those mixed by using a blac[k] from the tube.

MIXING COMPLEMENTARY COLORS

What happens when complementary colors are mixed? If the proportions are more or less equal, the resulting colors appear dark and muddy, and none is truly black. See the results produced with oil; none of the mixtures has a well-defined color. The reason is very simple to understand: When two complementary colors are mixed in equal amounts, the three primary colors are actually mixed, and black is the product of such a mixture. With complementary colors, the proportions to mix are 2 to 1 to 1.

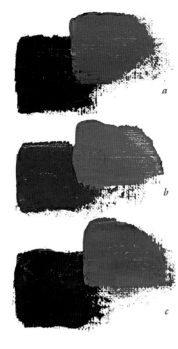

Mixtures of equal amounts of complementary colors in oil. Note the effect of adding a little white to each mixture.

a) *Carmine and green mixed in equal proportions: 2 parts carmine, 1 part yellow and 1 part blue. A very dark color is produced.*

b) *Yellow and intense blue mixed in equal proportions: 2 parts yellow with 1 part carmine and 1 part blue. A very dark greenish color is produced.*

c) *Red and light blue mixed in equal proportions: 2 parts blue with 1 part carmine and 1 part yellow. Again, a very dark color is produced.*

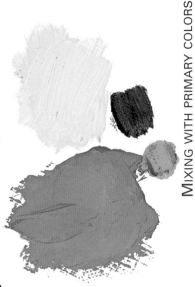

Mixture for producing an ochre.

HOW TO MIX COMPLEMENTARY COLORS

To obtain more defined colors from mixtures of complementary colors, they should be mixed in very different proportions. By such mixing, a very subtle range of colors can be produced. In most of these mixtures, particularly those in which a dark primary color predominates, it is best to add white.

When two complementary colors are mixed in unequal proportions, the resulting color is called a "neutral color." It is also known as a chromatic gray.

NEUTRAL COLORS

With each pair of complementary colors, there is one warm and one cool color. Intense blue is cool and yellow is warm. Similar relationships exist between red and blue and carmine and green. When two complementary colors are mixed, the resulting color has a neutral temperature. Hence the name neutral for this group of colors.

In some neutral colors, a warm tendency predominates. Others demonstrate a characteristic coolness in color. The color that predominates in the mixture of complementary colors determines the tendency and temperature of the mixture.

Mixture for producing sienna.

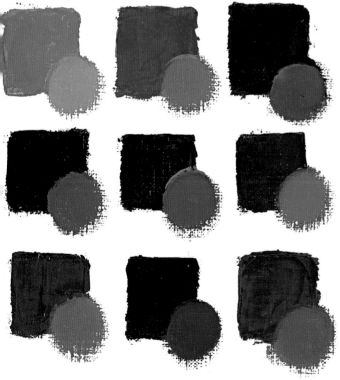

PRODUCING EARTH COLORS FROM PRIMARY ONES

Earth colors can be produced from the three primary ones. To produce an ochre, abundant yellow is mixed with some carmine and a little blue. A color similar to burnt sienna is produced from approximately equal amounts of carmine and yellow darkened with a little blue. Burnt umber is very dark. It can be made from carmine and blue in equal quantities, lightened with a little yellow.

Other dark colors, among which an ochre can be identified, along with various earth colors, and bluish and greenish hues. These are the results of mixing secondary and tertiary colors such that all three primary colors are involved in each mixture.

Mixture for producing burnt umber.

The Color Wheel

The color wheel is a theoretical tool. It is produced by placing primary, secondary, and tertiary colors in a specific order in a circle. Primary colors appear diametrically opposed to those secondary colors in whose mixture they are not involved. In this way, the three pairs of complementary colors appear. On each side of a primary color, the tertiary colors in which the primary predominates are placed.

The diagram of the color wheel is very useful, particularly because the exercise of producing its hues using the various media enhances the artist's experience with color mixing.

ondary, and tertiary colors. Note the color wheels here specific to each medium.

OIL

To most closely represent the pure theoretical color wheel for oils, lemon yellow, medium yellow, orange, vermilion, red, carmine, carmine-violet, violet, ultramarine blue, Prussian blue, emerald green, phthalic green, and medium green have been used.

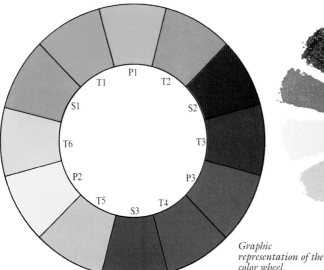

Graphic representation of the color wheel.

Here oil colors have been applied on a coarse-textured canvas in the form of a color wheel.

This color wheel is painted with watercolors on watercolor paper.

THE THEORETICAL COLOR WHEEL

The theoretical color wheel allows primary, secondary, and tertiary colors to be classified. The letter P refers to primary colors, S to secondary, and T to tertiary. An S color is always located between the two Ps from which it is produced. A T is located between the P and the S that produce it.

An important part of a color system is summed up in its color wheel. Color wheels vary depending on the color system they represent.

LIMITATIONS

Because a color wheel is theoretical, when put into practice and created from manufactured colors, the limitations of the pigments become evident. The color wheel can only be produced from pure colors, because this theoretical device does not allow for the existence of neutral colors. Nor are tonal values of colors considered, whereas in practice they do exist.

When comparing manufactured colors, it is easier to establish relations. Thus, one blue appears more violet than another blue. Furthermore, a color such as royal blue, for example, is a light cobalt blue with more PW4, or white pigment.

An analysis of manufactured colors also allows neutral colors to be identified, although these are not included on a color wheel.

IN PRACTICE

Arranging commercially manufactured colors is perhaps one of the most interesting practical exercises. Pure colors can be grouped by yellows, oranges, reds, carmines, purples, violets, blues, blue-greens, greens, and yellow-greens. This way of grouping colors follows the pattern of primary, sec-

WATERCOLOR

The color wheel for watercolors is made up of permanent lemon yellow, various azo yellows, permanent orange, permanent vermilion, dark red, madder lake, permanent violet-red, violet, violet-blue, ultramarine blue, phthalic blue, phthalic green, permanent green, and yellow-green.

Acrylic colors organized into a color wheel. The support is a medium-weave canvas.

Gouache colors organized into a color wheel. On matte Bristol paper, the gouache colors appear brilliant.

Pastel colors organized in the form of a color wheel. Only the intense tone of each color is present.

ACRYLIC

The color wheel for acrylics is made up of Hanseatic lemon yellow, deep yellow, cadmium orange, naphthalene vermilion, cadmium red, quinacrydone magenta, quincrydone violet, ultramarine blue, manganese blue, chrome cobalt blue, phthalo green, Hooker's green, and cadmium green.

GOUACHE

The color wheel for gouache is made up of lemon yellow, dark yellow, orange, cadmium red, vermilion, carmine, carmine pink, violet, ultramarine blue, cerulean blue, Paris blue, turquoise blue, green, bluish moss green, light yellow-green, and moss green.

PASTEL

The color wheel for pastels is made up of lemon yellow, medium yellow, orange, orange-red, vermilion, red, carmine, magenta, deep violet, violet, blue-violet, ultramarine blue, blue, turquoise blue, light blue, greenish blue, light green, and yellow-green.

It is useful to create a color wheel in another medium and to use available pigments to come as close as possible to the theoretical colors of the wheel.

UTILITY

The graphic representation of the simple, warm and cool harmonic ranges of the color wheel make this construct a useful tool for organizing color.

A representation of the simple harmonic range reveals the warm/cool contrasts between complementary colors. The wheel also suggests the richness of color interactions, which a palette that includes adjacent colors produces.

The warm colors far outweigh the presence of cool colors in the color wheel. Notice how small the area of truly cool colors really is, limited in their purest form to only blue, blue-violet, and blue-green.

At the edges of the cool range are yellow-green and red-violet, both warm colors.

COMPLEMENTARY COLORS

Direct complementary colors fall opposite one another on the color wheel. The principal complementary pairs appear: red and cyan, yellow and intense blue, carmine and green. Lesser complementaries also appear, such as yellow-green and violet, orange and violet-blue, and carmine red and blue-green. After creating color wheels in each medium, it will be easy to identify complementary colors.

MIXTURES OF COMPLEMENTARY COLORS

What happens when complementary colors are mixed? If the proportions are equal, the result is a very dark, muddy color, yet not truly black. Note the results obtained with oil on page 55. None of the mixtures results in a true black, only a color that is close to black. When two complementary colors are mixed in equal amounts, the three primary colors are being mixed. The color black is the result of such a mixture. With complementaries, the proportions are 2 to 1 to 1.

INDIRECT COMPLEMENTARY COLORS

Two complementary colors appear on the theoretical color wheel, such as intense blue and yellow. The first one is an indirect complementary of yellow-green or orange. Yellow is also an indirect complementary of violet-blue and violet. An indirect complementary of a color occupies the position adjacent to its complementary color.

In mixtures of indirect complementary colors, even when using equal amounts of each, the result is not as dark or gray as when working with direct complementary colors.

Simple harmonic range.

Warm harmonic range.

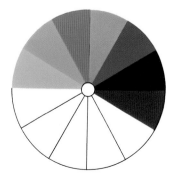

Cold harmonic range.

How to Produce Tones

In all media that allow paint to be applied in transparent form, transparent tones can also be produced. Watercolor is a medium based precisely on transparency. Likewise, in oil, acrylic, or gouache, transparent tones can be produced by reducing the opacity of the colors by adding a solvent. Opaque tones can also be produced in these latter three media by adding white. Pastel and gouache, two basically opaque media, can be used to produce tones that appear semiopaque.

paper. Then more water is added to the remaining color on the palette and mixed. A brushstroke is applied with this mixture next to the first brushstroke. The tone produced is lighter. It is also possible to obtain a tonal range in watercolor by applying wet paint onto dry. The tone produced is darker, because it is a mixture of two superimposed layers. Compare the images in (1a) and (1b), a transparent tonal range and a wet-on-dry tonal range, with (2), a graded wash.

2. A yellow-orange wash.

TRANSPARENT TONES

The intensity of a color can be modified by adding a solvent or a medium. The more solvent or medium added, the more washed-out color becomes—that is, the lighter the tone appears. Watercolor is designed to dissolve in water. Linseed oil and/or turpentine is used to work with oil color; for acrylics, water or a transparent acrylic gel is used. For gouache, water is used; however, for pastel, it is a question of controlling the amount of pressure applied on the support to achieve tones ranging from transparent to opaque.

Of all these media, watercolor is the most transparent. When mixing watercolor with water to create transparencies, remember that some washes can be so diluted that they hardly color the paper at all.

In oil, the more oil or turpentine added, the more transparent the color. In acrylics, adding water produces a subdued color and a lighter tone, and the layer of paint becomes thinner. If acrylic gel is added, it provides body.

GRADATION

In a gradation with transparent tones, the change from one tone to another is gradual, avoiding tonal jumps. Backgrounds or chiaroscuro produced with gradations are characteristic of oil painting. Graded washes constitute the basic vehicle for watercolor painting. Graded transparent tones in acrylic, made with water or transparent gel, create the glazes characteristic of this medium. Semiopaque gradations can also be produced with gouache. Finally, gradations in pastel, blended or otherwise, can be used to create the effect of chiaroscuro. Creating a tone by applying transparent layers of a single color is a very slow process. With each of these mediums, the beauty of transparency cannot be denied. With transparencies, a range of tones can be obtained; the more superimposed the layers of a single color, the darker the tone.

WATERCOLOR

In any watercolor wash, the intensity of the color diminishes and a specific tone, which becomes lighter every time more water is added, is produced. A tonal range can be obtained in the following manner: A little color is taken onto the brush, dipped in water, and placed on the palette. It is then applied in a brushstroke onto watercolor

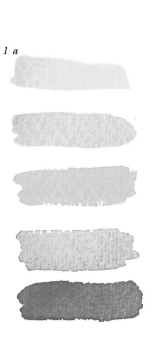

1. Tonal range in watercolors.
a The intensity of yellow-orange is reduced with every brushstroke, adding more water each time.
b Different tones are created over yellow-orange using the wet-on-dry technique.

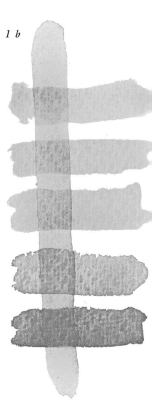

GOUACHE

This opaque paint can be diluted with water. The diluted color will be lighter in tone, although it will continue to be somewhat opaque or semiopaque. This medium does not lend itself to producing transparent layers, though it can be forced to produce somewhat transparent tones.

A tonal range in gouache, using light cobalt blue diluted in water.

OIL

To produce transparent tones in oil, the paint must be diluted. Different tones can be achieved, depending on the amount of turpentine and/or oil added. The more solvent a color contains, the lighter the tone.

A quantity of paint is placed on the palette or in some other mixing receptacle. A brush full of solvent is mixed with the paint. When the mixture is well blended, a stroke is applied on the canvas; the result will be light in tone. The procedure is repeated, adding more solvent each time to produce lighter tones. The images show a gradation of transparent tones (3) and a tonal range (4).

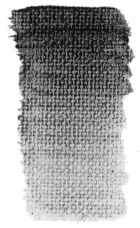

3. A transparent gradation of olive green oil paint.

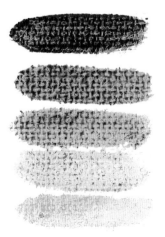

4. A tonal range in oil with olive green. The paint is gradually diluted.

ACRYLIC

Water allows you to dilute or subdue the tone of a color in acrylics, whereas a transparent gel subdues the tone but adds body as well.

To produce different tones with water, simply add water to the paint. The color layer becomes lighter and thinner as more water is added. When transparent gel is added to acrylic paint, on the other hand, a thick layer of color is produced while the color diminishes in intensity. Transparent effects can also be produced in acrylic. This paint dries very quickly, so a layer of color applied over a dry layer produces another tone of the color as a visual mixture or glaze. The more

5. A gradation of cadmium green acrylic, achieved by using water to thin the paint.

NOTE

Transparent gradations are quite useful for backgrounds, and atmospheric conditions.

Transparent layers, although they constitute a less immediate and more elaborate technique, produce unique effects because of the clarity of tones they create when the color of the underlying layer is light.

layers of color superimposed, the darker the tone becomes. The images show a tonal range for cadmium green with water and with a transparent gel (6a and 6b) and a gradation with water (5).

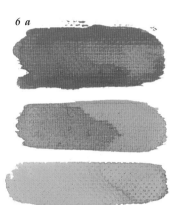

6 a

6 b

6. A transparent tonal range in acrylic.
a Cadmium green diluted with water.
b Transparent gel and acrylic thickener is gradually added to the cadmium green.

PASTEL

Pastels can be very opaque when applied intensely. But layers of transparent colors can also be applied, which allow the paper or layer of color underneath to show through their semitransparency.

Observe the tonal range of salmon pink as a transparent layer. The tones can be obtained through blending or by using strokes.

Pastels allow gradations of great quality because of the wide range of manufactured tones and the possibilities of blending.

A tonal range of salmon pink in pastel, moving from intense to pale.

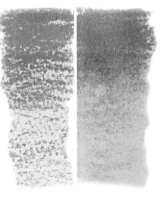

The effect of blending on pastel tones.

MIXING WITH PRIMARY COLORS

PROPERTIES OF DILUTED PAINT

Oil and acrylic applied on canvas can be very useful for producing tones. Notice the example done in oil paint using a warm color. An apple is created by wiping a cotton cloth over an area of diluted paint. Color must be removed from certain areas in order to produce a monochromatic tonal gradation.

An initial application of oil paint of this type when the paint has already acquired "bite" (that is, it is set and somewhat dry) is a good base over which to paint in a second layer of color. It is important to keep in mind when working in oils over the course of various sessions, thicker layers must be painted over thinner ones.

TRANSPARENT EFFECTS

Highly diluted paint, reduced in tone to nearly transparent, does not completely cover the dry color beneath it; it simply veils it. The result is a rich color produced by superimposing layers of paint, each one adding its qualities to the visual mixture. When working wet on wet, however, layers

of colors mix very easily, picked up by the brush.

HOW TO PRODUCE TONES WITH WHITE

When starting with an intense manufactured color (in oil, acrylic, or gouache) and opaque tones are desired, some white can be added to the mixture. Every time white is added, a lighter tone is produced. With watercolor, a medium based on transparency, the inclusion of white makes it more of a mixed media.

For painting in pastel, an extensive variety of colors is needed. As can be seen in a pastel color chart, each color comes in various tones. One is darkened with the addition of black, there is an intense tone, and there are several lighter tones. The lighter the tone, the more white has been added. With pastels, the tonal ranges of each color come premixed.

INDISPENSABLE WHITE

When working with wet media, white must be used to achieve hues of lightened tones. White is an essential and frequently used color when using oils, acrylics, or gouache. In most mediums, the tube of white is normally larger than the other colors.

Nonetheless, it is important not to abuse white; when it is added to another color, a second effect is created besides lightening. The color tends to lose its character and chromatic qualities and appears grayed out as well.

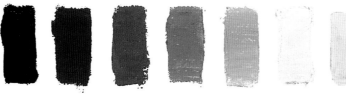

By progressively adding more white to ivory black, an extensive tonal range can be produced.

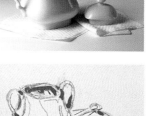
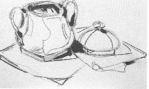

Effect achieved with the same paint in a gradation, avoiding tonal jumps.

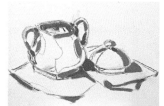
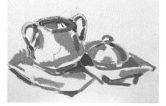
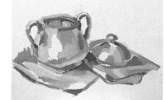

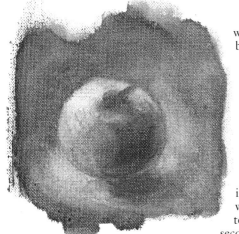

The tonal variations of this apple were obtained from highly diluted burnt sienna oil paint. Extra paint was removed with a cotton cloth.

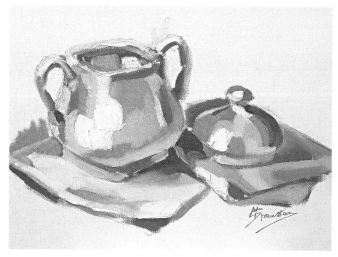

In this exercise in oil, the use of tones and the system of tonal variation can be observed. Based on a still life that is monochromatic, a sketch is drawn to define the most important tonal areas. Then gray is applied with the appropriate tonal values. In the last stage, the sketch shows a certain hardness, because the brushstrokes have not been blended. Blending along the lines where tonal values are juxtaposed will provide soft gradations.

OIL, ACRYLIC, AND GOUACHE

There is a strong similarity between these three media and the way they create opaque tones, although one is oil based and the others are water based. Though these mediums are lightened using white, their colors tend to become gray, duller, and less bright. The illustrations show how the progressive addition of greater amounts of white produces the tonal ranges. A lemon yellow loses its color very quickly, only producing a short tonal range. Some colors change dramatically when white is added. Carmine, for example, becomes pink.

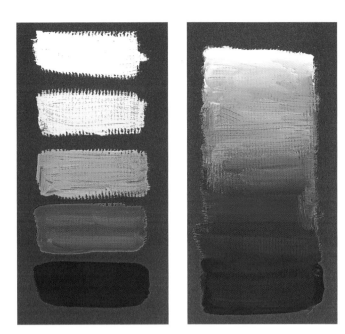

Tonal range in gouache mixed in light cobalt blue and white on red paper to provide contrast. On the right is a blended gradation produced with the same colors, keeping the paint wet.

On the left is a tonal range in oil based on cerulean blue and white. The covering capacity of this range can be observed in that it completely covers the dry layer of red. On the right is the effect of a blended gradation with the same colors.

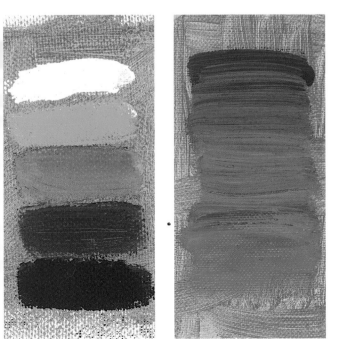

On the left is a tonal range in acrylic painted in light manganese blue mixed with white. Its opacity completely covers the dry layer of orange paint underneath. The image on the right shows a blended gradation mixed with cerulean blue and permanent green. Color has been applied over a wet base both layers mix.

WATERCOLOR

In this medium, different tones of a color are achieved by diluting the paint with water. The degree of tonal variation in watercolor depends on the transparency of the layer, which becomes lighter or darker, depending on the amount of water and pigment.

Chinese white is the white that is commonly used in watercolor, but its semiopacity affects the pigments of the colors it is mixed with. Instead of producing a lighter tone through transparency, it produces a lighter tone that is somewhat opaque.

If white is added in watercolor, a transparent wash can be alternated with opaque brushstrokes. Such contrasts can increase depth.

PASTEL

White is already added to pastel. A tonal range of a color can be produced using the selection offered by any quality brand. The results will be better than those produced mixing white with another color.

The color chart for pastel should be studied. Each color appears in all of these with its range of intensities.

COVERING CAPACITY

The opaque paints, when applied over a layer of paint, can cover it completely. If the layer of paint underneath is completely dry, the two layers will not mix; however, if it is still wet, the two layers will tend to mix.

Such opaque paints and their corresponding tones can be very useful for correcting errors. This property is true for oil and acrylic, though not for gouache, because it is water soluble when rewet.

NOTE

In a pastel color chart, each color appears with its range of intensities. Normally, a dark tone is offered, produced by adding some black to the deep tone of the color, as well as several lighter tones, produced by adding white. The name of the color and the tone is usually printed on the paper that wraps each pastel stick.

HOW COLORS ARE DARKENED WITH BLACK

It may seem logical that black should be added to darken a color. But experience shows that the result is not a darker tone but a blacker color. In all wet media that can be opaque (oil, acrylic, and gouache), black paint is available. But in oil, tradition has it that black should not be used to darken a color. The same holds true for the other two media, acrylic and gouache. For watercolor, the purest way to produce darker tones is to use similar colors that are darker or to mix opposites to create browns and grays.

OIL, ACRYLIC, AND GOUACHE

When working with oils, adding black to a color not only darkens it but also blackens it. Some colors even seem to shift to another hue. This is the case with yellow, which turns into green when black is added. To avoid such problems, manufactured black is normally used for specific brushstrokes and details. But for mixtures, chromatically mixed black or dark colors are usually used. A very dark color, practically black, can be produced by mixing madder lake and emerald green, which are complementary colors, and the result can be adjusted by adding a warm dark color such as burnt umber. Another equally dark color can be produced from carmine, burnt umber, and Prussian blue.

Again, rich blacks and very dark browns can be produced by mixing complementary colors. In fact, any color can thus be darkened by adding some of its complementary color. Any of these mixtures can then be used to darken other colors. Similar mixtures can be produced using acrylics and gouache as well.

When yellow is mixed with black, the yellow turns to green.

When vermilion is mixed with black, the vermilion turns to brown.

When ochre is mixed with black, the ochre turns to a greenish color.

When sienna is mixed with black, the sienna turns to a deep brown.

When medium green is mixed with black, the medium green turns to greenish gray.

When emerald green is mixed with black, the emerald green turns to a very dark green, nearly black.

a Mixture of carmine, burnt umber, and emerald green.

b Mixture of carmine, burnt umber, and Prussian blue.

When turquoise is mixed with black, the turquoise turns to a dark, earthy blue.

When ultramarine blue is mixed with black, the ultramarine blue turns to a very dark, nearly black color.

Mixtures for producing chromatically mixed blacks in oil. The samples show the original colors, the resulting mixture in the center for black, and the hues resulting from the predominance of one over the others. A little white shows the hue of each dark color.

WATERCOLOR

Watercolor work is based n the transparency of the aint. A color can be arkened by simply adding a arker color, a little blue, or ven some of a mixture made om the dark colors of the alette. Rich "blacks" can be ixed in this manner.

If a color is to be darkened y the technique of wet on dry, a layer of color is applied over another when the first one is dry, and the process is repeated successively. It is not a good idea to use a color at its maximum intensity, because it tends to appear opaque. Therefore, the point is to darken a color by working in transparent layers of color. Washes of complementary colors tend to darken the mixture and make it appear gray.

To darken a color, similar or even complementary colors can be used.

Watercolor darkened by uperimposing wet over dry layers.

Watercolors darkened by progressive ddition of black. These samples how how the colors darken without osing the brilliance of watercolor.

A yellow can be darkened in watercolor with a similar darker color, yellow ochre. Here it is progressively darkened with some ochre and some brown. Each color mixture is done directly on the palette and is then applied to the paper.

NOTE

To blacken is not the same as to darken. In each medium, and depending on the selection of colors, there are certain colors that when blended produce an almost black color. These blacks are said to have influenceable properties. The predominance of one of the original colors lends a certain tendency to the color mixture.

PASTEL

Pastel colors can usually be found in several tones of each hue, ranging from dark to light. There are also specific color sets, for portraits, still life, seascapes, and landscapes, as well as sets that have selections of grays.

Black colors are available in warm, neutral, or cool variations. In other words, the mixtures in oil, acrylic, and gouache produced to obtain chromatic black are premanufactured in pastel. Also, various tones of these blacks are available. Any pastel color can also be darkened by subsequent layers or juxtapositions of color. A gradation can be blended smooth with a stump or a finger.

In selections of pastel available, all brands normally include the dark version of each color. The pigment of the hue has been mixed with some black pigment. There are many browns and grays available with different hues.

Reducing a Color to Primary Colors

With watercolor we can paint using only mixtures obtained from the three primary colors: carmine, yellow, and blue. This is also possible with oil and gouache, but in the latter cases, white must be added to the mixtures in order to apply them in the form of opaque paint. Any object can be painted using only the three primary colors and white, if necessary. This makes a very useful exercise to gain experience in palette work, but it also has certain limitations. By looking at commercially manufactured colors on the palette and trying to reproduce them with mixtures of primary colors, you will quickly see that neither the luminosity nor the pureness obtained are the same. As a result, painters normally work with several manufactured colors from the outset, in addition to the mixtures made with primary colors. The commercially manufactured colors can also be used for mixing. Learning to use them in mixtures rests on studying the way they can be recomposed theoretically with primary colors.

HOW TO PAINT WITH PRIMARY COLORS

Secondary and tertiary colors are made up from the three primary colors, offering a broad range of colors with which to paint. Watercolor requires only three colors to mix with the others. Their transparency, taken with the white of the paper, creates a complete tonal range by mixing just the three primary colors together. In the case of oil, acrylic, and gouache, all opaque media, the matter becomes more complicated because white must be added. Therefore, to the range or ordered succession between two intense colors, all the tones that can be produced by mixing with white can be created.

When secondary colors are blended with tertiaries, the result is a series of very dark neutral colors. When two complementary colors are mixed in different proportions, almost the same thing happens. With watercolor, transparent browns and grays are toned by successive layers. But white is usually added to oil, acrylic, and gouache, with which a wide range of neutral colors and tones can be produced.

EXAMPLE IN OIL

As you see in the example reproduced on this page, with oil paints, in addition to the primary colors (carmine, yellow, and blue), white must be added to obtain light tones.

In the central area of the patch (**a**) are the secondary and tertiary colors: light blue, dark blue, blue-violet, green, blue-green, yellow-green, red-violet, red, yellow, and orange. The secondary colors have been produced by mixing two primary colors in more or less equal proportions. The proportions for the tertiary colors are, theoretically, two primaries mixed in a 3-to-1 ratio. The black in the center (**b**) is the result of a blend of three primary colors in equal proportions. The mixtures of secondary and tertiary colors with white produce light tones.

Around the main central composition there are three groups of mixtures (**c**, **d**, and **e**). All of them have been mixed with varying amounts of the three primary colors. Group (**c**) contains flesh colors for painting flesh in light and in shadow. They are produced with a generous amount of white, a little red and yellow, and a dash of blue. In the strip of grays and bluish grays (**d**), blue is the predominant color. The earth colors (**e**) are mixed with more carmine and yellow than blue. White has been used to lighten and reveal the character of each different hue.

Central zone
a) *The colors that can be made out are light blue, dark blue, blue-violet, green, blue-green, yellow-green, red-violet, red, yellow, and orange.*

Outer zone
c) *flesh color, highlighted and in shadow;*
d) *grays and bluish grays;*
e) *earth colors.*

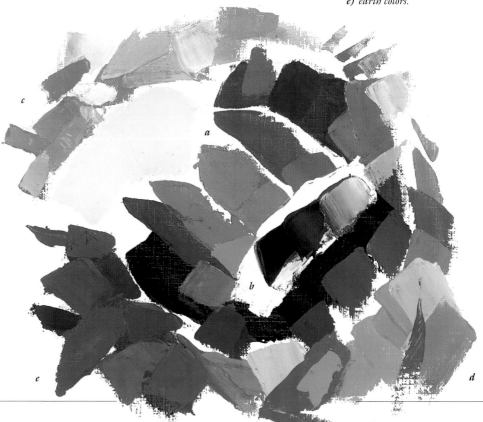

LIMITATIONS

There are certain colors that cannot be produced through mixtures of the three primary colors, but they can be purchased. Mixtures obtained from such concrete colors often possess some of the strongest chromatic qualities.

It is important to remember that all mixtures have a tendency to darken. A mixture between two colors, regardless of what they are, always darkens a light color, as it subtracts light from it; and if we add white to lend light to it, the color will take on a grayish appearance.

Also, it is very common to above all, ochre. Among the reds, it is important to have vermilion, a light red, a dark red, and some type of lake. To complete the selection of reds, a burnt sienna should also be included.

For artists with a taste for more modern colors, there is a wide range of purples and violets in acrylic from which to choose. Purple and violet allow the color range that runs from carmine to blue to be extended. Of the different blues, the painter usually has cerulean blue or turquoise blue, ultramarine blue, and a Prussian blue. With cobalt blue, it is possible to obtain highly luminous shadows. An emerald green and a light

CHOICE OF PRIMARY COLORS

It is always advisable to choose as primary colors those that are closest to those on the color wheel. If another red, another yellow, and another blue are used, the mixtures they produce when mixing secondary and tertiary colors will be marked by the chromatic qualities of those hues. Here we are making theory practical, and compromises are inevitable. Mixtures of any red, yellow, and blue will have a certain harmony and consistency within their own context.

CAUTION

It is important to get to know the properties of the colors of any particular palette or selection. It is not just a question of studying the visual characteristics of the color, you must observe them in practice: their tinting capacity, their possible dominance when used in mixtures with other colors, their drying time, their possible cracking and color loss once dry. To sum up, a suitable palette comes with trial and error. The ideal colors for your painting will be those that help you to mix the colors you are searching for.

COMPLEMENTARY QUALITY AMONG COLORS

It is important to pay special attention to the use of complementary colors, particularly if painting just with the primary colors or using complementary pairs to produce mixtures. Complementary colors neutralize intense hues and help create tones of browns and dark grays. Using complementary pairs rather than black for mixing dark colors lends a painting a harmonious overall feeling. Complementary pairs, used for mixing, do not dull color as black tends to do.

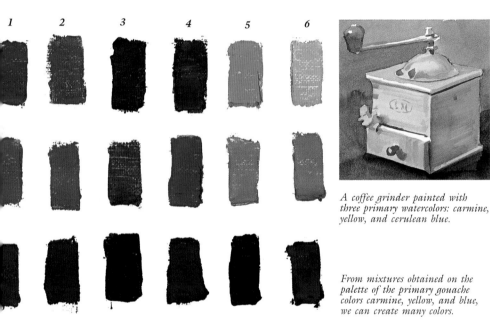

A coffee grinder painted with three primary watercolors: carmine, yellow, and cerulean blue.

From mixtures obtained on the palette of the primary gouache colors carmine, yellow, and blue, we can create many colors.

*Column **1** contains secondary colors; **3** and **5** contain the tertiary colors, created from lemon yellow, carmine, and Prussian blue. Column **2** contains secondary colors; **4** and **5** contain the tertiary colors, produced from medium yellow, cadmium red, and ultramarine blue.*

get caught up in the "gray trap" when painting with complementary colors. This may be further complicated when the painter begins solely with primary colors.

It is not unusual to start with a selection of several colors, among which are various colors from each group: yellows, reds, blues, greens, browns, white, and black. Yellow can be used in a wide range of hues: lemon yellow, a light yellow, a medium yellow, a dark yellow, an orange, and green are usually adequate for the greens. For the browns, the palette should include Van Dyke or burnt umber. When a manufactured black color is needed, smoke black or ivory black is a good choice. The first has a warmer tendency than the other. By using all the colors on the palette, it is possible to obtain an unlimited number of color blends.

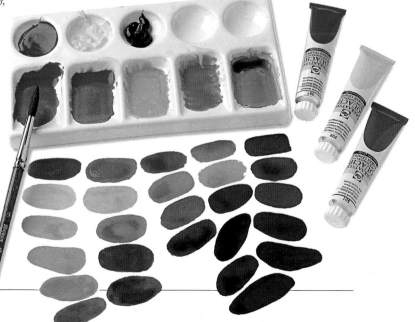

Mixtures with Yellows, Oranges, and Reds

Watercolor mixture. In this case, light yellow and red produce an orange color.

In order to work methodically with all the colors you have chosen, it is important to check the range of tones and hues that can be obtained with them. This chapter deals with yellows, oranges, reds, and their respective mixtures.

Yellow is the most luminous color of the spectrum. Red is an intense color. Its inclusion in mixtures made on the palette and its effective use in a composition requires a delicate touch. When various yellows, oranges, and reds are used, the possibilities for obtaining bright hues through mixtures are limitless.

COMMERCIALLY MANUFACTURED COLORS

Manufactured colors that are sold in tubes, jars, and pans come in standard colors. In addition, various brands market particular colors. The artist's choice of colors will, of course, depend on individual sensibility. It is important to develop an understanding of the chromatic characteristics of commercial colors. Even when the painter has a wide selection of colors from which to choose, there is usually the need to create colors that are not manufactured. This is when the artist can put into practice all the knowledge of color mixing gathered by the study of color theory, subtractive synthesis, complementaries, color harmony, contrasts, and so on.

RANGES OF OIL COLORS

By mixing the primary colors of yellow and red, a range of warm colors can be produced. By including other warm colors to create mixtures, the artist can produce a broad variety of warm hues. For example, with yellow and vermilion, the artist can produce an interesting orange range. If vermilion and carmine are mixed, several very intense reds are produced.

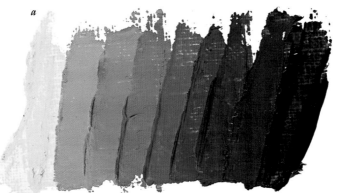

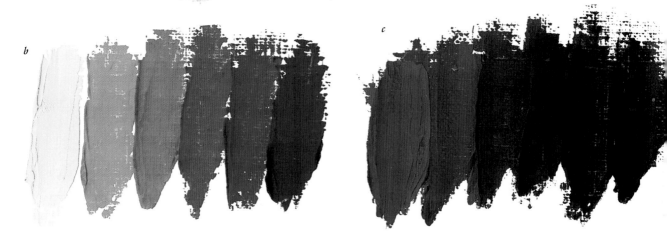

Having other colors on the palette besides the primary colors creates the potential for mixing these three oil color ranges. The second and the third represent a broadening of the first.
a Range produced from lemon yellow and carmine.
b Range produced from lemon yellow and cadmium red.
c Range produced from cadmium red and carmine.

THE DIFFERENCE IS IN THE YELLOW

The type of tone produced depends on the yellow used. The chromatic characteristics of a color affect the result when mixed with other colors. For example, compare the colors produced from blending lemon yellow oil paint with cadmium red, carmine, and white with the colors produced from blending medium yellow with these same colors. The first mixture produces a warm medium yellow, whereas the second mixture produces a cold lemony tone of lemon yellow.

THE DIFFERENCE IS IN THE RED

The following examples demonstrate the difference in hue produced by using two different reds. Note the effect of cadmium red and that of carmine when mixed with two yellows, lemon yellow and medium yellow. By adding a liberal amount of white to these mixtures, the artist can create various tones that can be used to paint very luminous flesh colors. The most significant differences between the two examples can be found in the orange, reddish, and pinkish tones they create. The inclusion of a variety of colors within hues enriches the subtle differences between tones.

PASTEL

There are many yellows, oranges, reds, and carmines available on the market. A standard color may vary slightly from one manufacturer to another. This gives the artist an even wider selection of colors from which to choose. The colors used here are light yellow, dark yellow, orange yellow, orange, permanent red (light and dark), geranium, scarlet, madder, and red verging on carmine. There are many more reds, including neutral and earth colors.

1 a

1 b

2 a

2 b

1. See the difference in hue produced by mixing two different yellows.
a Blends of lemon yellow with cadmium red, carmine, and white.
b Blends of medium yellow with cadmium red, carmine, and white.

2. Mixtures produced with cadmium red and carmine. In the two examples, both yellows lemon and medium have been used.
a Blending cadmium red with yellows. Cadmium red dominates; the tendency may be reddish, orange-colored, or yellowish.
b Blending madder with yellows. Carmine predominates; the tendency may be pinkish or carmine-colored.

NOTE

For acrylic and gouache, the mixing process is more or less the same as mixtures of yellows, reds, and carmines.

From the many available watercolor yellows, reds, and carmines, it is possible to obtain a limitless number of transparent mixtures. These can be mixed on the palette or directly on the paper by means of superimposing layers (using the wet-on-dry technique). Yellow ochre is a neutral color that is generally related to the group of yellows. The effects of mixing yellow ochre with other palette colors can be seen on pages 72 and 73.

Mixtures with Yellows, Greens, and Blues

By combining primary yellow and blue we can obtain a secondary green, yellow-greens, and tertiary blues. The mixing of yellow and blue with gradual changes in their proportions allows a greater number of blends with many more intermediate colors. If yellows and blues are combined, a wide range of greens can be produced. Furthermore, with manufactured greens, more colors are possible further still. Emerald green can be used to obtain many variations of green, which makes this color important to add to the palette. Certain green tinctures can also be added to the palette because they are now commercially manufactured. As a rule, they are made of synthetic pigments and, as such, are relatively new to the marketplace.

RANGE OF COLORS

An interesting exercise involves combining each color of the palette with each of the other palette colors. By experimenting with color mixtures in this way, the differences in hue qualities become evident.

In the example shown here, emerald green and medium green have been used to

3 a

YELLOWS, GREENS, AND BLUES

Blues are the coolest colors on the palette. Greens, colors that in addition to blue include yellow and perhaps ochre, can also be cool colors, although warmer than blues. The greater the amount of yellow added to green, the warmer its tendency. The range of colors that yellow and blue produces includes greenish yellows, yellow-green, greens, blue-greens, greenish blues, and blues. The chromatic qualities of each hue depend on the specific characteristics of the yellow, green, or blue used. For instance, a medium yellow does not produce the same result when mixed with emerald green as does lemon yellow. The results also change if these yellows are mixed with another green, such as a medium green. Study the examples on this page, which were mixed with lemon yellow and medium yellow, emerald green and medium green.

1 a

2

1 b

1. The potential of each oil mixture to create greens using yellows and greens or yellows and blues is demonstrated in the following examples:
a Mixtures of greens and lemon yellow. Some have had white added to them. The dominant tendency is cool.
b In this composition, medium yellow has been combined with several greens and some whites. The dominant tendency is warm.

2. Three different blue oil hues are mixed with medium yellow. All of the greens have a golden, even neutral tendency. The reason for this is that medium yellow is a yellow slightly tinted with red, so the three primary colors are present, giving the mixed color a slightly neutral cast.

create two ranges. Both have been mixed with all the other palette colors; most of the colors produced are other greens. There are also very dark, almost black hues produced that display the complementary or chromatic black quality that complementary pairs tend to mix. By studying both ranges, it becomes evident that each green allows a concrete line of greens to be produced.

3. The complementary colors have been added to these greens to neutralize the hue and create darks or blacks. These complementary mixtures have been produced with greens mixed with carmine.
a Range with medium green.
b Range with emerald green.

WATERCOLOR

The two main watercolor techniques are wet on wet and wet on dry. By using varying amounts of water, added to the pigment in order to produce a wash, a wide range of tones can be produced from one color. When this type of mixing technique is applied to mixtures of yellows, greens, and blues, working wet on wet, the artist can obtain multiple distinct greens. With the wet-on-dry

technique, the superimposing of layers of transparent color creates green hues. The luminous quality of the resulting color depends on painting the first layer light—that is, yellow.

OIL

Study the adjacent examples. On mixing yellow and turquoise blue together, a range of greens is produced. Now, by mixing yellow and medium green, yellow and emerald green, medium green and turquoise blue, medium green and ultramarine blue, emerald green and turquoise blue, emerald green and ultramarine blue, turquoise blue and ultramarine blue, the tones and possibilities are multiplied. Similar ranges can be produced with acrylic paint and with gouache.

Range of oil greens that are produced by mixing yellow with primary blues.

The greens obtained by mixing lemon yellow with three different blues (cobalt blue, ultramarine blue, and Prussian blue) have a cool cast.

4. Mixtures produced with manufactured colors.
a These greens are the result of mixing emerald green and medium green with white, in varying amounts.
b These blue-greens are produced by blending emerald green and medium green with cobalt, ultramarine, and Prussian blues, adding white as needed.

PASTEL

The limitations inherent in mixing pastels means the artist must rely on a wide variety of premixed sticks of different colors and hues. A pastel color chart shows the many hues available for purchase. Also, colors from among the various high-quality brands increases the possibilities.

To start, there are the lemon yellows and light yellows, each with different tones and shades, to which bluish greens, light greens, moss greens, earth greens, pale greens, cool greens, permanent green (light and dark), phthalo green, Verona green, and turquoise green can be added. Some greens, such as olive green, gray green, chrome oxide green, and Bohemian green, are neutral colors.

Mixtures with Reds, Purples, Violets, and Blues

From red and from the primary blues, the secondary dark blue and the tertiary colors carmine red and violet can be produced. By combining the two primary colors red and blue and varying their proportions in the mixtures, many colors between dark reds, purples, violets, and reddish blues can be produced. Also, if the artist decides to add any commercially manufactured red, purple, violet, or blue to the palette, the possibilities of creating a color from within the violet-red range are further varied.

OIL

The same procedure that allows the artist to make secondary and tertiary colors from primary colors can be used to produce mixtures with many more intermediate colors. If you use more colors than just the palette selection, your blends will contain many more tones. Different colors are produced, depending on the different reds or blues that are used to mix. Study the samples in oil (**1, 2,** and **3**) that are reproduced on this page, mixed from carmine with Prussian blue, ultramarine blue, and cobalt blue. Each mixture is distinct. On the facing page, example **5** illustrates the influence of cadmium red and **6** the mixture produced with manufactured violet.

3. Purples and violets that are produced from a mixture of cobalt blue with carmine. A touch of white can be added to these mixtures to lighten the tones.
a The inclusion of carmine is minimal.
b The amount of carmine is increased.
c The inclusion of blue is minimal.

COMPLEMENTARY MIXTURES

Complementary pairs are mixed to create the ranges shown in **4** (**a** and **b**). The first is produced with a mixture, in equal parts, of dark red with various manufactured blues and the second a mixture of madder with the same blues. As you can see, the blends produced with carmine are even blacker than those done with dark red. Each blue and each red, in equal parts, displays differing degrees of color negation, the neutral, dark quality produced by mixing complementary pairs.

1. Purples and violets that are produced from a mixture of carmine with ultramarine blue.
a The inclusion of carmine is minimal.
b The amount of carmine is increased.
c Carmine appears slightly darkened with ultramarine blue. A touch of white can be added to these mixtures in order to lighten the tones.

2. Purples and violets that are produced from a mixture of carmine with Prussian blue.
a The inclusion of carmine is minimal.
b The amount of carmine is increased.
c Carmine appears slightly darkened with Prussian blue. A touch of white can be added to these mixtures in order to lighten the tones.

4a

4b

4. *Note the complementary mixtures of these colors.*
The blending of cadmium red with cobalt, ultramarine, and Prussian blues demonstrates how to produce very dark colors.
When the same procedure is followed using madder, the mixtures produced with the same blues are even blacker.

6

5

5. Here are some of the mixtures that can be produced by mixing cadmium red with cobalt, ultramarine, and Prussian blues and some white.

6. The inclusion of a manufactured intense violet broadens the color-mixing possibilities, here producing tones of purples and violets.

Intense pastel colors: red-violets, purples, blue-violets, dark violet, Mars violet, ultramarine blue light, cobalt blue, and phthalo blue.

WATERCOLOR

With watercolor, two basic techniques are used: wet on wet and wet on dry. Mixtures can be produced directly on wet or can be superimposed in layers, wet on dry.

Commercially manufactured colors, such as certain violets, create even, homogenous washes, because the color does not separate. Mixtures of two or more colors produce results that vary from homogenous to multicolored.

PASTEL

Pastel mixtures usually produce limited results. For this reason, manufacturers produce a wide range of different colors and tones. A color chart makes it easy to locate the various hues of purples, violets, and blues.

All these colors have a dark tone that has been obtained by adding black pigment to the violet or blue hue. Usually, each intense color has two or three lighter tones. Each light tone is created by adding different amounts of white to the intense color.

All manufacturers sell, in addition to the standard colors, several colors unique to their product. Most often an artist uses pastels from a range of manufacturers in order to have a wider variety of colors. The following are standard colors of red-violets and blues: red-violet, blue-violet, dark violet, Mars violet, light ultramarine blue, ultramarine blue deep, cobalt blue, Prussian blue, and phthalo blue.

NOTE

The color ranges that can be obtained from acrylic and gouache depend on color mixing to a great degree, unlike those obtained from pastel.

Mixtures to Produce Neutral Colors

Using any of the different media discussed, it is possible to create a range of neutral, sometimes called broken, colors by mixing the three primary colors together in varying proportions. The secret to mixing strong, clean neutral colors is to use unequal parts. In order to obtain neutral colors between pairs of complementary colors, the artist should mix the colors in varying amounts. The more uneven the parts, the more brown or earthy the color appears.

HOW TO CREATE NEUTRAL COLORS

In every range of manufactured colors, there are a number of colors that are unmistakably neutral. The oil color yellow ochre is one such example. A blend made by adding one of these neutral colors to a pure color produces another neutral color; thereby extending the range of possibilities.

When using opaque media, you can add some white to these mixtures to obtain lighter tones.

There is an explanation on page 55 concerning how earth colors can be produced

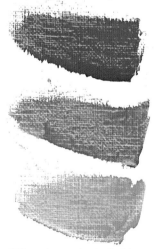

Yellow ochre earth mixed with varying amounts of white creates a gradation of this rich, creamy color.

with the three primary colors. There is also a series of mixtures between secondary and tertiary colors that produces neutral colors, in ad-

dition to the mixtures for an ochre, a sienna, and an umber, which are also obtained from the primary oil colors.

NEUTRAL COLORS PRODUCED FROM A PAIR OF COMPLEMENTARY COLORS

The standard way to produce neutral colors is to mix a pair of complementary colors together. Therefore, it is best to find the pair of manufactured colors that work in a complementary balance. Carmine and green as well as other reds and greens work as complementary pairs. Yellow and intense blue produce very dark greens. The redder the yellow when mixed in equal parts with blue, the darker the resulting green. Red and blue work as complementary pairs to mix neutral colors. The following colors also work as complementaries: orange and violet-blue, yellow-green and violet, and blue-green and carmine red.

NEUTRAL PALETTE COLORS

Manufactured neutral colors for the palette are mainly earth colors. They are usually grouped together as ochres, reddish earth colors, and browns. The dominant part of the reddish earth colors is red, whereas that of dark colors is a somber but warmish gray. There are several commercially manufactured

neutral colors, including greenish hues and the chromatic grays.

Every earth color has its own particular use in mixtures. In general, small amounts of neutral colors are added to pure colors to make the hue less intense, because too much intense color tends to overwhelm a composition.

OCHRES

The dominant color in ochre is yellow. Ochre can be obtained by mixing mostly yellow with some red and a touch of blue. The proportion of each depends on the

colors used in your mixture. The quality of your mixture—whether lemon, golden, orange-toned or burnt—depends on the chromatic qualities in the hues that are used to create it.

OIL, ACRYLIC, AND GOUCHE

Given that color mixtures produced with oil, acrylic, and gouache are similar, oil paint mixtures are normally used as a reference point. Refer to the examples of mixtures in illustrations **1**, **2**, and **3** to see the colors that can be obtained from yellow ochre earth. In example (**1**), the mixtures are produced with the warm colors, lemon yellow, light yellow, cadmium red, carmine red, and burnt sienna.

The second example (**2**) shows the result of combining ochre with different greens—here, emerald green and medium green. The mixtures are produced with thorough blending, and white has been added to some colors to produce a lighter tone.

*1. Color composition in oil paint based on yellow ochre. The ochre is lightened with lemon yellow and medium yellow (**a** and **b**). It is toned up and down with red (**c**), carmine (**d**), burnt sienna (**e**), and adding white wherever desired.*

The third example (**3**) illustrates the degree to which ochre complements intense blues: cobalt blue, ultramarine blue, and Prussian blue. Yellow ochre is a golden yellow, slightly grayish; by mixing ochre with the blues, bluish or greenish grays and browns are produced. The chromatic radiance of these mixtures is highlighted by adding white as needed.

a golden and neutral characteristic to the mixtures to which it is added. Watercolors provide a useful demonstration of the effect of yellow ochre in blends with other colors. Note in the example pictured the result of directly applied hues. Notice, too, the effect of the light green hue when it is painted in superimposed layers, wet on dry, over each of the three yellows.

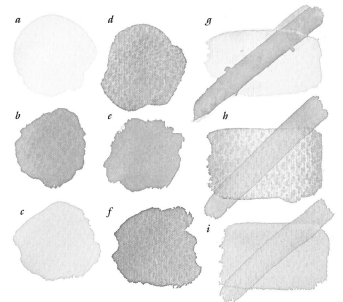

USING YELLOW OCHRE AS YELLOW

The strong luminosity of yellow and even yellow ochre is obvious. Yellow ochre lends

*2. Mixing yellow ochre with medium green (**a**) and emerald green (**b**).*

*When light yellow watercolor paints (**a**) and yellow-green (**b**) are mixed wet, they create an even lighter yellow-green (**c**), whereas with yellow ochre (**d**) and yellow-green (**e**), the result is a neutral green (**f**). The right-hand column of color areas are also mixed with watercolor paints, but this time by means of superimposing layers of color, wet on dry. In (**g**), the yellow-green is painted over yellow. In (**h**), yellow-green is painted over ochre. In (**i**), yellow-green is applied over a mixture of lightened ochre with yellow.*

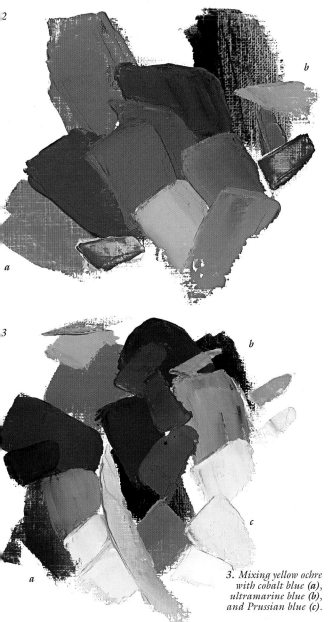

*3. Mixing yellow ochre with cobalt blue (**a**), ultramarine blue (**b**), and Prussian blue (**c**).*

OCHRES IN PASTEL

Again, the limited potential of pastel mixtures will necessitate the use of sticks of different tones and colors. All the possible shades of ochre available in pastel can be found in the color charts that accompany manufacturers' sets. The differences in tone and hue are striking. The following are some ochre tones that can be purchased: yellow ochre, golden ochre, flesh ochre, orange ochre, burnt ochre light, burnt ochre, olive ochre (light and dark), and brown ochre. Different brands of ochres have subtle differences in hue. By using different brands of colors, the artist can widen the tonal possibilities.

There are several types of ochre pastel colors available on the market.
a An opaque patch of golden ochre and a more tenuous stroke.
b Using burnt ochre in the same manner. An opaque color contrasted next to a transparent stroke.
c Olive ochre is another hue. It, too, has been applied opaque and also as a transparent stroke.

RED EARTH COLORS

By mixing yellow and carmine in roughly equal quantities and adding a touch of blue, an artist can produce a reddish earth color. Depending on the characteristics of the yellow, the red, and the blue, the neutral color will possess a reddish, burnt, or wine color cast. Furthermore, when using an opaque media (oil, acrylic, or gouache), an artist can produce many other tones by adding white. When using watercolors and the wet-on-dry technique, the colors of the layers required to produce the right neutral tone must be used. When using the wet-on-wet technique, the colors can be combined directly as the artist paints to produce, say, a burnt earth color.

BURNT SIENNA OIL PAINT

When mixed with other warm colors—such as yellows, ochres, and reds—a burnt sienna oil paint will produce any number of neutral colors. It is useful for "breaking" pure reds, darkening ochres, and creating exquisite chocolate and slate-toned colors. Burnt sienna can be used to produce a wide tonal

range when mixed with white.

Sienna works as a complementary color with cool greens, emerald green, and medium green, and cobalt blues, ultramarine blue, and Prussian blue. A wide range of tones can be produced by adding white.

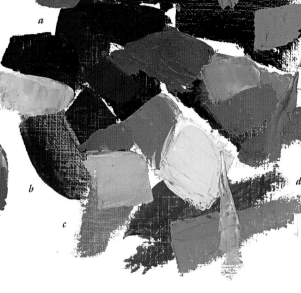

*When burnt sienna (**a**) is mixed with medium greens (**b**) and emerald green (**c**) and with cobalt blue (**d**), ultramarine blue (**e**), and Prussian blue (**f**), colors are broken. Note the browns and very dark grays that these mixtures produce, and how by adding white it is possible to obtain lighter tones.*

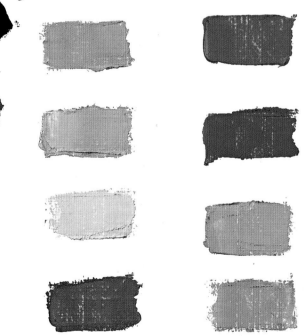

Oil paint mixtures for creating very light neutral colors with a warm tendency, in which raw sienna and burnt sienna are predominant.

In these oil mixtures, the use of sienna is important, regardless of whether it is used to break certain pure reds or to darken them, tone down ochres, or obtain chocolate and slate-tone colors.

BURNT SIENNA WATERCOLOR PAINT

The characteristics of burnt sienna can also be studied with watercolor paint. Luminous hues and tones can be produced by painting burnt sienna over yellow, yellow ochre, dark red, and carmine, applying the paint wet on dry. It is important to keep in mind that the effect of the glaze is more luminous when the underlying color is lighter.

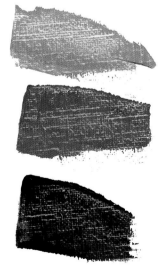

Burnt sienna oil paint produces a wide tonal range when mixed with white.

RED EARTH PASTEL COLORS

A commercial color chart can help the artist to find the following colors: bistre, umber, ochre brown, burnt ochre, raw sienna, English red, red iron oxide (light and dark), green burnt earth, Indian red, or their equivalents.

BROWNS

Brown is produced by mixing carmine red and blue in equal parts with a little yellow. The red and blue complementary colors, blended in equal parts, produce a very dark color; the yellow barely lightens it, producing a very dark, almost black warm variant. A color as dark as this is used to shade with and is combined with other colors to make tones.

Various earth colors are reproduced on pages 30 and 31. These colors present different aspects in each medium. In general, every brown has its own specific chromatic qualities. When a brown is mixed with another color, the final result is influenced by the characteristics particular to that brown. Brown comes in handy for toning other colors on the palette. When added sparingly, it is very effective as a tinting and darkening agent.

Many artists, especially oil painters, do without the color black in their mixtures because it tends to overwhelm color. Instead, umber combined with carmine and blue or carmine and green produces chromatically mixed blacks.

BURNT UMBER

A wide range of tonal mixtures can be produced with burnt umber and white. In the range pictured on the facing page are mixtures that have been produced using burnt umber oil paint and an equal amount of another color. The colors used in the first column **(a)**, bottom to top, are cadmium lemon yellow, medium yellow, yellow ochre, burnt sienna, cadmium red, and madder. All these colors can be classified as warm earth colors.

A second series **(b)** shows the results, following the same procedure, this time mixing raw umber (bottom) with emerald green, medium green, cobalt blue, ultramarine blue, and Prussian blue. With the exception of cobalt blue, which produces a somewhat warmer color, all the others are very dark, almost black, and cool.

Burnt umber mixed with yellow and other earth colors can produce any number of colors.

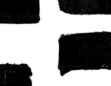

Burnt umber oil color allows earth colors to be shaded.

Mixtures of burnt umber creating transparencies with burnt sienna.

The tonal range with burnt umber oil paint can be very wide when combined with white.

*Range obtained by mixing burnt umber oil paint in equal parts, respectively, from bottom to top, with cadmium lemon yellow, medium yellow, yellow ochre, burnt sienna, cadmium red, and madder **(a)**, and emerald green, medium green, cobalt blue, ultramarine blue, and Prussian blue **(b)**. These examples show the darkening capacity of burnt umber.*

BROWN PASTEL COLORS

It is easy to find browns on a color chart, because they tend to be dark colors. In virtually all pastel brands, ranging from hard to medium to soft pastels, there is usually a wide assortment of browns. The most important are green umber, raw umber, burnt umber, Van Dyck brown, and light and dark sepia.

Mixing sepia brown and burnt umber in pastel. Note the area where the two colors blend.

Lightening and Darkening a Color

Lightening and darkening is a fundamental part of the mixing process. For any illuminated object, coloration appears as a gradation. From the most intensely illuminated area to the darkest, numerous tones and values of one local color appear on the object's surface.

In order to paint a subject with opaque media, just as it is perceived in nature, an artist may need to lighten or darken a color. White is not the only color used to lighten or brighten color; yellows, reds, and other neutral colors can also be used. In the same way, black is not the only color used for darkening; blues, browns, and complementary grays all create tones to lend realistic volume to an object.

ARRANGING THE COLORS

An organized palette, one on which the colors are systematically arranged, lend order to mixing. Oils, watercolors, and gouache are arranged on the palette. The color sticks of pastels are placed in a prearranged order. Regardless of the medium, every artist has an individual way of arranging his colors.

Keeping colors in a set order helps an artist find them easily while working. There is no one way to arrange the colors, but there are several obvious ways to group them. The warm colors can be separated from the cool ones, with warms and cools arranged according to their intensity. Earth colors can be kept in a separate area or included in the group they most correspond to.

LIGHTENING WITH WHITE, DARKENING WITH BLACK

In the sections on creating tones with white (page 60) and darkening tones with black (page 62), the process for creating a tonal range of a color using black and white is explained. Putting this theory into practice, however, reveals a number of limitations. An example in oil illustrates this

A paper bag painted with oils using a lemon yellow hue lightened with white and darkened with black.

point perfectly: The subject reproduced on this page is a yellow paper bag. White mixed with yellow does not reproduce the color of the highlights on the bag. In addition, black added to yellow, even sparingly, makes it turn green. The result is a muddy yellow, which in no way reproduces the colors in the photograph of the bag.

ANOTHER OPTION: RELATED COLORS

Another way to lighten or darken a color is through the use of related colors. Study the two representations of the jar of red paint, which are painted in oil, and compare the effect of lightening and darkening a color with related colors.

*1. Representation of the jar of red paint using a tonal range produced with carmine, white, and black (**a**) for the jar, and another range of tones in which three colors are used (**b**) for the lid.*

1

a

b

Tonal range of yellow: lightened with white it becomes cool and unnatural; darkened with black it turns greenish.

In the first representation, range was produced by lightening carmine with white and darkening it with black. The range used to paint the jar's lid is made up of three colors. In the second representation, the vermilion of the jar was lightened with yellow and white and darkened with black. The lid was painted with blends of carmine, blue, and white. The difference is obvious. In one version, the colors appear grayish and somber, whereas in the other, the colors are much closer to that of the real life image.

Model of the jar of red paint.

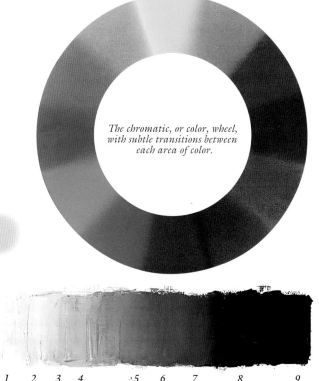

The chromatic, or color, wheel, with subtle transitions between each area of color.

*2. Representation of the same jar, but here using tonal ranges: The jar is painted using a range mixed with yellow, red, carmine, blue, and white (**a**), and the lid is based on the same colors (**b**). The result is far more realistic, having used hues to lighten and darken in comparison with the first example, executed with black and white.*

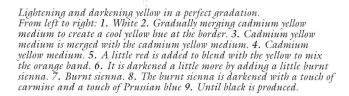

1 2 3 4 5 6 7 8 9

Lightening and darkening yellow in a perfect gradation.
*From left to right: **1.** White **2.** Gradually merging cadmium yellow medium to create a cool yellow hue at the border. **3.** Cadmium yellow medium is merged with the cadmium yellow medium. **4.** Cadmium yellow medium. **5.** A little red is added to blend with the yellow to mix the orange band. **6.** It is darkened a little more by adding a little burnt sienna. **7.** Burnt sienna. **8.** The burnt sienna is darkened with a touch of carmine and a touch of Prussian blue **9.** Until black is produced.*

GRADATIONS BY MEANS OF RELATED COLORS

When the colors of the spectrum are arranged in the form of a wheel, the borders of each area of color are easy to observe. Light blue is flanked by dark blue and blue-green. Violet is adjacent to cobalt blue. Green is wedged between blue-green and yellow-green; yellow, between greenish yellow and orange-yellow. Red is delineated by carmine red and orange-red and purple by purple-red and purple-violet. The boundaries between these colors must appear as blends of the corresponding gradations.

The following gradations are produced with the three primary colors, yellow, red, and blue.

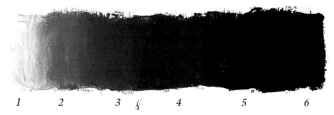

1 2 3 4 5 6

Lightening and darkening red in a perfect gradation.
*From left to right: **1.** White **2.** White with a touch of orange, as a mixture of red and yellow. **3.** By gradually diminishing the white, the color gradually acquires more warm red by mixing it with yellow, until a bright, balanced red is produced. **4.** Carmine is added to the red, blending the border between carmine and red. **5.** The carmine is darkened with Prussian blue. **6.** Until black is produced.*

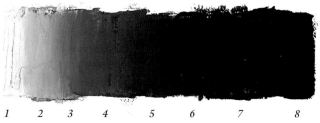

1 2 3 4 5 6 7 8

Lightening and darkening blue in a perfect gradation.
*From left to right: **1.** White **2.** To a mixture of white plus cobalt blue, a hint of lemon yellow is added, producing the greenish border of the light blue band. **3.** Cobalt blue with very little white. **4.** Cobalt blue. **5.** The cobalt blue is darkened with ultramarine blue. **6.** The ultramarine blue is darkened with a touch of Prussian blue. **7.** Some carmine is added to delineate the violet band from the dark blue. **8.** Until black is produced.*

HOW TO LIGHTEN AND DARKEN WITH RELATED COLORS

Within a group of related colors, there are the lighter ones and the darker ones. Every color belonging to a concrete group is related to all the other components of that group. For example, vermilion, red, is lighter than carmine, also red. Vermilion is therefore related to carmine, which is used to lighten it, and conversely, carmine is related to vermilion, which is used to darken it. But a warmer group may also lighten the color. To continue with the preceding example, yellows and oranges can be used to lighten the group of reds. White, an indispensable color, worked with opaque media in just the right amount, is used to adjust the hue to the correct tone.

Lighter colors related to a group of colors or a mixture of them can lighten a color from that group. When artists paint with opaque media, they usually add a touch of white to improve the final result of a light tone.

DARKENING A COLOR WITH MIXTURES

Within a single color group, any darker color can be used to darken a lighter color. Once the resources of a single group have been exhausted, an artist must resort to other colors to obtain the desired result.

In theory, in order to darken a color, all those colors that gradually cool it down should be used to darken it. Blue often appears in mixtures for shadows, because it is the cool color of the three primary colors. But blue is not the only color used for darkening; by combining blue with yellow, green is produced. So, in a mixture used to darken a color, all the colors that make up the color of the object itself should be used but in a darker tone. For example, the darkest color related to yellow is ochre, which already contains a little blue. As it gradually increases in darkness, an artist can add earth tones, in which the amounts of carmine and blue are ever greater.

To summarize, in order to darken a color, its complementary color must be added. Therefore, colors can be darkened in several ways. The choice of which one to use depends on the type of painting the artist wishes to achieve. The fauves, for example, based all their color mixing on complementary pairs in order to lend strength and luminosity to the shadows. The tonal painters, in their quest for perfectly representational gradations, painted their tonal transitions to dark without any abrupt transitions.

It is a question of color proximity, gradually adding colors or color mixtures that help darken it. Last, there is always a chromatically mixed black to depict the color in its darkest aspect.

With oils, in a mixture that includes carmine, burnt umber, and Prussian blue, the resulting mixture is cast toward the dominant color, which in this case is Prussian blue. The same thing happens in all mixtures, depending on the hues and quantities mixed.

WITH WATERCOLOR

Watercolor washes, which have transparent characteristics, may also be used to lighten or darken a color. White as a color does not exist in classical watercolor; in order to lighten a color directly, the artist must add related colors or mixtures. Likewise, in order to darken a color, the artist must add related colors or blends. The superimposing of layers of color, by means of the wet-on-dry technique, darkens a color, but if the underlying related color is lighter, it makes the visual mixture bright and luminous. A layer of watercolor can be darkened once it has had time to dry by painting a related darker color, or mixture, on top.

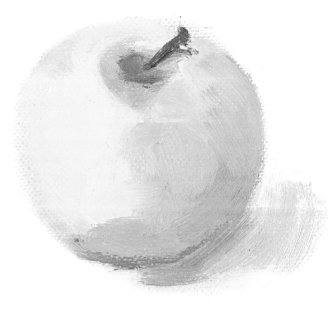

An apple painted in oil using white, yellows, ochre, and sienna. In a pinker hued apple, a touch of vermilion is added.

An orange painted in oil with white, yellows, red, and carmine. Blue is used in the shadow.

A tomato painted in oil with yellow, red, and carmine. White mixes with the other colors to create the highlights.

This lemon has a greenish cast. A touch of green was added to the lemon yellow in order to obtain this greenish aspect. But ochre is especially prevalent in the shadows.

WITH PASTEL

This medium has a wide a range of colors and tonal ranges to choose from. In box sets, the colors are normally arranged by tone. There are also sets available for specific purposes, such as for portraits and figures or for landscape and seascapes. There are also wider selections, such as the one sold by Sennelier, which contains 525 colors. For every intense tone, there is usually a dark tone, which is produced with black, and several lighter tones, which are produced with white. Brands usually sell the most important tones of each color. The volumetric representation that can be achieved by applying the right commercially manufactured colors allows for rich color interactions. The typical blending procedures used with pastel allow for perfect gradations, which convey very realistic darks or lights.

NOTE

Very dark colors, or at least black, are usually kept away from other colors. This is a precaution to avoid confusing it with other types of intense colors. In general, white is used in far greater amounts than any of the other colors.

Dark colors are applied in mixtures with vigorous strokes. The tinting capacity is very high; therefore, these colors must always be added little by little to the lighter color. Using the system of glazes, acrylic and oil can lighten and darken a color with a number of transparent layers of color that gradually take the color to its final result.

This color chart shows the various tones of pastel, of which the intense color, a dark color, and two lighter tones are provided. These tones and tints facilitate the lightening and darkening of pastel colors.

A plum always has very dark tones of purple and carmine. Ultramarine blue can be used to darken carmine, because it has a strong violet tendency.

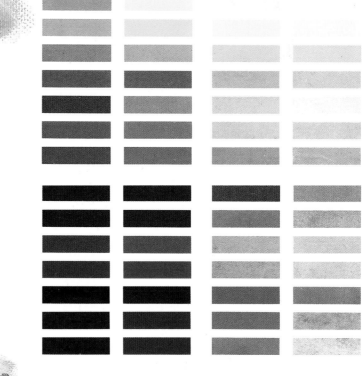

Terra-cotta can be reproduced nicely with a range of earth colors—that is, ochres and sienna. Very little umber is used, only enough to darken certain touches.

Warm Colors

Carmine, the various reds, oranges, yellows, all of the earth colors, and any mixture thereof are called warm colors. This section explores what is known as the temperature of color. There is a common denominator among these colors and their mixtures—red and yellow are used to produce them. Blue is used only minimally and is limited to neutral colors and violet-carmine.

On an orderly palette, warm commercially manufactured colors are grouped together. Any mixture produced with two or three of them gives rise to another warm color. The chromatic characteristics of each warm color produced in this way depend on the proportions of carmine, red, orange, yellow, ochre, or other earth tones used.

are associated with impressions of light and proximity. They transmit strength, creating a sensation of warmth and weight. The temperature of a color, in this case warm, suggests the sensation established by psychological association. The flames of a log fire, a blinding midday sun, the orange hues of certain sunsets, the impact of pinks on a spring day—these are just some examples of situations in which warm colors predominate. In all of these, light is the determining factor, the dominating aspect that produces the warm tendency.

WARM COLORS

In practice, each medium (oil, watercolor, acrylic, gouache, pastel, and so on) has a variety of commercially manufactured colors that could be included under this category. There are various yellows (lemon—light, me-dium, and dark—and other special ones), several reds (in two tones—light and dark—vermilion and lakes), carmines, ochres (golden or reddish), red earthen colors, and browns. In any medium, any mixture made from two or more warm colors produces another warm hue. The chromatic characteristics and hue of the mixture obtained depends on the colors from which it is made.

PSYCHOLOGICAL ASSOCIATIONS

Psychological associations with colors produce concrete sensations. Thus, warm colors

A neutral color in oil. This reddish earth tone is the result of mixing dark madder with cobalt blue in equal proportions and adding some ochre.

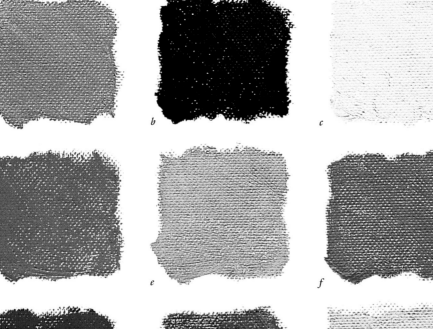

Samples of warm colors in oil:
a This ochre is obtained by mixing mostly yellow with some vermilion and a touch of turquoise. It is a neutral color.
b This earth tone is produced by mixing ochre with some white and a little light ultramarine blue. It is a neutral color.
c A cream color can be produced by mixing abundant yellow with some white and a touch of orange.
d Mixing a lot of vermilion and a little yellow produces orange.
e Indian yellow can be produced by adding some orange to medium yellow.
f This mauve color is the result of mixing madder, white, and some ochre.
g Some carmine can be added to vermilion to produce a dark red.
h Vermilion can be darkened with a little emerald green, producing a warm neutral color.
i An acid green such as this can be produced by mixing light green with some yellow and white.

COLOR AND TEMPERATURE

A color should always be regarded in relation to others. Thus, within the group of warm colors, some are warmer than others. The strongest are those that approach red, whereas the most brilliant are those with more yellow. When producing a color for an object that should be treated with warm commercially manufactured colors, the tone must be lightened or darkened. With media in which white is used to create tonal mixtures—such as oil, acrylic, and gouache—the effect is that the resulting color of such mixtures becomes duller and cooler. Standard colors that already contain white, such as dark or light Naples yellow or reddish colors, have a somewhat gray and dull cast. They are used primarily to obtain flesh tones.

LIMITS OF THE COLOR RANGE

Red, orange, yellow, green, blue, and violet are the colors that make up the white light spectrum. Red, orange, and yellow are the warm colors. Green tends to be warm until it becomes blue-green. Violet tends to be warm until it approaches blue, becoming blue-violet. The violet colors are the coolest limit of the warm colors, verging on blue.

NEUTRAL COLORS WITH A WARM TENDENCY

Standard neutral palette colors are ochres, reddish earthen colors, and browns. There are several commercially manufactured ochres available. Yellow ochre is the most common, but there are also golden, reddish, and brownish ochres. Some brands for oil, acrylic, and gouache offer a flesh ochre as well. In the case of pastel, ochres of different hues are available: yellowish, golden, flesh, orangey, light burnt ochre, light olive, dark olive,

and brown ochres. Of these, there is always an intense or saturated color, a dark tone, and several light ones.

There are a series of colors that, although they are red, show a tendency toward earth tones. These are English red and violet English red, both available in oil. For watercolor, reds related to earth tones would be English red and brown madder.

Other earth colors besides ochre are sienna, burnt sienna, (light or dark) iron oxide red, sepia, umber and burnt umber, and the browns, among which the most well-known is Van Dyke brown. These earth colors can be grouped into two categories: a very light one tending toward red and the other including very dark browns that are nearly black but have a warm note.

An earth color can also display a greenish hue. Some greenish earth colors are very dark, but when they are compared with the cool colors, they reveal their tendency toward warm. For example, green burnt umber is warmer than olive green.

NOTE
There are many commercially manufactured warm colors. All mixtures made from these colors lead to other warm colors. All mixtures take on tonal characteristics of the colors that make it up, more or less, depending on the amounts mixed. Adding white to any warm pure color or mixture has a double effect—on the one hand, it lightens it; on the other, it makes it grayer and duller. The use of white in lightening tones, necessary in oil, acrylic, and gouache, also causes the resulting mixture to become cooler.

Samples of warm colors in watercolor:
a This yellow is produced from 95% yellow and 5% carmine.
b A reddish ochre results from mixing three parts yellow to one part burnt umber. It is a neutral color.
c To produce this orange, 70% yellow was mixed with 30% vermilion.
d A red like this is produced by mixing equal proportions of yellow and carmine.
e To darken carmine and obtain a light garnet, simply add some ultramarine blue.
f A reddish ochre can be produced from equal amounts of yellow and burnt sienna. This is also a neutral color.
g This neutral green is made from equal amounts of yellow and burnt sienna, with the addition of a little emerald green.
h To darken burnt sienna, simply add some cerulean blue, which produces another neutral color.
i This olive green, a neutral color, is produced from 50% yellow, 20% carmine, and 30% emerald green.
j This other neutral light green is made by mixing about 90% yellow with 8% cerulean blue and 2% burnt sienna.

Cool Colors

The coolest colors of a palette are the blues, blue-violets, and blue-greens. In theory, green is basically made up of yellow and blue. The less yellow involved, the cooler the resulting color. Primary red added to primary blue produces intense violet-blues. The less red used, the cooler the violet is. Yellow-greens and red-violets can be considered the warmest of the cool colors or the coolest of the warm colors.

In practice, pigments with the same name vary from brand to brand. An artist should keep this in mind, because the characteristics of each blue or green can vary depending on the oxides or pigments that the paint contains.

Samples of cool colors in oil:
a A light turquoise is the result of adding white to turquoise and blending it with a little emerald green.
b A light gray such as this is the result of mixing a light ultramarine with some ochre and a good deal of white.
c This violet is obtained from madder, ultramarine blue, and white.
d A light blue results from adding white to cobalt blue.
e This dark violet is produced by mixing cobalt blue and carmine.
f This blue is made by mixing turquoise with light ultramarine.
g This blue is the result of mixing ultramarine blue and a touch of burnt umber.
h This green can be obtained by mixing turquoise with some yellow and a lot of white.
i This grayish green contains a mixture of cobalt blue, a touch of umber, and some white.

COMMERCIALLY MANU-FACTURED COOL COLORS

Different hues of blues and greens can be found in each medium, ranging from primary colors to neutral ones. Concentrating on those most commonly used in oil, acrylic and gouache, there are several blues available in different tones. In pastel, these hues are already mixed with white. Some blues in watercolor, for example, light and cerulean blues, also contain white pigment, although it is transparent. Classic blues are cobalt, turquoise, ultramarine, and Prussian blues. Each of these blues has its own unique character. In turquoise, for example, it is greenish; in ultramarine, violet.

Among commercially manufactured greens are emerald, cobalt, chrome, and phthalo greens. They often come in light, medium and intense tones. Some standard greens are less common, such as yellow-green, cinnabar green, sap green, and olive green.

PSYCHOLOGICAL ASSOCIATIONS

Blue colors are associated with the sensations of cold and distance. These colors are associated with lack of light, wintry atmospheres, cloudy skies, and nighttime. In the distance in a cold light, the atmosphere appears to have a generally bluish or violet tone, or perhaps a gray one. In landscapes, the presence of vegetation warrants the use of greens. In cool light, the greens tend toward greenish-blues. Though greens are warmer than blues, they move toward the cool end of the palette.

Many grays have a cool appearance, tending toward blue or green. Gray is also commonly associated with distance; rainy, misty landscapes; a lack of sun; and a dim, cloudy, silvery light.

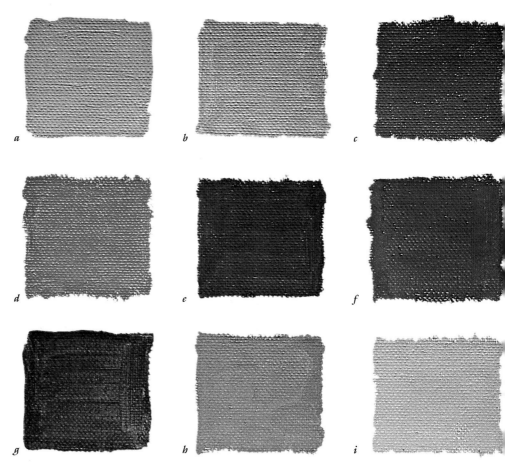

MIXTURES OF COOL COLORS

Any mixture of commercially manufactured cool colors produces other cool colors. Because of this, with a base of very few cool colors, a wide variety of cool hues can be produced. Mixtures made in the different media—oil, acrylic, watercolor, and gouache—display the color characteristics derived from those standard colors used to produce them.

NEUTRAL COLORS WITH A COOL TENDENCY

A neutral color can be produced by mixing two complementary colors in very different proportions. To obtain opaque tones in oil, acrylic, and gouache, white is also necessary.

In other words, a neutral color can be obtained by mixing yellow, red, and blue in unequal proportions and adding white when necessary to produce lighter tones.

By mixing with complementary colors, a wide variety of grays can be produced. But the grays dealt with in this chapter are those with a cool tendency, all of those in which one or more cool colors predominate.

Neutral colors with a cool tendency and with violet-bluish, bluish, or greenish hues are readily found in rainy landscapes, particularly city-scapes, where there is a profusion of asphalt and concrete.

Cool, neutral colors are also present when there is a dim light source. The less light present, the greater the tendency toward blue and dark tones.

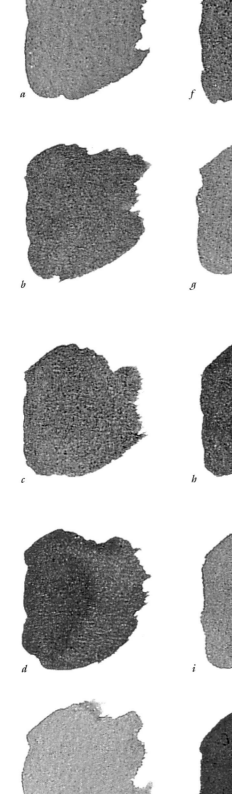

Samples of cool colors in watercolor:
a A sky blue made of mostly cerulean blue and a small amount of emerald green.
b This blue is produced by mixing cerulean blue and ultramarine.
c A greener blue is produced by mixing ultramarine with a lesser amount of emerald green.
d A purplish blue can be produced by mixing ultramarine with a little carmine.
e This neutral blue, very useful for painting horizons, is produced by neutralizing cerulean blue with a little burnt sienna.
f A bluish green can be produced by adding some ultramarine blue to emerald green.
g A lighter green is produced by adding some yellow to emerald green.
h This matte purple, a delicate neutral color, is a mixture of mostly ultramarine blue with some carmine and a touch of umber.
i This neutral green is produced from a lot of emerald green, somewhat less yellow, and a touch of burnt sienna.
j A jewel-like violet is produced by mixing ultramarine blue and carmine in equal proportions.

NOTE

To mix and produce neutral colors with clearly cool tendencies, complementary pairs can be used.

Because the mixture of equal proportions of yellow, red, and blue creates black or very close to it, the key to using complementary pairs to mix cool grays is to use unequal proportions.

To produce a cool color, a cool color must predominate in the mixture.

Harmonic Range of Warm Colors

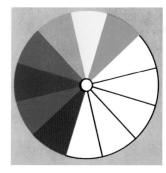

Theoretical color wheel representing the harmonic range of warm colors.

The artist's goal is to represent a chosen subject on canvas, paper, or panel using a harmonic range of colors to interpret that subject personally. Though a landscape has an objective physical color reality, the artist's sensibility demands a personal interpretation. The artist's own sensations and personal aesthetic is bound, therefore, to be expressed through choice and use of colors. All of these decisions are the result of the artist's personal use of the so-called harmonic ranges. The most complete harmonic ranges are those of the warm, cool, and neutral colors. The harmonic range of warm colors is explained in this chapter.

SUGGESTIVENESS OF THE SUBJECT

By simply looking around, one can discover many subjects that immediately suggest the selection of a warm color palette. For an artist, warm colors are those that allow the representation of a subject lit by a warm light, whether natural or artificial. There is a dominance of warm colors that is immediately evident in the subject.

In general, a painting does not necessarily reproduce the subject with total realism. Elements that are important to the artist will necessarily dominate and shape the painting. Warm and cool grays tend to emphasize and reveal intense color. Warm and cool contrasts produce chromatic effects.

CHOOSING THE DOMINANT COLOR

The color that is to dominate a work of art may be decided early on in the piece. This decision is based on the subject and the artist's interpretation of it. Supposing that the dominant color is orange, all the mixtures produced both on the palette and directly on the support will have an orange tendency. This tendency toward orange will characterize the picture and all mixtures will be oriented toward this specific dominant color.

A well-used palette of acrylic paint with mixtures that could be obtained within a warm harmonic range. Mostly warm colors are used; cool ones are only included in small quantities.

A series of colors applied on canvas-type paper with a brush or palette knife are shown here. Several oil colors are used. There are two yellows light and medium as well as cadmium red and madder. Also, some mixtures include white.
a Yellows mixed with white and a stroke of orange-yellow that is darkened with red.
b Orange colors produced from a mixture of yellows.
c Lemon yellow does not produce such warm colors.
d From dark yellow, reddish orange colors tend to be produced.

SELECTION OF COLORS IN PASTEL

All pastel colors showing a warm tendency constitute an ideal selection of colors for working in a warm harmonic range. The subject itself often suggests a color range. Pre-mixed sticks of colors mixed with white chalk in varying tones of each intense color and with black for darker tones, allow the artist to find all the tones needed.

USE OF COOL COLORS

Cool colors are usually compatible with a warm palette. Theoretically, yellow-green and red-violet are borderline cool colors. In practice, to produce violets and yellow-greens, blues or greens must be added. Commercially manufactured blues mixed with reds or carmines result in violets, whereas blues and greens mixed with yellows produce yellow-greens.

A more subtle color harmony would require including cool colors with warm colors, especially in order to change their hue or darken them. But, as previously mentioned, an interpretation seeking contrasts can juxtapose even highly complementary colors (which always consist of a cool color and a warm one).

The purples and violets are formed from mixtures of pink or madder, purple, and blues. The illustration shows some mixtures in which white is also used. Violets of a reddish or carmine tendency are basically used to tone down earth colors.

CONTRAST BETWEEN WARM AND COOL COLORS

In a painting based on a warm harmonic range, warm colors predominate. Any of the commercially manufactured warm colors and mixtures made from these serve to create this kind of range. In opaque media (oil, acrylic, and gouache), white can be used in mixtures to produce tones.

The predominance of warm colors does not preclude the use of standard or mixed cool colors, although these are included primarily to shift the hues of warm colors or to darken them. The contrast between a warm and cool juxtaposition of colors is one of the most beautiful color effects. The use, in effect, of the full spectrum of color—red, orange, yellow, green, blue, and violet, warms and cools—gives the color of a painting great richness.

The illustration of the color wheel on the previous page shows the colors that make up a warm harmonic range. Purples, violets, and yellow-greens appear as borderline colors; they are the coolest colors in a warm range.

THE EFFECTS OF CONTRAST AND INDUCTION

The search for the effective use of contrasts requires special attention to the use of complementary colors. This theme is discussed in the chapters on contrast, relating ranges of harmonic colors. If the maximum contrast occurs by juxtaposing complementary colors in their most intense tones, then a warm harmonic range with a dominant color tendency would obtain maximum contrast from the addition of the complementary of the dominant color.

NEUTRAL COLORS WITH A WARM TENDENCY

In addition to commercially manufactured warm earth colors (ochres, siennas, and umbers), all colors produced from mixtures with a warm tendency can also be considered warm neutral colors.

Olive green and cinnabar green, for example, are warm greens. Because of the complementary nature of carmines and greens, warm greens reduce the stridency of contrasts when painted next to any red.

Neutral violet colors are a good counterpoint for expressing a darkening of certain warm palettes. These violet colors can be produced from a good amount of red or carmine and a small amount of blue, in a mixture tending toward purple or violet. When toning down the result with a touch of any type of yellow, the basic result is a neutral violet color.

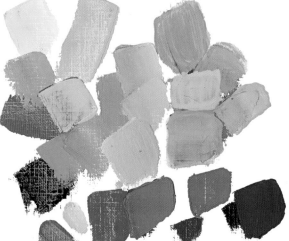

Cool colors can be used to tone down warm colors and darken them. These colors are present in the creation of yellow-greens and violets, which emphasize the warm tendency. Medium green and emerald green can be warmed by adding light, medium, and dark yellows and ochre. Adding a touch of red or carmine to a green mixture of this type as a complementary color leads to a precious neutral green, tending toward warm.

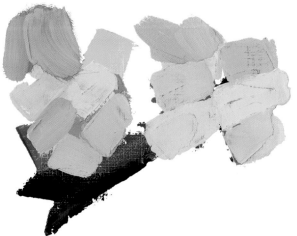

When cobalt blue, ultramarine blue, and Prussian blue are mixed with medium yellow in adequate proportions, additional greens that harmonize with a warm range are produced. To achieve this, a liberal amount of yellow and little blue must be used.

Areas of warm colors painted in watercolor. These would be ideal mixtures for working in a warm harmonic range.

Harmonic Range of Cool Colors

All the colors involved in a painting can be color related in a harmonious way through temperature, in this case the cool range. In theory, the cool harmonic range is made up of blues, blue-violets, greens and cool grays.

Any cool range, in practice, consists of mixtures of commercially manufactured cool colors. In media that can be opaque, mixtures can be made with or without white. Therefore, the dominant color tendency of a picture painted in a cool harmonic range can be bluish, blue-violet, greenish, or grayish.

BLUES AND GREENS

Standard cool colors include all the cool blues and greens. In any medium, a mixture made from such colors allows more cool colors to be produced: greenish blues, dark greens, and greens of all hues, depending on the color characteristics of each element of the mixture. The predominant color in absolute terms in these mixtures is blue.

LEMON YELLOW

The second color involved, although in a smaller proportion, is yellow. Theory states that any green is formed from blue and yellow. Even in yellow-greens, those colors made with more yellow than blue, the tendency is cool if the type of yellow used is cool. Lemon yellow, whose greenish tendency is quite evident, is the most unambiguously cool yellow. The rest of the yellow hues are warmer. In these colors, there is a greater or lesser degree of red involved, which is necessary to establish the warm or orange tendency of light, medium, and dark yellows.

Theoretic color wheel representing the harmonic range of cool colors.

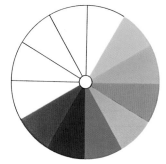

Oil mixtures of medium and emerald greens, with the addition of white.

When commercially manufactured greens and blues are mixed here in oil, additional greens and blue-greens are produced.

Palette with acrylic paints that have been mixed to create many hues obtained from cool colors.

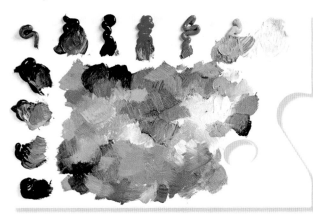

Here, three blues using oils, are mixed together. The colors used are cobalt blue, ultramarine blue, and Prussian blue. Some mixtures display a lighter tone if white is added.

WARM COLORS OF THE PALETTE

The study of how to use lemon yellow as the primary yellow of a palette with a cool harmonic range serves as an introduction to the possible relationship between warm colors and a cool palette. In general, the aim is to mix them with the appropriate colors in adequate proportions to produce harmonic colors with a generally cool tendency.

Carmines and reds can be mixed with blues to produce violets. The coolest version of each mixture is sought. Red-violets and yellow-greens are the warmest colors in a cool harmonic range.

When used as an opaque media in oil, acrylic, or gouache, white is also used in mixtures of complementary colors to obtain well-defined neutral colors. In general, these are dark mixtures that need white to lighten them and reveal their hue.

In oil, carmine can be mixed with blues cobalt, ultramarine and Prussian blue with the addition of white in order to produce lighter violet-blues.

Oil mixtures that require a delicate touch for using complementary colors are those that include blue, green, and carmine. Carmine must be added in minute quantities in order to produce grayish and defined tones. Take care when mixing complementary hues; too balanced a mixture will produce black or too dark a gray.

in mixtures with intense blues and the carmines in mixtures with intense greens.

In general, it suffices to mix highly complementary colors in different proportions, with the cool color predominating, in order to harmonize with the cool range.

To limit the effects of contrast, the color needs to be neutralized, or toned down. To do this, any mixture of direct or indirect complementary colors can be used. The complementary color must simply be added in a small amount. In general, it is enough to mix highly complementary colors in very different proportions to produce neutral colors with a warm or cool tendency.

CAUTION WITH COMPLEMENTARY COLORS

The mixture of two complementary colors in equal proportions produces black. To produce a harmonic range of cool colors, commercially manufactured greens and blues are mixed. The direct complementary color to intense blue is red; the opposite of green is carmine. The warm colors that should be treated with great caution are the reds

SELECTION OF COLORS IN PASTEL

Any set of colors in pastel includes blues, greens, and grays in all tones. The classical selection of several light tones for each intense color and at least one tone that is darkened with black simplifies the task of creating light and dark tones oneself.

Series of cool colors in watercolor. These mixtures are highly appropriate for working in a cool harmonic range.

THE COLOR WHITE

In all media that can be applied as opaque, light tones involve the color white. When added to warm colors, white lightens them while at the same time making them grayer. By adding white, warm mixtures and colors become somewhat cooler. On the other hand, when white is added to any cool color, the opposite effect is obtained. When the intensity of a cool color is dulled, comparatively speaking, the color becomes warmer.

NOTE

In a harmonic range of cool colors, the standard primary colors of a palette are the coolest blues and greens. All mixtures made from two or more of these colors also produce cool colors. To lighten these colors when they are used in an opaque manner, white can be added; the white will make the colors lighter, but at the same time grayer, making them lose some degree of coolness. Lemon yellow is commonly used in mixtures with blues or even greens in order to produce cool greens and make them brighter. All gray colors with a cool tendency harmonize perfectly with any cool range of colors.

Harmonic Range of Neutral Colors

The color of a work done basically in neutral colors displays a dull and grayish tendency. By definition, a gray color is produced by mixing two complementary colors. Using highly unequal proportions, the resulting mixtures are well-defined neutral colors. Therefore, gradually varying proportions of two specific complementary colors produces an ordered range or succession of colors.

The complete harmonic range of neutral colors is formed from mixtures of pairs of complementary colors. The selection of pairs of complementary colors depends on the subject to be painted.

3. Burnt sienna mixed with different blues and white produces a range of grays, blues, siennas, and greens. Note the harmony of the colors as a whole.

SELECTION OF PAIRS OF COMPLEMENTARY COLORS

To gain a sense of the types of ranges that can be produced from two complementary colors, observe the results obtained with carmine and green in illustrations **1a** and **1b**. When mixed in equal proportions, they produce black, which when lightened with white results in an extensive tonal range of neutral gray. With a predominance of carmine, the mix tends toward violet, whereas when more green is added, it tends toward blue. White can be added to any of the two mixtures to produce the tonal succession of each mixture.

STANDARD NEUTRAL COLORS AND OTHERS

Among the neutral colors of the palette, the group of earth colors has the widest range of hues. These include ochres, siennas, and umbers. Green neutral colors such as olive green and sap green also belong to this category.

English red and burgundy are standard colors that can be used to produce neutral colors of delicate hues.

Among the blues, the hues appear very different. When each is mixed with its most complementary yellow, ranges of neutral colors are produced. The subtle differences between the products of these mixtures depends on the chromatic characteristics of each blue and yellow used. As an example, see the colors in illustration **4**, showing the types of mixtures that can be obtained from colors of a single group. In this case, they are blues mixed with yellow ochre.

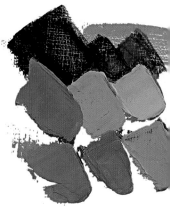

4. Ochre mixed with cobalt blue, ultramarine, and Prussian blue along with white produces lovely greenish and bluish grays.

ON PROPORTIONS

Mixtures between complementary colors tend toward black or very dark gray when similar proportions are used. In media that can be opaque, the addition of white allows tonal ranges of these grays to be produced. A painting may require very dark colors, in which case the amounts of each complementary color used for the mixure will be more or less the same.

But other subjects require mixtures of a more defined tendency, with clear hues of yellow, carmine, violet, blue, green, and brown. In these cases, the proportions of each

1. The two tendencies that can be used as a base, producing neutral colors from two complementary colors: carmine and emerald green, with the addition of white.
a) Abundant carmine is mixed with a small amount of green and some white is added.
b) Here a lot of green is mixed with little carmine and white is added after.

2. Mixtures with commercially manufactured neutral colors: yellow ochre and burnt sienna.
a) Yellow ochre mixed with blue produces another neutral color.
b) Burnt sienna mixed with green also produces a neutral color.

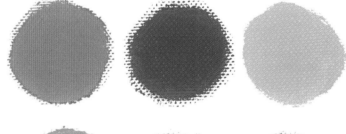

Oil painting of a box with candles. All of the mixtures involved here are neutral colors.

complementary color added to the mixture will be highly unequal (see illustration **5**).

5. *Mixture to obtain complementary colors that produce neutral colors when mixed. Emerald green and yellow are mixed to obtain a yellow-green (shown); carmine and blue produce a violet. Because violet and yellow-green are complementary colors, their mixture in unequal proportions with the addition of white produces two ranges of neutral colors, from greenish hues to violets.*

HARMONY

The harmony produced among neutral colors is very delicate. The subtlety between the different hues is achieved through a knowledgeable use of complementary colors. With neutral colors, contrasts are reduced. Most of the tones used are opaque, creating very fine hues through the addition of white.

The light tones of neutral colors are probably one of the most beautiful and visually harmonious ranges of colors. The effect of adding white here enriches the special, delicate nature of neutral colors. When working with neutral colors in pastel tones, a beautiful and rich color harmony of grays can be produced. On the following pages (90–95), the different possibilities of contrast are discussed. This theme must be related to the concept of harmony.

SELECTION OF COLORS IN PASTEL

The harmonic range of neutral colors is extensively represented in the color sets offered by major pastel brands. For more information, see the sections on warm (page 81) and cool (page 83) neutral colors.

For painting, it helps to arrange all these neutral colors according to their hue and tone, and the specific ranges suitable to the subject to be painted should be chosen.

WORKING WITH NEUTRAL COLORS

It is easy to produce a range of colors from a pair of complementary hues by progressively varying the amount of each color used, with or without the addition of white. But in practice, when painting a subject, the artist must choose the right pair or pairs of colors and so must be familiar with the commercially manufactured complementary colors available as well as with those that can act as complementary colors once mixed. In general, when two colors that could be complementary are mixed in equal proportions, a very dark color is produced. This useful test will indicate the degree to which the two colors are indeed complementary. It helps to remember that, using this color system, yellow and intense blue function as complementaries, as do red and blue and carmine and green. It is also very interesting to reduce any one color to its theoretical composition of primary colors.

Some samples of the neutral colors used to paint the box with candles.

NOTE

The harmonic range of neutral colors consists of all the neutral colors that can be mixed. In a neutral palette, the color harmony tends to be beautiful and delicate. A palette of neutral colors can display a clear tendency toward warm or cool colors.

Contrast

Contrast of color or tone can be observed between two colors (whether pure or mixed) when the colors are next to one another or when one surrounds the other on a support. In a painting, this type of relationship is established between all the colors appearing in it. When seen as a whole in a piece of work, the warm/cool contrasts and light/dark contrasts become clear and obvious.

Many color ranges can be established. In each case, the contrast by range depends on the general color value of each one and on the sensations produced by their juxtaposition. The difference between a warm and a cool range is easily distinguished and reaches maximum strength when complementary colors are seen in juxtaposition. The contrast, as you will see, diminishes with the use of more similar ranges. The most subtle and delicate contrasts can be produced between neutral colors.

CONTRAST BY TONE

When two areas are painted with the same color but in two different tones, the overall result is that the lighter tone appears even lighter next to the darker one. In a similar way, the dark tone appears darker next to the lighter one.

Illustration **1** shows the tonal contrast that can be seen between two consecutive values of a tonal range. Two tones with a greater tonal jump display a more evident contrast. Two consecutive tones are seen in the following manner: A lighter tone appears lighter when placed next to a darker tone and a darker tone appears darker next to a lighter one.

A sample of a smooth gradation avoiding tonal jumps (illustration **2**) allows the impact of contrasting tones to be seen by comparison.

Another sample can be made by surrounding one tone of a color with another tone of the same color. Observe the effect of the contrast (illustration **3**).

3. Simultaneous tonal contrasts: a) A light color appears lighter when surrounded by a darker one. The dark background appears lighter by contrast. b) A dark color appears darker when surrounded by a lighter one. The light background appears darker by contrast. Observe both small boxes at once. They are the same size, but the optical effect is that the darker one (below) appears smaller than the lighter one (above). This phenomenon should always be kept in mind, no matter which media is used.

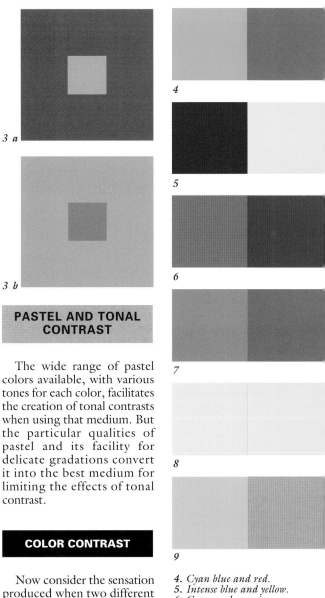

3 a

3 b

4

5

6

7

8

9

PASTEL AND TONAL CONTRAST

The wide range of pastel colors available, with various tones for each color, facilitates the creation of tonal contrasts when using that medium. But the particular qualities of pastel and its facility for delicate gradations convert it into the best medium for limiting the effects of tonal contrast.

COLOR CONTRAST

Now consider the sensation produced when two different colors are juxtaposed. Note the illustrations in **4, 5,** and **6**. Each of these complementary pairs produces a maximum contrast. Furthermore, a strong visual impact is

4. Cyan blue and red.
5. Intense blue and yellow.
6. Green and carmine.
7. Two indirect complementary colors orange and carmine violet.
8. A warm color (yellow) and a cool one (blue).
9. Two different greens one primary and the other neutral.

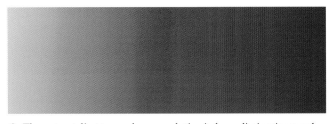

1. Tonal range of primary red. Contrast produced by juxtaposing two different tones of the same color.

2. The contrast disappears when a gradation is done, eliminating tonal jumps. Observe the difference in effect between the tonal range and the gradation.

produced between a warm color and a cool one. With more similar colors, the impression becomes softer (illustration **9**). The color contrast diminishes when two colors belonging to the same group are juxtaposed (illustration 7).

The effect when the intensity is at a maximum in both colors is different from the effect produced between two tonal values (illustration **8**). Two different factors act simultaneously, color and tone.

MAXIMUM CONTRAST BY COLOR AND TONE

When a color is surrounded by its complementary, the contrast reaches a maximum if both colors are saturated (see illustrations **10a** and **10b**). This type of contrast is produced between intense red and cyan blue, yellow and blue, and magenta and green. A violent contrast between complementary colors can be softened by reducing their intensity with a lighter tonal value of one or both colors. It could also be reduced by adding another hue to one or both of these colors.

REDUCING CONTRASTS IN PRACTICE

When two complementary colors are painted next to one another in their intense tones, the visual impact is enormous. The artist, depending on the desired effect, may wish to exaggerate or limit this effect.

To gain ease in using contrasts between complementary colors, it is best to know the pairs of complementary colors in each selection of commercially manufactured colors. To establish the pairs of complementary colors, it suffices to produce a mixture of equal proportions of red and light blue, yellow and intense blue, and green and carmine. Mixtures producing a darker color that is nearly black is a sign that the pair is complementary.

Other pairs to be contrasted are yellow-green and violet, blue-green and carmine red, and orange and violet-blue, although the contrast between these pairs is not maximum intensity.

The effect produced by two or more juxtaposed complementary, but toned down, colors is not as strong. An artist should seek out colors to soften the contrast. Take, for example, complementary green and carmine. If the green is to be modified, yellow or blue can be added. If the carmine is to be modified, yellow, red, or blue could be added. If both are to be modified, the rule is to add a touch of the same color to each, in this case blue to darken and yellow to lighten.

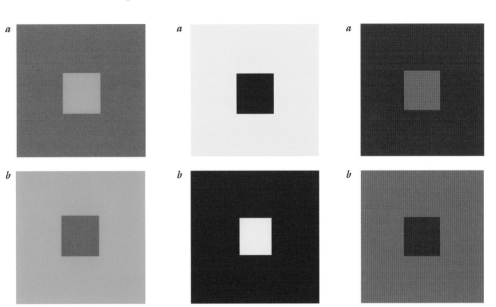

10. *Observe the small squares: Those with a warm color (row **b**) appear larger than those with cool colors (row **a**), although the real size is the same.*

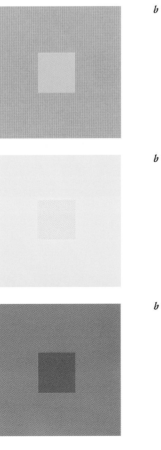

11. *If the level of saturation between indirect complementary colors is reduced the contrast diminishes. Nonetheless, the small square with a warm or light color (column **b**) continues to appear larger than the cooler or darker squares (column **a**), although they are both the same size in reality.*

MODERATE CONTRASTS

With colors that cannot be considered direct complementary colors, the contrast diminishes (illustrations in **11**). This occurs when a cool color is painted next to a non-complementary warm color.

The contrast between two warm colors, even intense tones, is moderate, as would be the case between a yellow and a red. The same would hold true for two cool colors, such as green and blue.

Within one color group, the closer the colors are to each other, the less contrast they produce; for example, there is little contrast between cobalt blue, ultramarine blue, and Prussian blue, only shifts in hue.

COLOR RANGE CONTRAST

A contrast of colors or tones can be observed between two colors (whether pure or mixed) that are painted next to one another or when one surrounds the other. In a painting, though, these relationships become complex and subtle and are established between all the colors present in the composition. When in the whole of a composition there are many colors with one tendency coexisting with others of another tendency, then it can be said that there is a general contrast of color ranges.

Many different color ranges can be defined. In each case, the contrast of color ranges depends on the general color value of each one and on the effects produced when they are juxtaposed. The difference between a cool range and a warm one is always obvious and reaches a maximum when two direct complementary colors are juxtaposed. The contrast diminishes with the use of more similar ranges.

CONTRAST BETWEEN WARM AND COOL RANGES

A work based on a harmonic range of warm colors uses cool colors or mixtures made from them to change the hues or darken the warm colors, or to produce contrasts that enrich the construction of form. Contrasts are greatest between direct complementary colors and softer when neutral colors are used. In a warm painting, warm colors predominate and cool colors stand out, providing great contrast.

Conversely, in a painting based on a harmonic range of cool colors, warm colors are used to add hue or introduce color contrasts by temperature. Cool colors predominate, but some warm colors may be used to provide variation to the general monotony of the palette. Contrasts are always less dramatic with mixtures produced with the basic colors of the painting, whether warm or cool predominates.

2

3

4

1

5

1. Contrast between a cool color range and a warm background, with juxtaposition of direct complementary colors.
2. Contrast between a warm range and a cool background, with juxtaposition of direct complementary colors.
3. A warm range with a cool background. Optically, the warm colors appear to expand. The lighter blue of this background changes the resulting effect of the contrast.
4. A cool range on a warm background. Optically, cool colors appear to contract.
5. Contrast between a warm range and a green background, a direct juxtaposition of complementary colors.

CONTRAST BETWEEN PRIMARY AND NEUTRAL COLORS

Another way of creating contrast between color ranges involves juxtaposing primary colors with those that appear neutral. There are many possible combinations. Contrast will always occur between a warm range and a cool neutral one, a cool range and a warm neutral one, a warm range and a neutral warm one, a cool range and a neutral cool one, and a neutral warm range and a neutral cool one.

CONTRAST BETWEEN SIMILAR RANGES

If a range is created of colors that are dominantly orange and another in which carmine is dominant, a contrast is produced, regardless of the medium or support used. Contrast is greater between intense colors and lesser between lighter colors.

A larger jump between colors, even when they are similar, produces a greater contrast, although the creation of tones always softens it. For example, when a range of greens and a range of blues coexist in a painting, there is a certain type of contrast. If, on the other hand, there are two ranges of blues, the impression produced by their contrast is different.

6 and 7. Samples of contrasts within a single warm range, making the importance of the background color evident.

8

6

9

7

10

Samples of contrasts that can be produced between:
8. a cool range with some warm neutral colors;
9. a predominantly cool range and a warmer neutral background;
10. a predominantly cool range and a range of warm neutral colors;
11. primary and neutral colors within a warm range.

11

SIMULTANEOUS CONTRASTS

When observing the color impact of a finished painting, the need for discussing simultaneous contrasts becomes important. As an introduction to this topic, the simplest and most obvious approach is to identify tonal and color contrasts. But complex painting techniques, whether in oil, acrylic, watercolor, gouache, or pastel make it clear that elements of contrast cannot always be isolated. In practice, contrasts that are produced by several factors at a time are constantly being created. The procedures for making gradations are different in each medium. The gradation of a color provides a perfectly ordered succession of tonal values without jumps. Contrasts within a gradation are a clear example of simultaneous contrasts.

TONAL CONTRASTS

By applying a brushstroke onto a graded background, it is possible to emphasize a tone (images in **1**). The tonal contrast between two isolated and concrete brushstrokes makes the lighter tone appear lighter next to the darker one and the darker one appear darker next to the lighter tone. If a brushstroke of a color is applied over a gradation of that same color, the same effect will occur, exaggerating the impact of applied tones. This is a tonal contrast. But the effects produced in a complex composition are the consequence of many simultaneous contrasts between tones in the areas where they meet in juxtaposition.

COLOR CONTRASTS

In a painting, a color applied in a brushstroke or line or as an area of color is not always surrounded by a single color. Contrasts between a brushstroke integrated among others of diverse colors are multiple and complex. The variety of tonal values must be added to the variety of colors as well. Simultaneous contrasts generally consist of those between colors and tones at the same time (images in **2**).

Observe the simultaneous contrast produced by applying a circular carmine gradation onto a gradation made of two colors (blue and white). A full effect of depth and volume is achieved (images **3** and **4**). Without these gradations, the shapes appear flat.

2. Examples of simultaneous contrasts between gradations of two tonal ranges, each one being a complementary pair: yellow and blue, green and carmine, and red and blue.

3. Surfaces colored in a flat manner.

4. The background is made up of a blue gradation with white, while the circular shape is made up of a carmine gradation, creating the effect of volume.

RANGE CONTRASTS

Simultaneous contrasts are numerous in a finished painting. In works based on harmonic ranges, the artist searches for the right hues and contrasts by mixing colors on the palette. Often several developed ranges appear in the painting based on the harmonic range selected. Colors used to break the monotony of one range will often be used. The simultaneous contrast is that produced by juxtaposition of tones and hues.

COMPLEMENTARY CONTRASTS

The different techniques that a medium allows foster the production of simultaneous contrasts. The plastic effect of certain textures constitutes a wealth of resources for modifying the contrast, which should be maximal between complementary colors. Examples are mottled effects and the frottis or scumble, technique.

The matte quality of a color contrasted with a shiny complementary color is a factor that dramatically reduces the intensity of the contrast. Oil paint becomes matte when wax or turpentine is added; acrylic becomes matte or shiny when thickening gels are added.

At a certain distance from a painting, the eyes mix juxtaposed colors. The contrasts between color, tone, and ranges—whether they are intended to harmonize or to shock—also pass through the filter of human vision.

1. Two examples of simultaneous contrasts between tonal gradations of a single color.

INDUCTION OF COMPLEMENTARY COLORS

The intensification of colors, the phenomenon of successive images, and maximum contrasts between colors with a pair of complementary colors all permitted the brilliant physicist and color theoretician Chévreul to establish a principle fundamental to any artist. According to his research, applying a brushstroke of color onto a support not only colors it in that hue; at the same time, it bathes the entire area around the color in its complementary.

The principle of simultaneous contrasts and the phenomenon of induction of complementary colors are two essential phenomena that an artist should consider when creating the general color structure of a painting.

PHENOMENON OF IMAGES

Observe the three leaves in the image below. Each one is painted in a primary color: yellow, carmine, and cyan blue. The exercise involves staring at the three leaves at the same time for at least 30 seconds. When this time is over, move your gaze to the white background of the paper. Now you see three bright shapes, but their colors do not correspond to those of the leaves—their complementary colors are seen instead.

OPTICAL PHENOMENON OF THE INDUCTION OF COMPLEMENTARY COLORS

The induction of complementary colors, the optical phenomenon observed by Chévreul, can be very useful for the artists' understanding and handling of color. The physical characteristics of the eye are such that viewing a color generates the sensation of its complementary simultaneously, as was apparent in the phenomenon of images exercise.

Observe the three gray circles. A yellow background surrounds the first, a blue one the second, and a carmine one the third. If you stare at the gray circle with the yellow background for at least 30 seconds, the gray circle appears bathed in blue; that is, it tends toward yellow's complementary—intense blue.

If you repeat the same process with the gray circle surrounded by blue, after about 30 seconds this circle appears tinged with yellow, the complementary to intense blue. In the circle surrounded by carmine, its complementary, green, is induced.

When viewing the gray circle, the induction of red, the complementary to cyan blue, should occur.

INTENSIFICATION OF COLORS

Contrasts by tone are yet another example of simultaneous contrasts, because the effect of viewing two juxtaposed tones of a single color is the intensification of both. The color in its lighter tone appears even lighter next to the darker tone. Simultaneously, the darker tone appears even darker next to the lighter one.

When viewing the gray circle, the induction of blue, the complementary to yellow, should occur.

SIMULTANEOUS CONTRASTS

Although the different factors of contrast between colors can be dissociated in theory, in practice, two different colors have several elements of contrast at once. When colors are mixed on the palette, various hues are created. And when these hues are applied to the support, with the various possible textures that it offers, the combinations of contrast can be infinite.

Induction of complementary colors. After staring at the leaves in the three primary colors for at least 30 seconds and then moving your gaze to the white background above, the three leaves can be seen in their complementary colors. The shapes appear luminous. This experiment is quite useful as an introduction to Chévreul's conclusions.

When viewing the gray circle, the induction of green, the complementary to primary red, should occur.

Induction of Complementary Colors

One way of understanding the induction of complementary colors is to observe how this phenomenon acts on spots of one color surrounded by another. The surrounding color would have to cover the entire canvas or support as the background.

Backgrounds are always an important element in any painting. For a portrait or figure and for still lifes, the central subject is generally placed in the foreground surrounded by a background color. In landscapes and seascapes, the infinite depth of the sky or sea makes up the background. Its color depends on the light, the dominant color of the painting, the atmosphere desired, and the artist's interpretation.

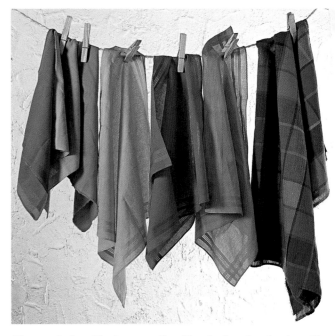

Photograph of napkins hung on a line. The selection of a color that will work well for the background of a painting is very important. The proportion of space given to it in comparison to the entire area of the painting also affects the look of the final work through induction of complementary colors.

AN OIL STILL LIFE OF NAPKINS

A still life based on subjects such as the napkins hung on the line in the photograph allows an understanding of the scope of the effect that complementary color induction can have on a painting.

All of these napkins show a predominance of blues, with a variety of hues ranging from violet to greenish. The wall behind the napkins is covered in stucco. The stucco provides an interesting background, with its texture enriching this simple still life. It would also be possible to represent a subject, the local colors of which have a cool harmonic range in a light that is also cool.

What happens when a specific color is applied around the napkins? In each example, a different background is blocked in. In the first, there is a predominance of yellow; in the second, magenta; in the third, cyan blue; and in the fourth, neutral gray.

In the painting with the yellow background, the blue in the napkins becomes more intense by the effect of induction of the complementary to yellow, intense blue. On the magenta background, the napkins display a greenish-blue tendency because of the induction of the complementary to magenta, green. On the blue background, the napkins display a violet tendency because of the induction of the complementary to blue-red. On the neutral background with undefined grays, the color of the napkins is unaltered.

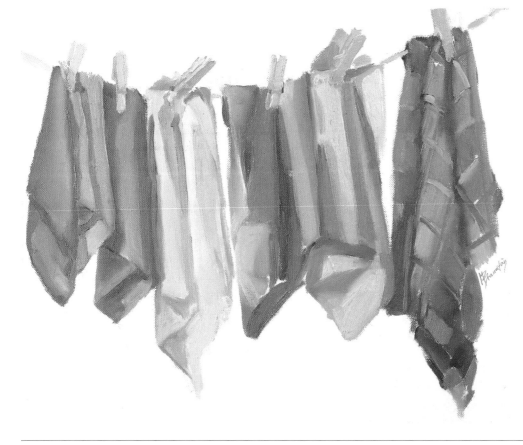

Napkins on a Line, *painted in oil. What would be the most appropriate color to paint the stucco wall in the background?*

BACKGROUNDS

The selection of the color for the background of a painting is important. The impact that its induced complementary can have on the foreground and the middle ground is enormous, because of the amount of space it occupies. The viewer's eye adds its complementary color to the rest of the colors on the surface. For example, the pallid face of a young woman against a magenta background appears green; against a yellow background, green; against a blue background, reddish. On the other hand, a face with pallid, porcelain-like features surrounded by a neutral background with neutral, warm or cool grays remains unaltered.

NOTE

The induction of complementary colors on objects does not produce the same effect as when it is reflected on flesh colors. In a painting where the subject has a large area of skin showing, the choice of background color is fundamental. Although a background color may be chosen to highlight the outline of the figure, the induction of the complementary into the rest of the painting should not be considered. With a still life, the use of sharp contrasts may be more acceptable because the colors, textures, highlights, and reflections of still life subjects are less fragile than flesh is.

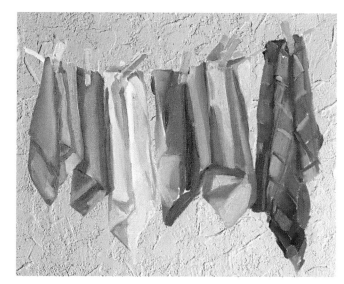

In this example, blue predominates. The wall is painted in blues. The blue of the napkins, surrounded by an equally blue background, pushes the napkins toward violet, induced by the complementary to blue red.

In this example, yellow predominates. The wall is painted in a lemon-type yellow. The blue of the napkins appears even bluer because of the induction of the complementary to yellow intense blue.

In this example, the background is in a light neutral color. The stucco wall painted in neutral grays and white causes no induction of complementary colors in the eye. The colors of the napkins are not modified by the surrounding colors. Opting for a neutral background is always less risky.

Magenta predominates in this example. The wall is painted in dark reds, carmine, and purple lightened with white. The blue of the napkins appears greenish-blue because of the induction of the complementary to magenta green.

Painting the Color of Objects

The still life on this page is more classical in character and further illustrates the subject discussed on the previous page. Representing this still life entails expressing the chromatic scheme of the subject, its tonal or local color, and colors reflected by objects onto each other. The still life is a traditional theme, one that allows volumes to be represented by contrasting colors and tones. The direction of light is key in a still life; this aspect, too, must be represented in tones and hues. This work is painted in acrylic, which can be applied as a glaze or with opacity. The exercise involves reserving areas, a technique that leaves parts of the support uncolored. The composition is done on paper.

LOCAL, TONAL, AND REFLECTED COLORS

It is helpful to work out the color mixtures required to paint the chromatic qualities of the object's own color. By starting with a base mixture, an artist can then darken or lighten it, depending on the different tonal values that are observed from nature. The related lighter colors are added to the mixture to lighten it and the darker ones to darken it. The quality of the light is what defines the object's general coloration. The highlights are the areas that possess the lightest tones; these are usually painted with a liberal amount of white and a touch of the object's local color, tinted by the reflected color.

The way color or colors reflected from the environment effects an object depends on what the object is made of and what its local and tonal colors are. To achieve a realistic rendering, the most useful techniques are those that produce transitional gradations, without abrupt changes in tone. This exercise, with an emphasis placed on the synthesis of forms and color, allows the basic areas of this still life to be visually represented.

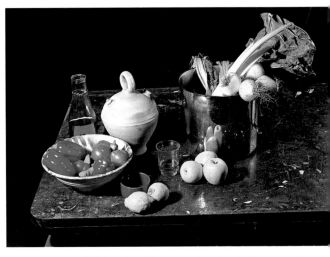

A conventional still life such as this one can be painted with any medium. A modern medium like acrylic allows the artist to apply opaque color and transparent layers; when executed opaquely, light colors can be applied over dark colors, whereas when painting transparently, glazes produce a more luminous effect when applied over light colors. Painting with acrylic on paper has its own particular characteristic, as seen by this exercise.

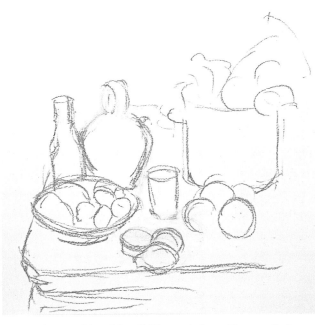

1. First the composition of the still life setup is chosen. Then a preliminary sketch is drawn with a black watercolor pencil. The artist must concentrate on the most important lines of the subject.

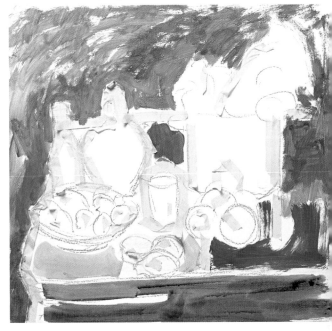

2. Several areas of the paper are reserved with adhesive tape for two reasons: They indicate the highlights and areas occupied by white objects and leave the paper clean for their subsequent application. The first washes of very thinned paint are applied virtually without mixtures. They block in the most important areas of the still life the table and the background.

3. *The next layers, diluted in the background and applied more thickly, lend greater contrast and depth to the whole. The entire background and table has been roughed out. The tape is removed as needed.*

4. *The bottle is painted with a very transparent umber. The glass is painted with burnt sienna, also very thinned. Three washes are created for the saucepan of ultramarine blue and ultramarine blue mixed with carmine to obtain violet.*

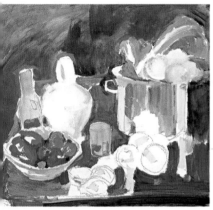

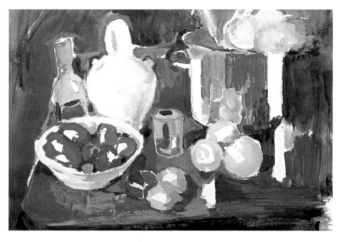

6. *The plate and the pot are illuminated a little more, with white and with a second semiopaque layer. The artist paints the ceramic pot, the apples, the lemons, and the respective highlights on the saucepan. Note the luminous shadow cast on the table by the plate. At the end of this stage, all the remaining adhesive tape is removed, leaving the reserved areas clean and intact.*

5. *Acrylic paint dries so quickly on paper that a second layer can be applied almost immediately. The chard is painted with a broken green, and the tomatoes and the red peppers are colored with different tones of carmine.*

Next, the ceramic pot and the plate are given shape, painting warm white in the highlights and light grays and light bluish grays in the shadows. The paint is applied more opaquely, ensuring that the onions get similar treatment, although with fewer contrasts.

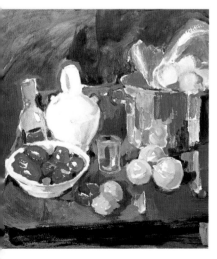

7. *Next, all the reflections that had been reserved under the tape are worked, looking for the best way to depict their volume by means of highlights. The highlights on the peppers, tomatoes, lemons, and apples are painted with the glazes corresponding to each element.*

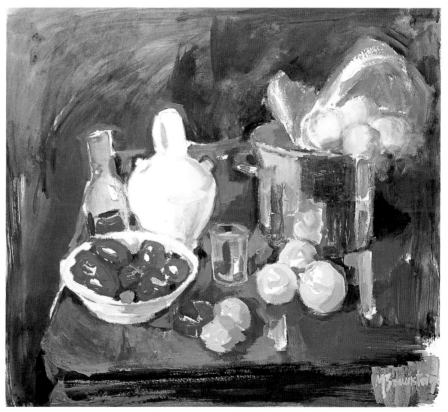

8. *The final stage involves bringing the shadows on the table to life with blue washes. The saucepan is illuminated with layers of paint, which also lend volume to it. These last touches add force to a painting in which basic areas of light and shadow have been adequately developed.*

Reflected Color and the Environment

All objects with reflective surfaces produce highlights as multiple light areas and reflections. With careful observation, an artist studies not only the qualities of the color but also the texture. When the highlights are an important element in the subject, as in this one, the quality of the representation depends on the artist's own particular technique of synthesis and blending. The execution in oil of this multi-sided coffeepot, a transparent glass, a mirror, and a napkin, all arranged to construct a strong composition, demonstrates various aspects of reflected color. Oil can be used opaquely or as transparent glazes.

A COLOR REFLECTED ON AN OBJECT

When an object's surface is reflective, the reflected, or environmental, color adds a chromatic quality to the surface of the object, the result of the surrounding objects. In this still life, it is not difficult to identify the sources of the reflections. The work thus involves a straightforward representation of the observed tones and hues.

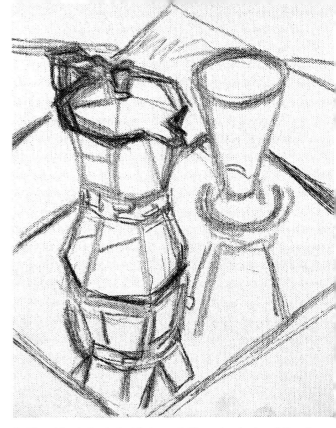

1. The subject is sketched with charcoal. The main aim is to define the dominant shapes of forms and areas of color and tones. To avoid muddying the painting, it is best to draw the lines lightly, they can be fixed with turpentine when the drawing is done. Once the turpentine has evaporated, a rag is passed over the paper to remove the charcoal dust. The preliminary drawing is now complete.

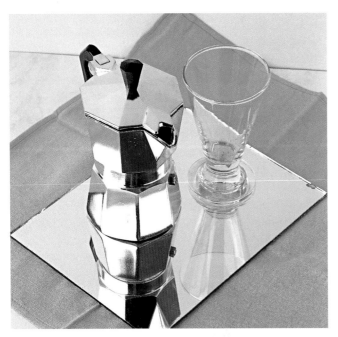

There is a multitude of highlights and reflections in this composition. The many reflective surfaces of the coffeepot, glass, and mirror; the light illuminating the still life; and the effect of the surrounding objects of the subject must be observed and studied. A palette containing very few paints (yellow, vermilion, carmine, burnt sienna, emerald green, turquoise blue, and ultramarine blue) are enough to paint this work.

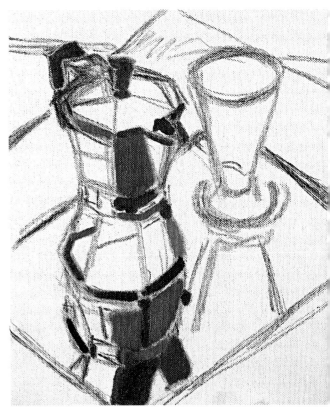

2. Based on observation, the artist applies strokes of various tones to begin to add volume. The main shapes of the objects are blocked in with patches of chromatic tonal mixtures. Carmine, emerald green, and ultramarine blue are mixed in equal parts to obtain black; the different tones of gray are produced by adding white.

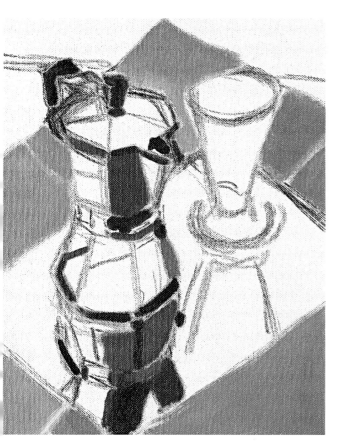

4. The reflections on the mirror are painted with a bluish gray, different from the gray used for the coffeepot. The color combines turquoise blue, a hint of yellow, a touch of carmine, and a liberal amount of white. The violet tones are produced by increasing the carmine.

3. The napkin is painted with mixtures of various tones; there is a pink verging on orange and another more salmon-colored tone, both in various hues. To obtain a more orange mixture, yellow, vermilion, and white are used. The salmon hue is produced from the previous mixture to which carmine and a touch of sienna are added.

5. The artist continues working on the reflections of the coffeepot, the roughing out of the glass, and its reflection in the mirror. The reflections on the coffeepot cast by the napkin are very important because they heighten the composition with warm-cool chromatic contrasts. The other blue-gray reflections on the coffeepot are produced with blue, a touch of carmine, and plenty of white.

6. The paint applied in step 5 must be given time to dry before the final strokes and glazes are applied to achieve the desired effect. The whites represent the brightest highlights, while the bluish tones outline the forms; the tones of the reflections of the napkin are heightened with some orange.

The Color of Objects and the Quality of Light

Landscape provides an excellent example of how the quality of the light that illuminates it affects its chromatic compostion. The atmospheric light alters the colors of all the elements that make up a landscape (vegetation, rocks, sky, and so on). To illustrate this point, the first landscape is executed with watercolor washes and the second landscape, which has very different characteristics, painted in oil.

Tree trunks on a foggy day acquire particular colors. If the landscape is also covered in snow, then the coloration of the snow will have a significant effect on the whole. Watercolor is an ideal medium to capture the qualities of light and color. This winter landscape will illustrate the wash techniques of wet on wet and wet on dry.

A snow-covered landscape like this has a particular light. The artist's task is to capture it accurately. Watercolor washes permit the artist to capture an essential image with speed.

1. First the planes are defined with very few faint black lines, sketched with a watercolor pencil, which will combine easily with successive washes. The first wash to be applied is a very diluted light gray.

3. The foreground is painted on dry, taking care to leave the white areas of snow intact. Several small areas of washes are used to establish the general color of the vegetation.

2. Still working wet on wet, playing with raw and burnt sienna, the artist blocks in the outline of the trees in the background; with this technique the contours remain undefined. The tree in the midground is painted with a little umber wet on wet.

4. Once the paint has dried, brushstrokes that define the silhouettes of the trunks and branches are applied and graded in intensity. The elements in the foreground are painted with a more intense color, and those situated farther away are painted with less saturated color.

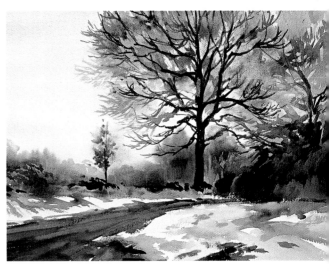

5. Note how some of the very light gray washes and certain dark tones convey the impression of snow. The composition seems lit with daylight, characteristic of watercolor.

THE ARTIST'S INTERPRETATION

Artists always have the last word in the way they interpret what they see. The differences between the model from nature and the painting can be striking. But the result of heightening it with a predominant chromatic feature can produce a harmonic effect that does not really exist. This is what the artist does in the next exercise, in oil.

1. The basic shape of the trunks and the main branches as well as the different planes are sketched in. The charcoal strokes are sparse, but enough to define the most essential elements of the landscape.

2. The roughing out is done with mixtures obtained from cobalt, ultramarine and Prussian blue. Mixed with plenty of turpentine, the middle ground and background are blocked in. The paint is applied more densely to the trees, which produces an opaque result. Finally, the areas between the trees are cleaned with a cotton rag.

This landscape with trees will be interpreted according to the artist's vision, which is to lend a cool appearance to the light. The depth of distance to be represented requires the background to be blurred, in contrast with the energetic brushwork in the foreground.

3. Violet and white are used to define the sky, while ochre, sienna, and white capture the coloration of the middle ground.

4. With a minimum number of brushstrokes, the area of the trees in the foreground is given more detail; their direction defines the road and the land, thus lending perspective to the composition. These mixtures are obtained from burnt umber, ochre, sienna and plenty of white.

5. The trunks and the main branches are painted with browns, green tones, and very dark blues. Note the impression of volume that is achieved with the tonal values used for each area.

6. The final details consist of thin, fine brushstrokes, which allow tone and highlights to be added in the branches. Some frottis or scumbling work creates an atmosphere around the branches that integrates trees and environment.

Color: Atmosphere and Contrast

Both the characteristics of light and the effects of the intervening atmosphere affect the quality of contrasts in a scene. Here, there are two landscapes, one painted in pastel, the other in oil. Both have been painted with neutral colors, which is something quite common in urban landscapes; nonetheless, the effect and the atmosphere achieved in either case is strikingly different. The artist not only needs to consider how to combine the colors but also how to apply them in a way that creates accurate tones and contrasts so that the representation is convincing.

USING CONTRAST TO CONVEY A CLEAR ATMOSPHERE

In all landscapes, where the light plays a key role, the main task for the artist is to capture the atmosphere that surrounds the subject. The elements in a clear atmosphere tend to have strong contrast.

There is always a greater contrast in the foreground between colors and forms. This contrast diminishes in the objects located in the middle ground, while those in background are completely blurred. Pastel is the perfect medium for depicting an urban landscape with a clear sky.

An urban landscape with skyscrapers is an excellent subject for differentiating between planes, and using color and texture to convey their forms and detail.

4. The color of the paper that remains visible between the pastel strokes blends perfectly into the work as a whole, creating appealing effects particular to pastel work. With whites, grays, creams, sienna, and umber, the artist continues defining the details of the tall buildings and developing the dimensions of the central skyscraper.

1. On a sheet of light brown paper, which provides a good contrast for pastel color, several cream-colored lines are drawn to outline the shapes of the most significant vertical forms. The general lines of the foreground are sketched in.

2. The sky is colored in with blue tones, taking into account the greater luminosity of the lower area. The lowest buildings are blocked in with vertical strokes of raw umber and white.

3. The buildings are further defined with representations of their most intense shadows; first an intense blue is used and then, on top, sienna and burnt umber are added to tone it.

5. The illuminated planes and the brilliant outlines of the buildings in the foreground are defined with all hues of white. The color of the paper allows the pastels to be heightened by simultaneous contrasts.

6. The windows of the building on the right are painted with light bluish gray strokes, which provide a contrast over the dark base, a mixture produced by superimposing intense blue and umber. The general illumination is executed with several touches of pastel. The shadows are illuminated with lighter pastels. Then the right-hand part of the picture is toned with light golden ochre.

7. The final stage involves retouching the shadows.

CONTRAST AT DUSK

The light at dusk alters the strength of contrasts. Oil is the medium used to convey this type of contrast in another urban landscape. The denser paint applied in the second session lends the required contrast to this work.

The foreground usually possesses more contrast between colors and forms than the subsequent ones. This contrast diminishes in the objects of the middle ground, and those in the background appear blurred. Pastel is the perfect medium for depicting an urban landscape with a clear sky.

In this urban landscape, at dusk, a grayish tendency and an unmistakable contrast between warm and cool colors prevails. The array of antennas requires a delicate touch so that their lines don't appear too hard or exaggerated.

1. In the sketch on the canvas, the most significant line is that which separates the buildings from the sky. The other strokes depict the general view of the urban landscape. The charcoal sketch lines are drawn lightly so that the oil paints do not become muddy .

2. With very thinned paint, the entire surface is roughed out, applying the appropriate color mixtures to each area. The grays are produced by mixing umber, ultramarine blue, and white. The warm colors are produced by mixing yellow, ochre, sienna, and umber. The sky is painted with turquoise blue and white toned with ochre or umber.

3. The second layer of paint is applied over the first once it has had time to dry. The buildings are first painted with darker colors; the touches that are to be added to define the most illuminated facades create a contrast with the bluish brushstrokes.

4. Now it is a question of drawing with the brush, lending detail to the flat shapes and adding dimension using mixtures of varying tones.

5. The first row of buildings is toned with white to adjust the value.

6. The final strokes, which depict the network of antennas, must be applied very carefully. Using a very fine brush and very little paint, a series of touches are added to create the general ambiance of this landscape. The texture of the rooftops is finished off with several strokes of light bluish gray.

Nearby Colors

Because of the effect of a subject's surroundings, be it clear or hazy, distant colors of forms require varying degrees of detail and contrast according to their spatial situation. But the colors of the foreground require maximum definition and contrast. In order to avoid unnecessary hardness, the color must be applied with a sensitive touch. Note that the detail and the contrast of the colors in the foreground depend not only on the color but also on the way they are applied.

This running shoe on a paving stone is used to demonstrate how to paint a nearby object in the simplest possible way. Simple though it is, the final result is a strong and effective representation of volume. Also covered is the effect of impastos and the way in which they are applied onto the support in order to achieve particular effects.

The model is a running shoe.

1. A thick sheet of paper is given a texture using acrylic modeling paste, which once worked and dry, will provide a base on which the shoe can be painted with very few pastel colors. The paste is applied with a rubber brush with the aim of adding dimension to the shoe. The direction of the brushstrokes defines the details of the object as well as the overall mass.

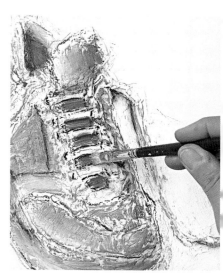

2. When the paste is dry, the most significant features of the shoe are redrawn with a very dark gray pastel.

3. The shoe is colored with black, light gray, and sepia.

4. Using a clean dry brush, the pastel pigments are blended into the crevices of texture in order to create concrete gradations.

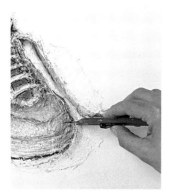

5. The dry modeling paste can be given a sgraffito treatment using a utility knife to open up grooves in the white modeling paste in a direction that gives dimension to the shoe.

6. A watercolor or acrylic wash is applied to further add dimension.

7. Note the depth achieved in the representation of this object; all the techniques have contributed to this result.

CONTRAST THROUGH COLOR

The running shoe in the last exercise was barely colored, the representation of its form relying instead on its texture. This exercise illustrates how to convey the detail and contrast of the foreground through color. This still life is painted with oil glazes, with layers that are extremely fine. The final stage demonstrates the possibilities of contrasts that the alternative use of glazes and opaque paint can create.

The model here is a still-life setup.

1. The mixtures for the glazes are liquid and transparent, compared with the others on the china plate.

2. With light charcoal strokes, the basic forms of the still life are sketched in.

3. The areas surrounding the objects are painted with very thinned ultramarine blue and bluish gray (ultramarine blue and burnt umber). Brushstrokes of less diluted burnt sienna and burnt umber are used to define and block in forms and shapes.

4. The colors are mixed to represent each object transparently, with its colors and tonal values.

5. A cotton rag applied to the surface, as in the photograph, reduces the intensity of the colors. At this point the painting must be left to dry until it has set.

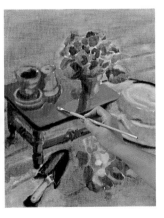

6. The second layers of paint are applied quite diluted. By superimposing layers of colors, the picture is given dimension while the tonal values are conserved. This second layer of paint will not entirely cover the first, roughed out applications; in contrast, the volumes and outlines are far more prominent.

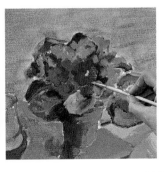

7. A third layer of glazes, applied during a third session (having given the second layer enough time to dry) allows the artist to finalize the remaining details. Strong, defining contrasts will effectively finish the painting.

8. The last step shows the effect achieved with delicate strokes of very diluted color to represent highlights.

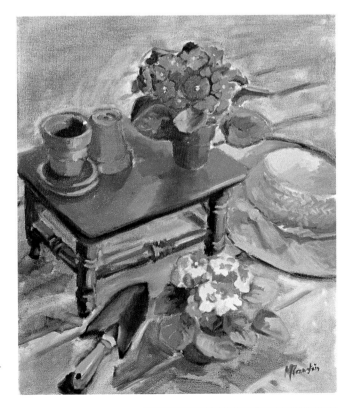

Distant Colors

The next painting provides a good example of techniques used to paint colors seen from a distance. This beautiful twilight landscape contains only a few trees in the foreground, which are backlit by the setting sun; the rest is sky. This subject is painted in two stages: In the first, the background is applied; in the second, the branches and trunks are added on top.

GRADING TO CREATE A BACKGROUND

This type of landscape could be painted in oil, acrylic, watercolor, or pastel, because all these media allow for subtle and highly transparent grada- tions in a background. Thi subject has been painted i oil. The very diluted gradatio is done in one application The branches and trunks ar painted using thicker paint, ir the second stage.

Twilight landscape with trees in backlighting.

1. With diluted paint, the warmest area of the sky is painted with very few strokes.

2. Only a few strokes are needed to convey the sky's basic coloration.

3. With the brush dipped in solvent (a mixture of turpentine and linseed oil) the remaining spaces are finished off, by "stretching" the colors applied previously.

4. The blending work, whether it be executed with a finger or with a clean, dry brush, continues until the essential tones of this sky at dusk are captured.

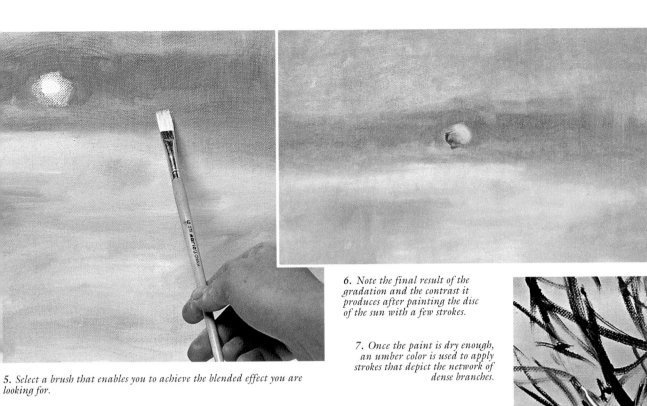

6. Note the final result of the gradation and the contrast it produces after painting the disc of the sun with a few strokes.

7. Once the paint is dry enough, an umber color is used to apply strokes that depict the network of dense branches.

5. Select a brush that enables you to achieve the blended effect you are looking for.

8. The finished effect of blended colors for the distance, with strong brushwork for the branches in the foreground.

Painting Shadows

No matter what you want to paint or which medium you choose to do it in (oil, watercolor, acrylic, and so on), shadows are one of the most important elements to achieve volumetric form. The quality of the shadows, their hardness, blending, or chromatic interpretation is a study in itself.

It is important to distinguish between the object's own shadow, the so-called local shadow, and the shadows that are cast on and around it. The shape of the object creates the shape of its shadow. The shapes of shadows cast on an object are determined by objects that appear in proximity. The tonal values and hues of the two shadows must be carefully observed and their nuances depicted. The artist must mix colors in order to paint them convincingly. When painting impressionistically, color solutions can range from painting luminous shadows to using direct complementary colors, thereby interpreting observed reality using a creative style.

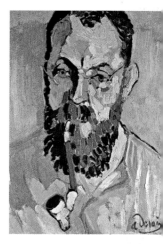

Fauvist painters gave a dramatic quality to shadows through the use of direct complementary colors. Portrait of Henri Matisse, *by André Derain*

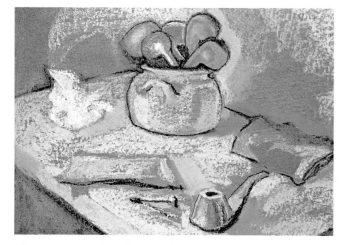

The treatment that the painter decides to give the shadows always determines the effect produced by them on the finished work. The Pipe Corner, *by M. Braunstein has been painted with a colorist technique, giving emphasis to the blue of the shadows.*

CHALKS OR PASTEL

These media share a common chromatic characteristic: They can be used to heighten color bursts. This painting, *The Pipe Corner*, by Braunstein, was executed with colored chalks on kraft paper. The medium is used in such a way that it intensifies the contrast of the paper's texture and its color. Simple school chalks like these can be used to achieve striking effects because of the dramatic quality of the shadows. The imaginative impression conveyed transforms an ordinary still life into a magical, vibrant painting.

DRAMATIC QUALITY OF SHADOWS

In order to intensify the colors of the shadows, they should be reduced to their blue characteristic. A yellow object, with a shadow painted intense blue, makes the yellow appear more vibrant. This is caused by the induction of the complementary of intense blue, which is also yellow. For the same reason, the blue of the shadow appears deepened by its complementary of yellow. If a red object was given a blue shadow, the blue would be perceived as cyan blue, the complementary color of red. If the shadow were painted with cyan blue, it would take on a reddish tinge, while the red object would acquire some of the complementary color of intense blue, which is yellow. In other words, this red would appear slightly more orange. A shadow painted blue is perceived as greenish or violet, depending on the colors that surround it. When the artist is not working with direct complementary colors, no simultaneous contrasts are produced; the dramatic quality lessens as the tones are reduced and the complementary colors are altered.

SHADOWS WITH COMPLEMENTARY COLORS

When the shadow of an object is painted with only its complementary color, the result is striking color contrasts, the maximum being the most intense colors. The fauves used this type of maximum color contrast; the colors they painted, the shadows of objects, and even figures were based on direct complementary pairs.

LUMINOUS SHADOWS

Conveying the luminous quality of painted shadows is one of the keys to capturing them successfully. Under an intense midday summer sun, a shadow can be painted using all the possibilities of the palette. In his work *Calm Morning*, the painter Frank Benson brilliantly conveyed the luminous qualities of the shadows in the boats, the dresses, and the flesh colors, achieving vibrant colors and extraordinary dimension.

ACCENTUATING THE COLOR OF THE SHADOWS

It is important to remember that the color of a shadow includes, first, its own local color in a darker tone; second, blue, which is present in darkness; and third, the complementary color of the object's own color. By exaggerating the blue or the complement of the object's own color, a heightened effect can be produced, lending a touch of drama to the shadow.

Calm Morning, *by Frank Benson. Note the luminous quality of the shadows in this work.*

In the painting Motorcycles in the Boulevard *by M. Braunstein, this urban landscape has been treated in a traditional way, placing special emphasis on the contrast between the area in light and that in shadow; in other words, between the warm neutral colors and the blues and grays.*

This terrace, also a work by M. Braunstein, shows another way of painting shadows. The intention of the representation is to convey the searing effect of the light on a stifling afternoon in summer. The colors of the object are included in the shadows cast in a darker tone mixed with the blue of the darkness, and the complementary color of the object's own color.

The Artist's Stool, *by M. Braunstein. This composition highlights the different planes of the subject. The treatment of the shadows in the foreground (stool and platform) is different from that of the wall. The treatment given the exterior panorama is even more distinctive.*

Value Painting or Colorist Painting?

This section demonstrates two different ways of interpreting a subject that possesses a wide variety of chromatic possibilities. Pastel is the medium with which this still life is painted. The first interpretation is a value painting—that is, it conveys a realistic effect by means of tonal values. The second interpretation is a colorist painting—that is, it is based on the application of flat colors, in which intense interactions of color dominate.

Several colored skeins arranged on a small table.

VALUE PAINTING

In order to paint a work using values, the artist has to discern the different degrees of tone that make up the surface of the subject. This approach entails the use of conventional pastel techniques: blending and grading. In this type of painting, much of the application of color is worked with the artist's fingers.

On white paper, the colors read in a straightforward way, unmodified by any base color as they are with a tinted pastel paper. The aim here is to create a painting that appears as realistic as possible.

1. The model is sketched lightly on the paper, in order to create semi-transparencies. Only the most essential lines to define the shapes of objects are drawn in. Each object is assigned its own color.

2. First the background is colored in, using several blue tones, a green, an umber, and a black.

3. The colors are then used in their tonal values and applied to the appropriate areas. Note that the color is not applied very densely; the underlying color of the paper can be seen through the pastel.

4. Next, the tablecloth is worked on. A bluish gray is superimposed over the lighter tone of the tablecloth. In the lighter areas, the first layer is illuminated with a very light tone of yellow ochre.

5. Blending colors is an important process; the entire area of the background is worked with a finger. Note the effect produced.

6. *All the skeins have been blended with a stump or with the hand. The direction of the blending adds dimension to the objects.*

7. *Now the colors of the tablecloth are blended. When working with light colors, care must be taken not to mix the blends with the intense colors of the skeins or the wall.*

8. *After the basic work of blending, each of the skeins gets toned with a darker hue of its own local color. From here on, the artist must concentrate on depicting the texture of the wound skein. With delicate free strokes, various strands are painted with a color and a tone that makes them stand out against the background.*

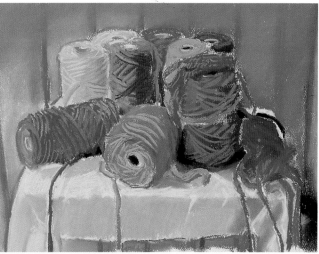

9. *The values of the highlights that were added in the previous stage are intensified, and the contrasts with the new blends are softened.*

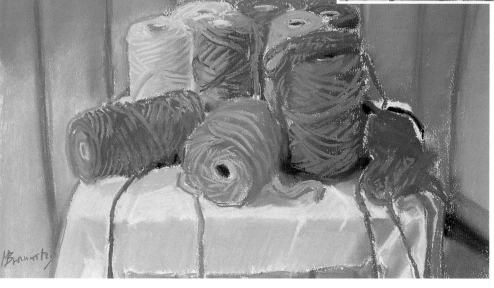

10. *The shadows have been worked without making them too hard. The plain simplicity of the surface of the tablecloth provides a very suitable counterpoint to the intense colors of the skeins.*

COLORIST PAINTING

The colorist technique with pastel enables artists to produce works of extraordinary chromatic impact. In this type of painting, the colors are applied flat, or pure, their luminous values representing the dimensions of the objects. It is not surprising that this method produces intense and dramatic color juxtapositions in the shadows.

Using the colorist technique, the capacity of the impasto to hold the color and the highlighting of contrasts through texture are two key elements. The effect of the color over the relief of the paper is one of the principal effects produced with this technique. Colorist painting is, without doubt, one of the most creative approaches to painting. The impact of the finished work depends solely on color rather than on value.

There are two good reasons for working on turquoise blue paper: First, it is the same color as the woodwork that serves as a background. Second, because blue is present in all shadows, it can be used to represent the shadows of the elements in the composition.

The companies that manufacture colored paper for pastel have sample collections. The artist can choose from a wide range of colors to find the one that best suits the interpretation of the subject to be painted.

In order to create a colorist interpretation of the same still life painted in the last exercise, the artist attempts something more risky. The paper's turquoise blue color is similar to that of the background. Note during the different stages of this work the way the color of the paper gradually blends into the picture.

1. The subject is sketched with a very light blue pastel, because this color can be easily distinguished against the turquoise blue paper and will merge into the work (the most intense colors applied will cover it).

2. The turquoise blue of the paper mixes with applied chalk to represent the background. The highlights and shadows that divide the strips of wood at the back must be painted. The very dark shadows are painted with a broken dark violet. The tablecloth is blocked in.

3. To convey the appearance of the skeins, it is necessary to paint only some of their strands. The shadows are obtained by leaving parts of the surface of the paper unpainted. It is important that the direction of each stroke appropriately conveys the volume of the skein.

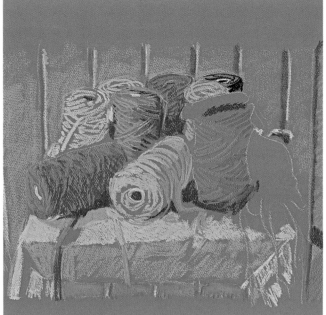

4. The effect produced as the artist applies more color. The juxtaposition of colored strokes of the skeins with the turquoise blue support lend a dramatic quality to the composition, because the viewer s eye will blend many of these colors.

5. Simultaneous contrasts are produced between the different colors applied; the maximum contrast produced is between blue and red. But a contrast is also created between the warm colors of the skeins and the cool turquoise blue paper. Finally, the hint of color of the darkest areas makes the skeins stand out against the blue background.

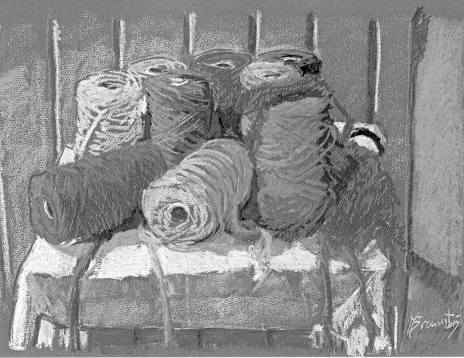

6. At this stage, the shadows and reflections on the tablecloth are worked. It is important not to forget the color of the tablecloth itself and that of the objects that cast their shadows over it. In addition, the highlights are intensified and developed.

7. In order to center the viewer s attention on the skeins, the artist softly blends the colors of the creases of the tablecloth draped over the table and darkens the lower part to produce a heightened effect of depth. When this interpretation of the still life is compared with the first one, the difference between value painting and colorist painting is evident.

The Color of Darkness

Pastel is an excellent medium for producing paintings quickly, which also makes it a practical medium for capturing a precise moment of the day. Evening subjects, such as the light of dusk or of a stormy sky, last for only a very short time. An evening landscape presents the best example for illustrating the importance of the color blue in darkness.

Nighttime seascape painting with warm and cool tones.

DARKNESS WITH PASTEL

In subjects that demand very intense or very dark colors, the choice of the color of the paper is key for establishing the tonal value of the pastels. On black paper, all the colors must be light, because the black of the paper is the darkest color. Dark colors can be applied on deep-hued papers that are lighter than black and are as visible as the lightest colors; in this case, the color of the paper functions as the intermediate value. For instance, a violet-gray paper, a twilight color, provides an ideal intermediate value on which the pastel colors can be applied. The differences in this picture between the pinks, the violet-blues, and the highlights offer a contrast with many color and tone possibilities.

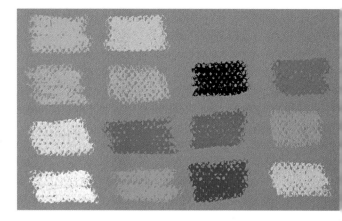

A violet-gray paper, known as twilight color, is a fitting background color for this scene. The first two rows of colors of these sample swatches correspond to the highlights; the third row of colors is for painting the coast; and the last row will be used for the sky and sea.

1. The sketch is done simply. Only the horizon line and the most important details of the coastline are drawn.

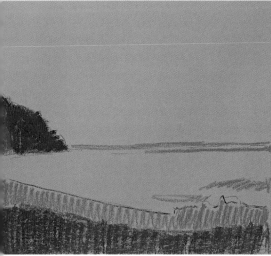

2. The essential features of the coast and the horizon lines are colored in using very few colors.

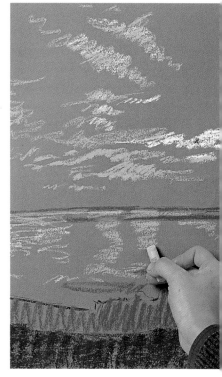

3. The highlights are blocked in with the lighter and warmer colors seen in the selection reproduced above. The chalk strokes follow the direction of the clouds and the waves as well as the form of the surface of the sea.

4. *The blue colors complete the effect, alongside the warm ones. The strokes and coloring continue to conform to the direction of the clouds and waves. It is important to represent the areas of the colors of the sky reflected on the water.*

5. *More colors are added in order to deepen the color with strokes that are sometimes superimposed over the earlier ones.*

6. *The details of the coast are brought out by superimposing more color and blending. Even in the dark, it is possible to discern the different hues and tones of a landscape.*

7. *Because blending of the surface of the work is being done with the artist's fingers, the artist must be careful when changing from one value of hue to another, especially with the colors for the coast, so that one color does not pollute the next.*

8. *In order to increase the effect of depth in the landscape, the coastal area is further darkened. This can be done by applying black over the blended layer of browns.*

9. *Note the way the darkness of the foreground heightens the sense of distance once the colors are blended.*

10. *The final strokes are drawn for the shoreline, applying highlights on the water. These strokes will be defined rather than blended, and so must be applied with sensitivity in order to convey the softness of the waves washing up against the beach.*

Studying Light and Shadow

Interiors make very interesting subjects from which to study light and shadow. The first thing is to locate the brightest point of light and assess its intensity. The study should proceed by assessing the relative value of all the visible colors. From the backlighting to the semidarkness of the foreground, the darks and lights convey the volume dimensions.

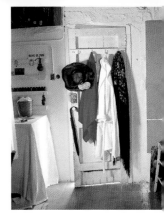

An interior like this provides an interesting study of light. The most intense light originates from outside the room; the interior is in half light. The clothes hanging from the door and the tablecloth have all the characteristics of drapery viewed from a distance. Because of the glazes it creates, acrylic allows the artist to capture the warm antique feeling of this interior.

LIGHT AND SHADOW WITH ACRYLIC

Acrylic paint allows hue mixtures to be alternated by superimposing very transparent layers with touches of opaque and dense color. The glazes reflect the ambience, in this case, of an attic. The darks and lights depict the dimensions. The principal themes are the light shining through the doorway and the clothes hanging on the door. This representation is not a comprehensive development of form, but more of a quick impression. The strength of the piece is in concrete applications of color.

1. The sketch is drawn in charcoal. Few strokes are needed to block in the most essential lines of this interior.

2. Several areas are reserved with tape for the most illuminated areas. The first forms are painted with thinned paint. The reserves will be uncovered and painted as the work progresses.

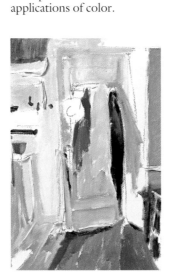

3. The mixtures are applied very diluted, laying in the color and tonal value. At this stage, the difference between the neutral cool and warm colors is apparent.

4. The roughing out continues, making sure that the first very thinned layer is lighter than the color that will subsequently be painted over it.

5. The second layer, also very diluted, is applied over the first, after it has dried. This process is known as wet-on-dry technique, done layer by layer.

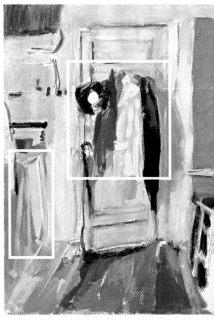

6. The forms, values, and details of the clothes hanging on the door and the tablecloth are applied with slightly denser paint.

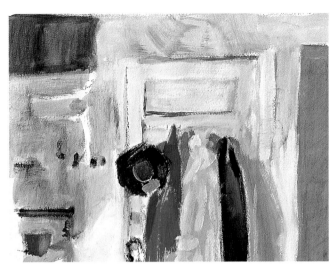

7. With a sponge dampened with very diluted burnt umber, a glaze is applied to give the paint an aged appearance and to convey the surface characteristics of the interior.

8. The effect of the glaze. Notice the unifying hue it gives to the piece.

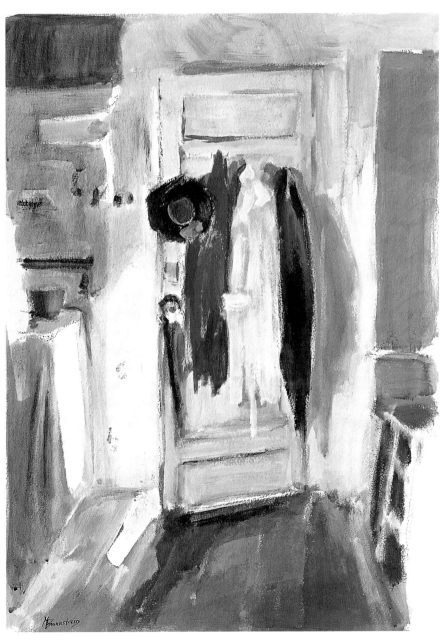

9. Adjustments can be made to tones and hues when using acrylics by adding touches of opaque color. Here the draping and fall of the clothes have been developed.

10. Here is the final result. The different layers of glazes applied wet on dry have established the forms and colors. The value study of forms illuminated by light has been developed and resolved.

The Center of Interest

The tulips and two black vases placed against a dark background will be painted in oil.

The center of interest of a painting is where the viewer's attention is focused. The artist chooses a portion of the subject meant to attract the viewer's gaze and works the textures of the painting to heighten that portion's effect as the center of interest. The color, the way in which it is applied, and the execution of brush and palette knife work help to highlight this area.

The center of interest is first established when composing the piece, but the contrast between the colors and the texture that is established as the painting is developed finishes the effect. Volume cannot be conveyed solely by color; the texture is an additional element that heightens its illusion. In order to help clarify this subject, two exercises that use as their subject a bouquet of flowers are provided.

1. The subject is sketched with simple lines.

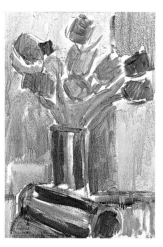

2. The first color is applied thin as a base on which the subsequent colors can be painted.

THE CENTER OF INTEREST AND THE BACKGROUND

The flowers in these compositions are clearly the center of interest. Flowers are commonly used as subject matter to introduce artists to the technique of free stroke. This example in oil explores how the flowers and the background should be worked in order to heighten the center of interest.

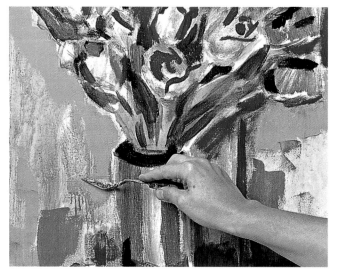

3. The second layer of paint is applied more densely with a palette knife. A third layer of well-chosen colors produces interesting mottling; the details of the petals are executed with brush and impastos.

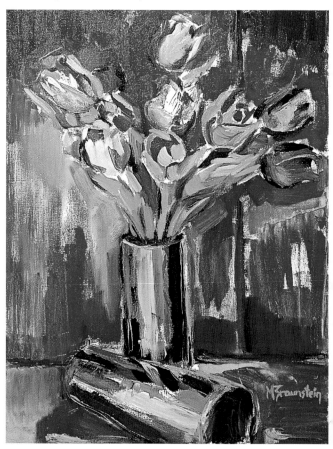

4. Both the color and the texture heighten the center of interest of this work. By starting with such intense colors, a work of this nature requires a chromatic study that functions by contrasts. In this case, the dark but warm and textured wooden background highlights the tulips and the cool light vases.

THE TEXTURE OF THE CENTER OF INTEREST

This example in acrylic illustrates one of the possible ways of working with a subject in order to heighten the effect of volume. The strength of the contrasts between the applications of diluted paint and opaque color is heightened by leaving an area of the canvas unpainted around the flowers.

Irises and gladiola.

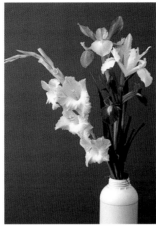

1. The sketch is drawn directly on the canvas, with very thinned acrylic.

2. The first strokes are applied to each flower, with tonal values of each color; to do this the intensity of each color must be reduced.

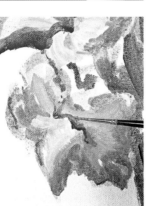

5. Detail of the texture of one of the details of the iris.

3. The next layer of paint, which is slightly denser, models the shape of each petal. The strokes give each flower volume.

4. By outlining with a fine brush certain details that help to silhouette the nearest elements, the artist creates greater depth.

6. One of the most important elements of the center of interest is the pinpoints of light and the areas of maximum illumination of the representation.

7. The sequence of procedures to increase the volume of the flowers and bring out their most characteristic features is complete.

Choosing the Dominant Color

The subject is a snow-capped mountainous landscape.

The dominant color depends on the light and the colors of the subject and the artist's own interpretation of the subject. It is important to decide what the dominant color of the work will be because that choice influences all the mixtures the artist blends throughout the painting process.

Regardless of the media and techniques employed, the basic chromatic structure of a work must be linked in some way to the general color scheme. There are two exercises in this chapter: one painted in watercolor and the other in acrylic.

1. The sky is painted with multicolored washes.

CREATING A DOMINANT COLOR

In this watercolor exercise, the artist has chosen to alter the subject's colors. The composition is based on two forms of warm pink colors, contrasted against sharp and cool blues. The artist decides to "break" all the colors in order to lend a warmer tendency to the whole.

2. The luminous summits are painted yellow.

3. The snow in the area in shadow produces a contrast with the bright snow-capped summits.

4. The shadowed areas of the mountain without snow are painted with a damp earth color.

A DOMINANT COLOR WITH FLAT COLORS

This building with its numerous windows and various planes allows the artist to choose a dominant cool color very close to the real one.

The exercise can be done with very few colors. A cardboard mask is to be used in order to reserve the areas where the acrylic is to be applied.

The model is an urban landscape that will be painted in acrylic.

1. The drawing should be sketched freehand, while roughly following the laws of perspective. The mask is placed underneath and the outlines are drawn with a sharpened pencil.

2. The cardboard is placed on a board and the shapes are cut out with a utility knife.

3. The work in progress after painting the sky and the areas in shadow.

4. The left portion of the mask is removed, thus freeing the reserved area for the part that is in shadow, and the gray is painted. The windows are painted through the unreserved areas of the mask, each zone with its corresponding mixture.

5. Now with the mask removed, one facade is painted with a light tone of neutral gray.

6. Details are painted in order to depict the windows in perspective.

7. The final work. In total, seven mixtures have been used and some brushstrokes of white.

Texture: Sequences

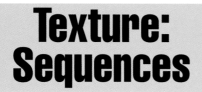

In order to create the appropriate texture for an object, it is necessary to apply the different layers of paint in a specific sequence. When working with a water-based medium, the effects are created as strokes and lines are applied wet on wet or wet on dry. When the artist is working with a dry medium, such as pastel, the texture is created by means of applying opaque or transparent, blended or graded strokes and patches.

This exercise uses a combined media technique, starting with pastel and finishing with several strokes of acrylic paint. The artist gives the dog's hair texture by following a sequence of steps. To do this, the strokes that best describe the rhythm of the dog's coat must be given greater prominence; they should indicate the direction of the tufts of hair and their tonal colors and values. The artist can achieve this energetic effect by not filling in patches with abundant color. In fact, by leaving certain areas unpainted, the volume of the model can be heightened.

This dog's shaggy coat is painted with pastel and gouache.

1. The sketch lines block out the dog's most important features.

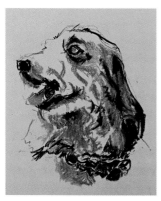

2. The head is colored in with the colors that represent its darkest values.

3. The strokes used to draw the increasingly lighter tufts of hair are superimposed by completely covering the dark base.

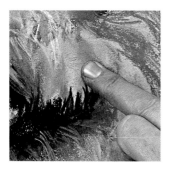

4. The dog's shaggy coat begins to acquire texture.

5. Details of the color and texture obtained with a fine brush and gouache.

6. The brushwork in gouache is done in small touches.

7. The completed picture. The mixture of media and the direction of brushstrokes describe the movement of tufts of hair.

TEXTURES IN OIL

A landscape is a good exercise for understanding the importance of applying the strokes of paint in specific directions. The direction of the brushstroke, the sequence of colors, and the perspective help to create the center of interest, in this case a house.

The subject for this exercise is a beautiful landscape of warm neutral colors.

1. In this fast sketch executed in charcoal on canvas, the neutral color of the sky is painted. Then the mountains, bluish in color because of their distance, are given texture with a cotton rag.

2. Once the neutral colors of the horizon have been painted, a sponge is used to form the shape of the nearest mountains.

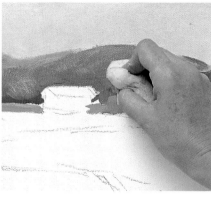

3. The direction of the brushstrokes conveys the rows of crops and gives perspective to the furrows in the middle ground.

4. The chromatic quality of the foreground is obtained with sweeping strokes. Note their direction and how they heighten the depth of the landscape.

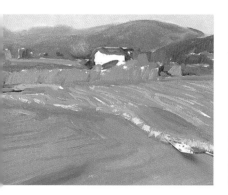

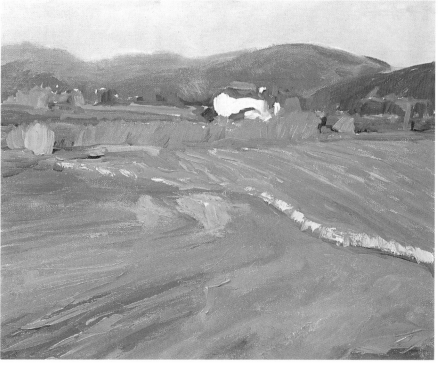

5. The work is highlighted with the detail and relief of the earth, achieved by applying impastos, and several streaks of paint are added to the field.

6. The final touches of color, several strokes of white to indicate the house. This building is the center of interest in this work. The direction that the paint was applied leads the viewer to the painting's center of interest.

Texturing or Modeling

The artist applies textures and effects in a painting in order to model form. Just as a sculptor molds materials to create a three-dimensional object, even in the flattest form, such as bas relief, so the painter uses special techniques to model or imitate the texture of the subject.

TEXTURE AND THICKNESS

Oil is a medium that accepts thickening agents. These substances give the paint greater density, thus allowing it to be applied in thicker layers. The addition of pumice or washed sand to the paint produces a good texture and helps to make the representation of sand dunes look more realistic.

DIRECTION AND MODELING

A palette knife can be used to create movement by helping the artist direct each application of paint. This representation of movement lends form to the objects represented. No matter how competent the artist or true the choice of colors, if the paint is not applied in the direction that conveys the form, no illusion of depth will be created. Brushstrokes applied with very diluted paint or thick impastos can heighten all textures. Not only can paint be given texture, it can also be used to create relief, almost sculpting the surface of a support.

The direction in which a texture is modeled is not arbitrary. It is governed by the rules of drawing. In order to paint the dimensions of an object correctly, the direction of the strokes must follow the intersections of the subject's horizontal and vertical planes.

Detail of the dunes.

1. Painting a canvas with thinned paint: yellow and golden ochre.

2. The drawing of the basic shape of the dunes can be done with a cotton rag, which is used to remove the surplus color.

3. The second layer of paint is worked by mixing the colors with a thick substance, such as pumice, in addition to washed sand.

4. The texture of the dunes is developed by using mixtures of the appropriate colors and a palette knife to give the dunes depth.

5. Detail of the texture of sand created.

MODELING PASTE FOR THE SUPPORT

Another process for creating form and texture involves applying modeling paste to the surface of the canvas before painting. The paste also adds dramatic quality to the colors that are to be applied over it. The paste, made of latex, Spanish white, and a touch of acrylic paint, is modeled as it dries, using a palette knife or wooden sticks.

The texture creates the appearance of rusty iron.

1. The chalk and pastel colors used for this exercise.

2. To lend texture to thick paper, a combination of latex paste, Spanish white, and a touch of acrylic paint are laid down.

3. A sketch of the iron structure is drawn with light charcoal lines.

4. All the elements are colored in with the selection of pastels.

5. The pastel colors are blended with a brush.

6. The blend can also be created using a finger.

7. The combined effect of the color and texture. Note, for example, the key details and the depth given to them.

Flesh Colors

A standard palette is used to obtain the wide range of tones required to paint flesh colors, with concentration on the colors used in the mixtures and their proportions. The same considerations should be kept in mind for a portrait or a figure painting as for an object painting or still life. There will be local color—the skin's own color in relation to the tonal values—the color of flesh in shadow, and the effect of the colors of the environment on the skin.

The surface of flesh may, on occasions, have reflections. Surface oils, moisture, or a pallid complexion are just a few of the factors that can increase the presence of reflections and highlights. These will be influenced by the type of light that illuminates the figure and the objects that surround it. Drapery is commonly used in this type of subject, because it can be used to great effect to build a strong composition.

A figure bathed in an orange-toned light.

An intimate scene, bathed in a warm light, is generally made up of colors with an orange tendency. For a woman posed with her back to the viewer, illuminated by warm lighting, a suitable selection of colors may include white, yellow, vermilion, and carmine.

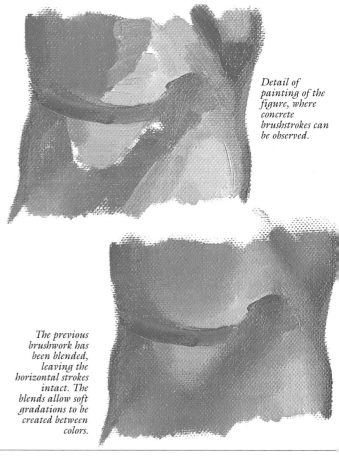

Detail of painting of the figure, where concrete brushstrokes can be observed.

The previous brushwork has been blended, leaving the horizontal strokes intact. The blends allow soft gradations to be created between colors.

Enlarged detail of the left leg.

BROWN SKIN

Brown skin, illuminated by a neutral type of light, retains its neutral color characteristics. There is no single color to paint human flesh. It always comes down to observation, studying the model's particular flesh color and then lightening or darkening it as the artist sees fit.

The brown skin of this model would be mixed, when using oils, from earth colors and white, adding some vermilion, red, or carmine.

Enlargement of a detail of the right leg.

The model's brown skin appears even darker due to the effect of backlighting.

The main color of this application is sienna, a color that is lightened with ochre and white, reddened with a little vermilion, and darkened with umber or a touch of blue.

GOUACHE COLORS FOR A NUDE

Gouache is a type of paint that can be applied wet on wet and wet on dry. With gouache, highlights and shadows can be painted over a base color. In the images here, two general color applications can be seen: one for the illuminated area of the figure and one for the shadows. In the next step, the shaded strokes that represent the flesh tones can be seen.

Model for the work in gouache.

1. The thin base color, over which more concrete colors are applied, provides a general tonal value.

2. The second application of colors is used to represent the shadows. Brushstrokes are painted over the base color to convey the different values of tone and color that add depth to the figure.

Flesh Colors in Shadow

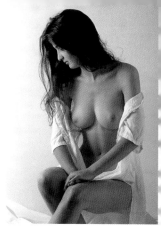

It is important not to forget that flesh tones are essentially made up of neutral colors. Red and yellow are base colors for flesh, with some white to obtain illuminated tones. In order to paint flesh colors in shadow, blue is added to the mixture in small amounts. The mixture can be lightened by adding white, but this also lends it a grayish tone, whereas by adding blue to red and yellow, a neutral tone is produced. Therefore, a clean flesh color can only be obtained by adding small amounts of blue or green and just a hint of white.

The model is illuminated by cool lighting, which calls for a cool interpretation of the subject. Watercolor is an ideal medium for painting flesh colors in soft tones.

A COOL TENDENCY

When a shadow is created, its color mixes with the object's local color at its darkest tone, a combination of blue and the complementary of the object's color. With this general rule, the problems inherent in depicting the effects of lighting are simplified. In all shadows, the absence of light implies that blue must be present. When the quality of the light is such that the dominant color of the subject is blue, the painting can be treated as a monochromatic composition.

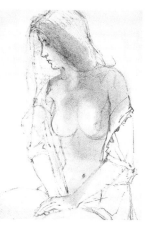

1. Over an outline that details all the forms, a very diluted violet wash is applied. The most illuminated parts of the body are reserved from the outset.

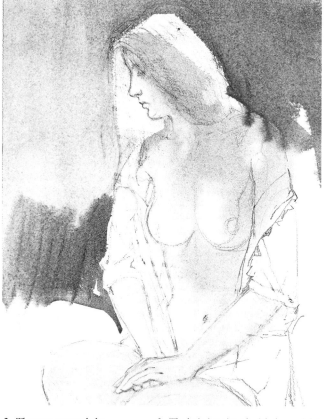

2. The area around the figure is blocked in with a much darker tone of the same wash.

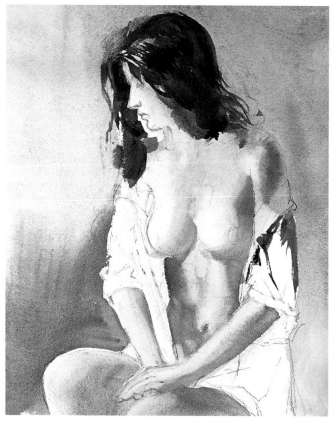

3. The hair is painted with dense violet, toned with carmine directly on the paper. Without waiting for the surface to dry, washes are superimposed wet on wet to bring out the volume of the shoulder, torso, arms, and legs. These are very precise applications, each of which has a bluish or violet tendency.

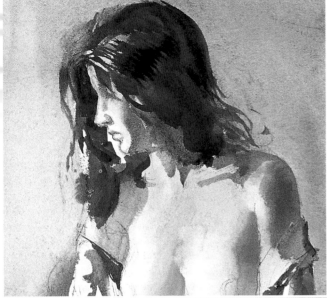

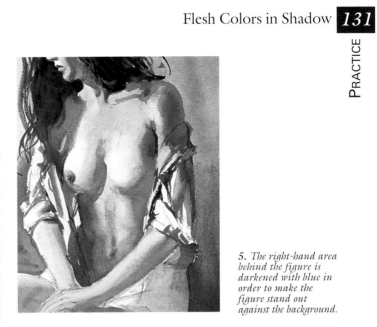

5. *The right-hand area behind the figure is darkened with blue in order to make the figure stand out against the background.*

4. *The features of the face are painted in. The illumination of the face is framed within the shadows of the hair; the shadows on the body are made up of blue and carmine glazes applied onto a dry surface.*

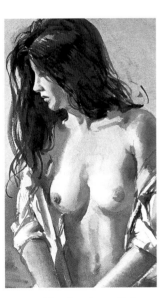

6. *Very diluted washes applied over dried areas further model the details and forms.*

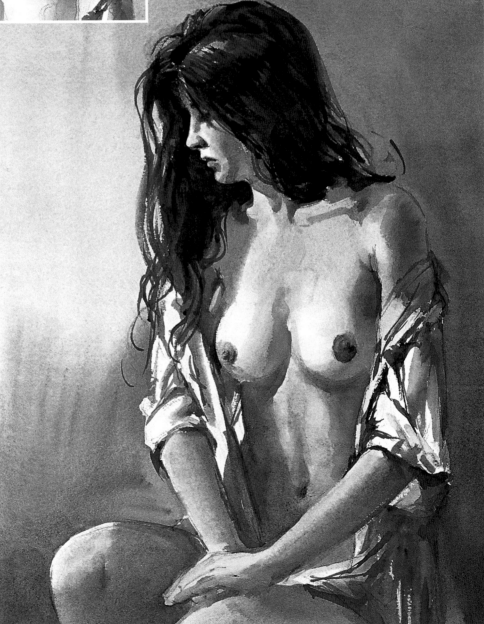

7. *The final strokes add finer details and clarify shapes, applying the watercolor wet on dry. These last touches develop the underlying layer, thus heightening the contrasts. The lighter values of the painting are produced by leaving parts of the paper unpainted.*

Harmony and Contrast

The predominant color of a subject can be determined by studying it through squinted eyes. The artist can capture color realistically, but it is also possible to use exaggeration to heighten the possible chromatic effects of contrast. Each medium and its different techniques provide the artist with abundant possibilities, as is apparent in the next three exercises. The first demonstrates the application of dense layers of oil paint and the special effects created with palette knife techniques. The second, a seascape, explores the effect of glazes, particularly how they can be used to achieve color harmony. Finally, the third, done in pastel, shows how optical, or visual, mixtures can be used to heighten a painting of a neutral tendency.

In this view of Venice, made up of warm colors that contrast with blues, the way in which the palette knife is used is important for adding movement to the waves. The palette knife can also be used to mix directly on the support, creating streaks of color. This creates mixtures of a highly vibrant nature. The reflection of the buildings on the water is an interesting element from a chromatic point of view.

A Venetian landscape contrasting warm and cool colors.

1. The canvas is first primed with blue acrylic that represents the dark color of the sea. When the layer of paint has dried, the sketch is drawn over it in white chalk.

2. The qualities of the sky are painted with various shades of blue and with brushwork that gives the sky depth.

3. The buildings, painted in warm colors, produce a marked contrast with the blues of the sky.

4. The details and texture that describe the buildings are added.

6. *The reflection of the buildings on the water begins to take on a key role. The movement of the waves is produced with the palette knife.*

5. *The darkest and lightest areas of the water are defined by delineating the most important areas of color.*

7. *The launch moving through the water is painted with very few strokes of white and orange tones. Simple white lines indicate the foam produced along the waterline.*

8. *The final touches are applied to develop the reflections on the water. Note the contrast between the warm and cool colors and the weight and force of this work.*

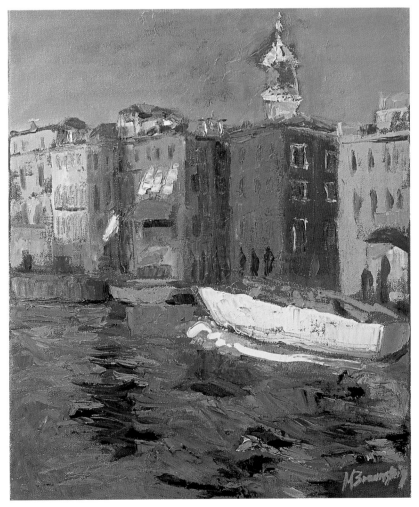

A DOMINANT COOL TENDENCY

This seascape has been painted with very few oil colors. It is a perfect example of what can be achieved by applying a general glaze in the last stage of the work. Keep in mind that a glaze painted over a broad area of dry paint lends the whole uniformity of color. In this case, the very diluted blue paint, applied in a very fine layer, produces a veiled effect of darkening to produce the color of the dusk light.

1. A small selection of oil colors allows all the colors of this seascape to be produced. The colors are yellow ochre, cobalt blue, ultramarine blue, and white.

This seascape illustrates the effect of a glaze applied at the end of the painting.

2. The sketch is drawn on the canvas with light charcoal lines, defining only the most important areas.

3. The first thin application of very diluted paint is executed with two blues. Cobalt blue is used for the light values; the seas and shadows are painted with tones of ultramarine blue and mixtures of both blues.

4. Once the first application has dried, a perfect opaque gradation is painted in the sky. To cobalt blue mixed with white, a little ultramarine blue is added. The sea is painted with darker values and with a greater tendency toward ultramarine blue.

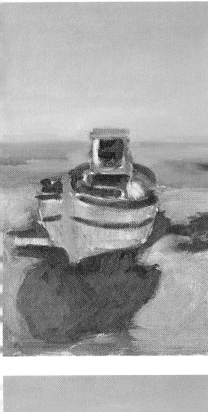

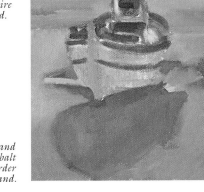

5. Some ultramarine blue mixed with a little yellow ochre is used to paint the sand and the details of the fishing boat. In this way, an entire range of dark neutral colors has been produced.

6. The beach is painted with yellow ochre and tiny amounts of ultramarine blue and cobalt blue, applied with directional brushwork in order to capture the forms of the sand.

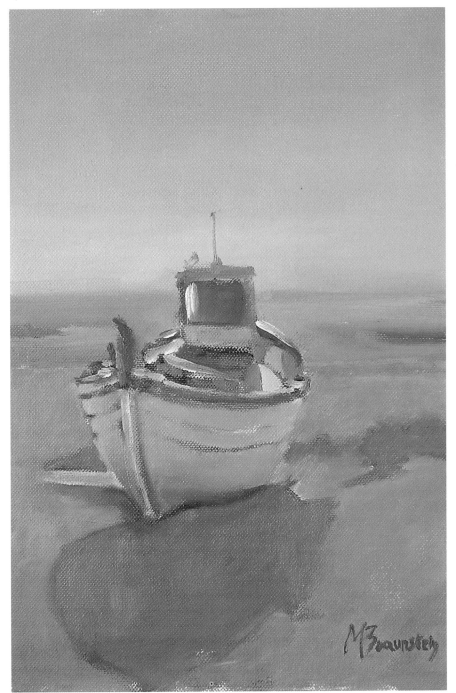

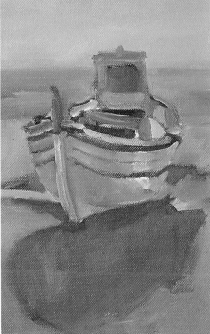

7. In order to give depth to the boat, a bluish-gray range is mixed and applied in all its tones.

8. This work has basically been painted with cool and neutral colors. The bluish aspect of the light of the seascape can be heightened, once the paint is dry, by applying a fine glaze of ultramarine blue, which balances the general color and reduces the underlying color contrasts.

PRACTICE

WORKING WITH NEUTRAL COLORS

A river landscape like this one, which contains many neutral colors, is painted with pastel. The method used here involves superimposing energetic strokes of color. By leaving spaces between the colors, the viewer's eye mixes colors itself. The mixtures are produced directly with commercially manufactured neutral colors or are superimposed with more or less complementary colors. It is important to remember that the amount of pressure applied to the pastel stick as it moves over the paper determines the amount of pigment that is deposited onto the paper. The effect of a neutral palette is quite beautiful. Together, mixtures produced with commercially manufactured colors and mixtures produced by the viewer's eye lend great harmony to the work.

Reflections must also be painted on the water in this painting. Thanks to their shape, pastel sticks can be used to produce texture on all surfaces. The nature of the medium's free strokes can be used to create many effects. The successive strokes and patches of color give the composition a certain rhythm. The color and texture are intimately related.

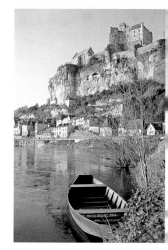

This river landscape and castle allows the artist to develop a range of neutral colors. The sky and the reflection of the buildings on the water are important elements of this composition. The rowboat in the foreground lends more perspective to the scene.

A selection of cool colors to be used in this work.

A selection of warm colors arranged in tonal order.

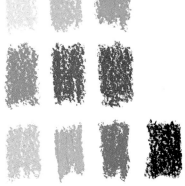

Blue colors and bluish green for the final details.

1. The paper is a smoke gray, a perfect background color for this subject. Using a gray pastel, the most important shapes are lightly sketched in. The almost ariel point of view that frames the composition make it look more dramatic.

2. The colors are applied with energetic strokes; their lines lend a colored rhythmic look to the drawing.

3. Note the direction of the strokes; some are applied vertically, while others are applied diagonally or horizontally; the direction of the lines conforms to the lines and vanishing point of the perspective.

4. The entire subject is blocked in, depicting the masses of the buildings and their image reflected on the water. The same treatment is given to the boat.

5. The colors of the sky are blended with a finger. The blending contrasts with the more precise work of hatching and superimposed colors applied to the buildings.

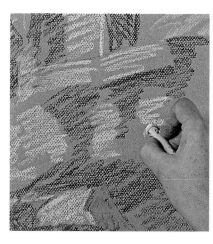

6. Now the right contrast for the middle ground is sought. The procedure entails silhouetting certain buildings and adding the right tones for the shadows.

7. The coloration of the reflections of this calm river is given more detail.

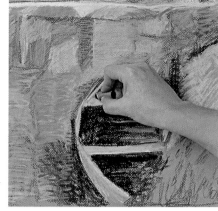

8. The coloring of the rowboat requires the most contrast, because it is the closest object. The colors of the shadows are rendered very dark, whereas the lighter, more illuminated areas are very light and luminous.

9. The vegetation in the foreground must have enough contrast, although it should not be given the same hard treatment as the boat.

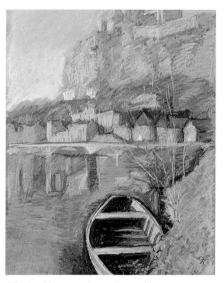

10. At this stage, the work to achieve a correct balance between the middle ground and the foreground is completed.

11. The last strokes and colors constitute the highlights on the calm waters of this river. The mirror effect of the landscape on the water is finished by adding green tones to the middle ground and blues to the foreground.

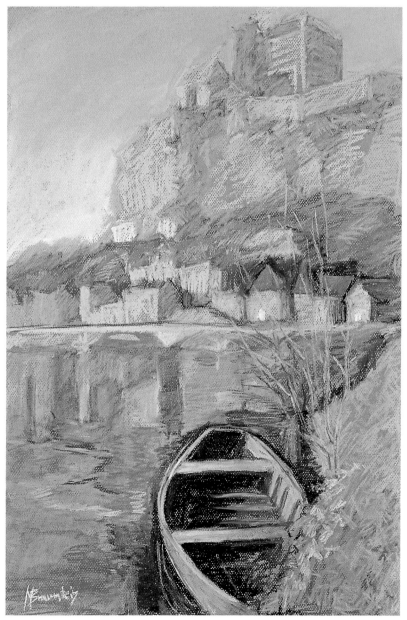

Color Theory

A thorough knowledge of both the practical and theoretical characteristics of color is of prime importance to the artist. In order to understand the countless combinations of color and their applications in painting, the artist should be familiar with several aspects of light theory. The principle of absorption and reflection, for example, explains why objects have a certain color. Additive synthesis explains how colors are composed with light, while subtractive synthesis deals with pigment colors. It is also useful to understand how the eye works as a receiver of colors and how it transmits a visual message to the brain via the optic nerve.

THE COMPOSITION OF WHITE LIGHT

As long as there are no physical defects of vision, such as color blindness or partial loss of sight, the human can distinguish color. It is impossible to speak of color without light to reflect on the objects and the eye to receive the images. However, human vision is complex. Light, which must illuminate the objects if we are to distinguish their colors, has been an object of study for many prominent physicists.

The experiments of two physicists, Newton and Young, established the bases for a greater understanding of the nature of light. To sum up their findings, white light can be broken down into waves of different colors: red, orange, yellow, green, blue, and violet. The combination of these different wave lengths, or colors, produces white light.

The most significant implications of the physical behavior of light for the artist are dealt with in the following sections.

ADDITIVE SYNTHESIS

A graphic representation of the principle of additive synthesis uses three beams of light in primary colors to illustrate the breakdown and reconstruction of white light. Superimposing red and green light gives us yellow. Red and dark blue make magenta, whereas dark blue and green make cyan blue. The superimposition of the three primary light colors—red, green, and dark blue—gives us white light. This process is called additive synthesis because the addition of dark colors produces lighter colors.

A graphic representation of Young's experiment, showing the principle of additive synthesis.

THE SPECTRUM OF WHITE LIGHT

It is interesting to examine the spectrum of white light, from the point of view of perceiving the complex nature of light and the relationship between different colors. The wavelength of the colored beams of light is measured in nanometers. The diagram below gives the wavelength for each color in the spectrum. Orange has a wavelength of 585 and 595 nanometers, which is the area between yellow and red. The standard for moderate orange is perceived in the range of wavelengths between 580 and 650 nanometers. Browns are colors of medium to low luminosity, which produce the perception of reddish colors and dark violets. Black is the absence of color, because it neither emits nor reflects light.

The spectrum of white light is represented by a color wheel. This wheel, which is very useful to the artist, is a synthesis of what appears in a color spectrum.

The color spectrum. The wavelengths correspond to the colors that the retina sees: 1. intense blue; 2. blue; 3. green; 4. yellow; 5. red; 6. violet.

THE COLOR OF OBJECTS

The color of an object, or what the artist sees when looking at it, is the result of white light being broken down into different colored beams. In this way, the color of an object is the result of reflection and absorption. As its name implies, reflection is the capacity of a surface to reflect some or all of the light it receives. Absorption, on the other hand, refers to the capacity of a surface to absorb some or all of the light it receives.

All objects have color, but this color can only be perceived by humans when the object is illuminated. What actually happens is that the light that hits an object is broken down into different colored beams, some of which are reflected by the object while others are absorbed.

These principles of reflection and absorption are essential to understanding the color of objects. There are six basic principles: 1. White objects reflect all colors. 2. Black objects absorb all colors. 3. Gray objects absorb and reflect equal amounts of the primary colors red, green, and blue. 4. Yellow objects absorb blue and reflect red and green. 5. Magenta objects reflect blue and red and absorb green. 6. Blue objects absorb red and reflect blue and green.

Examining the graphic illustrations of additive synthesis along with the principle of reflection and absorption helps to explain why we see objects with different colors. Nevertheless, there is still one missing step: how this information is captured by the visual organs and transmitted to the brain so that it can perceive and identify the colors.

THE EYE

Our visual organs make up a perfect optical mechanism. The iris and pupil are the diaphragm, whereas the crystalline lens acts as a zoom lens. The cornea functions as a protective lens, and the retina, which is connected to the brain via the optic nerve, reproduces the images and colors.

A picture of a cross-section of the retina explains the connection to the optic nerve. The rods and cones act as photoreceptors for color images. These sensitive cells capture the wavelengths of the light that enters the eye, which, because of additive synthesis, reproduce images and colors. The bipolar and ganglion cells transmit the images to the optic nerve in the form of electrical impulses. Finally, the optic nerve sends all of the information that has been received in the retina to the brain. All of this information is processed in the brain to produce color, depth, and movement.

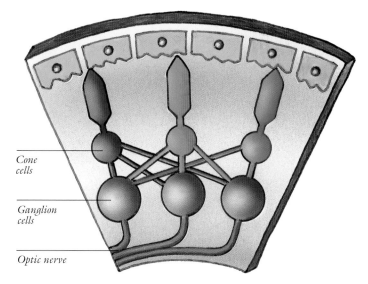

Diagram of the transmission of colors to the brain by additive synthesis.

Cone cells

Ganglion cells

Optic nerve

A graphic illustration of the absorption and reflection of light on colored surfaces.
1. White objects reflect all colors.
2. Black objects absorb all colors.
3. Gray objects absorb and reflect equal amounts of the primary colors red, green, and blue.
4. Yellow objects absorb blue and reflect red and green.
5. Magenta objects reflect blue and red and absorb green.
6. Blue objects absorb red and reflect blue and green.

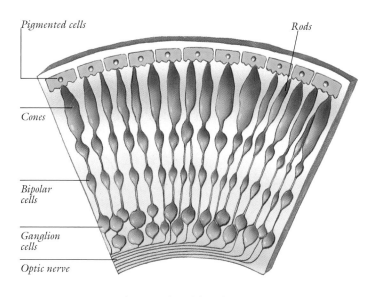

Pigmented cells

Rods

Cones

Bipolar cells

Ganglion cells

Optic nerve

A cross-section of the retina.

AN ARTIST WORKS WITH PIGMENT COLORS

Light, which is made up of different colors, has its own characteristics. Artists see colors as a result of light and their sense of sight. However, they do not work with this kind of color, but rather with pigment colors. Thanks to the above-mentioned scientific experiments, we know that "light colors" work according to the principle of additive synthesis, whereas pigment colors work according to a principle of subtractive synthesis.

As additive synthesis has revealed, a mixture of red and green light produces yellow, red and deep blue produce magenta, and deep blue and green make cyan blue. White light is the result of mixing deep blue, green, and red. Thus, in additive synthesis, darker colors produce lighter colors when mixed.

PIGMENT COLORS: SUBTRACTIVE SYNTHESIS

When working with pigment colors, the principle that applies is subtractive synthesis. A graphic illustration of this is useful for several reasons. The three primary, or basic, colors are a red tone called magenta, a light blue called cyan blue, and yellow. These three primary colors form the basis from which the artist can produce all other colors.

The illustration shows how yellow and magenta produce red, magenta and cyan blue produce dark blue or violet, and yellow and cyan produce green. Finally, mixing all three basic colors—cyan, magenta, and yellow—produces black.

This process is called subtractive color because as the colors are mixed, they become darker, with less "light." The difference between the two principles can be easily understood by comparing this process with the illustration of additive synthesis.

Additive synthesis. An illustration of the results obtained by mixing the primary colors of light.
1. White comes from mixing the three primary colors of light. Secondary colors are produced by mixing two of the primary colors.
2. Yellow is produced by mixing red and green.
3. Magenta is produced by mixing red and deep blue.
4. Cyan blue is produced by mixing green and deep blue.

Subtractive synthesis. An illustration of the results obtained by mixing the primary pigment colors.
1. Black comes from mixing the three primary pigment colors.
2. A mixture of yellow and magenta produces red.
3. A mixture of magenta and cyan blue produces deep blue.
4. A mixture of yellow and cyan blue produces green.

COMPLEMENTARY COLORS

Although the term *light colors* is no longer used, it is still useful for the artist to know the type of colors that are being dealt with and to distinguish them from pigment colors. The complementary colors for light can be deduced from the illustration of additive synthesis. Red and green make yellow, which is complementary to the "light" color that is absent in its composition, blue. In the same way, magenta and green are complementary, as are cyan blue and red.

Complementary pigment colors are easily recognized with the help of another diagram that shows each pair separately. The primary colors (P) are cyan blue, magenta, and yellow. The secondary colors (S) are deep blue (or violet), red, and green. The mixture of magenta and blue gives us deep blue. Deep blue is therefore complementary to the P that was absent in its composition, yellow. Thus, deep blue and yellow are complementary colors. Similarly, red and cyan blue are complementary, as are magenta and green.

THE COLOR WHEEL

The color wheel is a simplified illustration of the spectrum of white light. This extremely useful tool classifies colors as primary, secondary, and tertiary. Tertiary colors are the result of mixing a primary color with a secondary color. To each side of the primary colors are the two tertiary colors that can be obtained from it. The secondary color, which is complementary, is located directly opposite the primary color.

Diagram of the complementary pigment colors.
P_1 *Yellow*
P_2 *Magenta*
P_3 *Cyan blue*
S_1 *Secondary blue (or violet)*
S_2 *Secondary red*
S_3 *Secondary green*

Pairs of complementary colors:
1. *Primary yellow (P_1) and secondary blue (S_1) are complementary.*
2. *Primary cyan blue (P_3) and secondary red (S_2) are complementary.*
3. *Primary magenta (P_2) and secondary green (S_3) are complementary.*

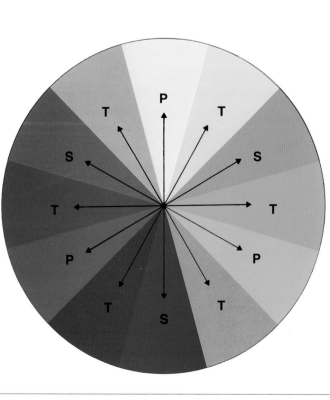

The color wheel for pigment colors. The color wheel is a diagram that shows the primary, secondary, and tertiary colors. Note the way the wheel is organized: A primary color is flanked by the two tertiary colors it generates, and each tertiary color is flanked by the secondary color that is mixed with the primary color to produce it. The complementary colors are directly opposite one another on the wheel.

Tertiary orange, T (P_1, S_2) comes from mixing equal parts of primary yellow (P_1) and secondary red (S_2).

Tertiary light green, T (P_1, S_3) comes from mixing equal parts of primary yellow (P_1) and secondary green (S_3).

Tertiary emerald green, T (P_3, S_3) comes from mixing equal parts of primary cyan blue (P_3) and secondary green (S_3).

Tertiary ultramarine blue, T (P_3, S_1) comes from mixing equal parts of primary cyan blue (P_3) and secondary blue (S_1).

Tertiary violet, T (P_2, S_1) comes from mixing equal parts of primary magenta (P_2) and secondary blue (S_1).

Tertiary carmine, T (P_2, S_2) comes from mixing equal parts of primary magenta (P_2) and secondary red (S_2).

ALL ABOUT TECHNIQUES IN COLOR

Topic Finder

ALL ABOUT TECHNIQUES IN COLOR

Original title of the book in Spanish:
Todo sobre la técnica del Color

© Copyright Parramón Ediciones, S.A. 1999—World Rights
Published by Parramón Ediciones, S.A., Barcelona, Spain.
Author: Parramón's Editorial Team
Illustrators: Parramón's Editorial Team

© Copyright of the English edition 2000 by
Barron's Educational Series, Inc.

All inquiries should be addressed to:
Barron's Educational Series, Inc.
250 Wireless Boulevard
Hauppauge, New York 11788
http://www.barronseduc.com

International Standard Book No.: 0-7641-5229-7
Library of Congress Catalog Card No.: 00-031246

Library of Congress Cataloging-in-Publication Data
Todo sobre la téchnica del color. English.
 All about techniques in color / author, Parramón's Editorial.
 p. cm.
 Includes index.
 ISBN 0-7641-5229-7
 1. Color in art. 2. Painting–Technique. I. Parramón Edíciones.
 Editorial Team. II. Title

ND1488 .T63 2000
752–dc21

 00-031246

Printed in Spain
987654321